For Olivia,
With love,
Aaron

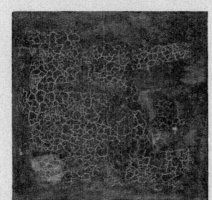

WORLD WAR, MODERN ART, & THE

POLITICS OF PUBLIC CULTURE IN

RUSSIA, 1914–1917 | Aaron J. Cohen

IMAGINING

THE UNIMAGINABLE

UNIVERSITY OF NEBRASKA PRESS • LINCOLN AND LONDON

Portions of chapters 1, 2, and 5 previously appeared as "The Dress Rehearsal? Russian Realism and Modernism through War and Revolution" in *Rethinking the Russo-Japanese War, 1904–05: A Centennial Perspective*, vol. 1, ed. Rotem Kowner (Folkstone: Global Oriental, 2007); portions of chapter 5 previously appeared as "Making Modern Art Russian: Artists, Politics, and the Tret'iakov Gallery during the First World War" in *Journal of the History of Collections* 14, no. 2 (2002): 271–81. ¶ © 2008 by the Board of Regents of the University of Nebraska ¶ All rights reserved ¶ Manufactured in the United States of America ¶ ∞ ¶ Library of Congress Cataloging-in-Publication Data ¶ Cohen, Aaron J. ¶ Imagining the unimaginable : World War, modern art, and the politics of public culture in Russia, 1914-1917 / Aaron J. Cohen. ¶ p. cm. — (Studies in war, society, and the military) ¶ Includes bibliographical references and index. ¶ ISBN-13: 978-0-8032-1547-4 (cloth : alk. paper) ¶ 1. Art, Russian—20th century. ¶ 2. World War, 1914–1918—Art and the war. ¶ 3. Art and society—Russia—History—20th century. ¶ 4. Modernism (Art)—Russia. I. Title. ¶ N6988.C65 2008 ¶ 709.47'09041—dc22 ¶ 2007047098 ¶ Set in StonePrint by Kim Essman. ¶ Designed by R. W. Boeche.

For Stanley

Contents

Illustrations

Artworks

Graphs and Tables in the Appendix

Acknowledgments

I have many people to thank. My family encouraged and supported me in the most difficult times. Jeffrey Brooks, my doctoral adviser at The Johns Hopkins University, read several versions of the dissertation that later became this book and has been very supportive through the years. I would also like to thank the rest of that dissertation committee—Vernon Lidtke, Jane A. Sharp, Brigid Doherty, and Dan Todes—for their time and advice, as well as the anonymous readers who gave advice on the manuscript. Original support for this research came from The Johns Hopkins University Department of History, the German Academic Exchange Service, and the International Research and Exchanges Board. Special thanks to Elizabeth Demers and Heather Lundine, editors at the University of Nebraska Press, for taking on this project.

The expert reader in art history should be ready for some oversimplification, which I have found necessary to make the material more compact and more accessible to historians and general readers. It has been difficult to navigate around the mines in the no-man's-land between academic fields where there are many experts and opinions; all factual mistakes and inadvertent omissions are mine. Note that I use the Library of Congress transliteration system with some exceptions. In the text, soft signs are dropped in proper nouns (e.g., Igor Grabar, Tretiakov) to improve readability, and if a person or place is known by a Latinized name I retain that usage (e.g., Alexandre Benois). Dates before February 1918 are Old Style. All artworks are reproduced with the permission of copyright owners.

This book has been shaped by an unexpected tragedy in my own life, much as the personal tragedy of war shaped the lives of so many individuals whose experience I describe. This event has affected how I have structured the narrative, especially its emphasis on the agency of impersonal forces, the contingency and uncertainty of our lives on earth, and the ways that existential challenges can structure art and life.

Introduction

War has been no stranger to Russian life in modern times. Three violent cataclysmic events—World War I, the Russian Revolution, and the Russian Civil War—devastated the country in the early twentieth century, and Russian people suffered incredible hardships during the horrific years of World War II. In the Soviet Union, military culture, values, and imagery came to pervade official public language, while countless novels, paintings, and films extolled Soviet military deeds. This militarized culture stood in stark contrast to pre-revolutionary Russian traditions, for war played only a minor role in the achievements of the artists and intellectuals who made Imperial Russia a center of European culture before 1917. Military conflict was something that happened long ago or far away for most people in the Russian Empire, and warfare, on the whole, was not a prominent theme in the country's intellectual life. The great exception was World War I (1914–18), which forced artists in Russia to grapple with the consequences of modern war, transformed the way they understood the artist's place in society, and patterned the invention of one of the most important Russian contributions to modern culture: the non-objective art of Kazimir Malevich, Vladimir Tatlin, and other avant-garde artists. War was more important in Russian cultural life during the Great War than at any other time in the half century before 1914, and World War I, in important ways, had a more profound influence on the politics and aesthetics of Russian visual culture than even the revolution.

One reason for this book is to help restore the Russian ordeal of the First World War to Russian and European history. For modern historical memory, as Pierre Nora has pointed out, is not what individual people remember; rather, it consists of sites of memory, those public symbols about the past that focus collective identity: the people and events, monuments and buildings, institutions and concepts, and books and works of art that represent the past in everyday social, cultural, and political life.[1] After 1917 the Bolsheviks determined the public memory of the Russian past and set the agenda, both explicitly and implicitly, for the study of Russian history.[2] Soviet leaders thus memorialized their conception of their history, a vision based on the thoughts and lives of Marx and Lenin, the Russian and European revolutionary traditions, and the revolutionary leadership of the Bolshevik Party, and they celebrated their military victories over their enemies in the revolution, the Civil War, and World War II. With no positive place in the Bolshevik understanding of the revolution, World War I, for the most part, "sank into silence" after 1917.[3] There were no public monuments to the war, no great cemeteries for its fallen, and no Armistice Day or Remembrance Day in the Soviet Union. The First World War seemed to be a "forgotten" war, a "blank spot" in Russia's twentieth century.[4]

Imperial Russia has therefore remained peripheral, if not missing, as historians of Europe debate the impact of World War I on the society and culture of the twentieth century. Was the Great War a decisive break in European history and culture? How extensive was mass mobilization among intellectuals and the general population? Were the war's cultural effects reactionary or revolutionary? Did it strengthen modernism or traditional aesthetics? For years historians have been debating the nature of these issues in wartime Britain, France, and Germany.[5] Yet European public culture continues to exclude Russia from the common war experience, even when European historians are conscious of its absence.[6] The war's weak historical memory in the Soviet Union certainly contributed to this isolation, as did the compartmentalization of academic fields during the cold war,

which decoupled the study of the Soviet Union from Western Europe. But the Russians are also omitted because present-day political needs heavily inform the memory of World War I in the European Union, where public commemoration and cooperative academic scholarship can be used to reconcile the divisions of the past. Specialists from former allies and former enemies, for example, worked together to create the Museum of the Great War (L'Historial de la Grande Guerre) in Péronne (Somme), which has a mission to explain the war "through the parallel histories of the three main protagonists, France, Germany and Great Britain."[7] The Great War killed some two million people from Russia, brought large-scale dislocations to Russian life, and dragged on for three and a half difficult years, but it still belongs to the West in our popular and professional minds.[8] The wartime voices of Imperial Russia's writers, poets, and artists remain lost.[9]

The place of World War I in Russian history has also been obscured by the Soviet experience. Long focused on the history of the Bolsheviks and their state, historians of Russia have often overlooked the war, and those who did study the conflict understood its significance only in its relationship to the revolution.[10] Today, most historians view the revolutionary era as the product of long-term political or social problems, and they have, perhaps naturally, minimized the role of World War I in shaping subsequent events. Richard Stites, for example, has recently written that the war was responsible for little, if anything, new in Russian culture, that high and low culture remained divided, and that "nothing like mass mobilization or nationalization of the arts took place."[11] Peter Gatrell, however, has shown how effects of the war created a new social category, refugeedom, while Eric Lohr suggests that the war was a distinctive "nationalizing event" that marked the abandonment of prewar attempts to assimilate minorities.[12] But few others have suggested that Russia's war introduced new institutions or ideas into public life, including the émigrés and historians who once considered it the main reason for the fall of the empire and the Bolshevik rise to power. Peter Holquist has thus made a powerful

and convincing plea for us to reconsider the importance of the war experience for postwar Russian and European history, but even he devotes just one chapter to World War I in his recent book.[13] Today it is not uncommon for academic studies of Imperial Russia to end in 1914 and histories of the Soviet Union to begin in 1917. The very existence of this gap, perhaps, tells us that something happened between 1914 and 1917 that does not fit into conventional conceptions of twentieth-century Russian history. Years after the end of the Soviet Union, we still look at Imperial Russia through the prism of the revolution.[14]

I look at Russian history from a different perspective, as a history without the revolution, to argue that there were significant developments in wartime life that the memory of the revolution should not obscure. World War I, in this view, was more than the final indignity of a falling empire, a simple prologue to revolution, or a blank spot in a view of Russian history dominated by the Soviet experience; it changed Russian culture and ought to be considered an important event in its own right.[15] I show, for example, how many Russians reevaluated their prewar attitudes toward politics, social engagement, and public activity in response to the material and intellectual disruptions of mass mobilization after 1914. New institutions, new public behaviors, and new cultural forms emerged from this new engagement with war, some of which continued, some of which were reinterpreted, and some of which were destroyed in the revolutionary period. Such changes were striking in the Russian art world, where one can trace, through specific institutions, ideas, and images, how a rapidly shifting wartime public culture could destabilize conventional patterns in cultural politics and aesthetics. Out of this re-imagining came an art culture with more room for individual artists, a broader definition of Russian art, and a non-objective ideal that revolutionized modern thinking about art. Without the revolution, Kazimir Malevich's *Black Square* (1915) (figure 1) would still rank with Pablo Picasso's *Les Demoiselles d'Avignon* (1907), which broke the picture plane and redefined modern vision, as one of the most important paintings of the twentieth century.

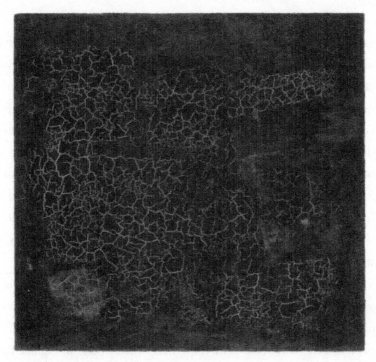

1. K. S. Malevich. *Black Square*. 1915. Oil on canvas, 79.5 × 79.5 cm. State Tretyakov Gallery, Moscow.

With this book I also aim to reaffirm the importance of the public sphere in our understanding of Russian history and culture. The experience of Russian painters in World War I suggests that the war was important because it brought new mobilization conditions to an already existing, self-mobilized civil society. On the one hand, the war accelerated historical trends already present in prewar society, especially the expansion of public institution-building, intensification of market relations, and destabilization of traditional social identities that characterized life in late Imperial Russia. On the other, World War I sent Russian life onto new trajectories. The country's isolation from international trading partners and Polish industrial areas distorted the economy, while military conscription, massive battles, and economic changes caused population movements, demographic shifts, and social disruption. Warfare was suddenly an important topic in educated society after decades of sporadic interest and benign

neglect, the entertainment industry and the information media became militarized, and patriotism, altruism, and civic activism bloomed as never before in Russian history. Before August 1914, individuals and groups mobilized themselves to achieve a variety of public goals in different ways, for particular purposes, and at different paces. After August 1914, a culture of war suffused with mass mobilization aligned the less focused, more chaotic civic activism of peacetime in ways that had profound effects on public behavior and attitudes. Civil society, not the state, remained the most important factor in shaping the broad public culture even as the country and its people faced the economic, political, and psychological stresses of war and revolution.

Most historians have judged the significance of Russian civil society by the effectiveness of its political opposition to the authoritarian state, an approach rooted in the ideas of the German sociologist and philosopher Jürgen Habermas.[16] For Habermas, intellectuals in eighteenth-century civil society gathered in a space of autonomy outside the state, bound together through the ideas of the Enlightenment in institutions such as literary salons, periodicals, and voluntary associations like the Freemasons. In this public sphere, civic activists formed a critical public opinion that tried to influence or guide the exercise of absolutist state power. Habermas's political understanding of the importance of civil society and the public sphere seemed plausible as communism crumbled in Eastern Europe during the late 1980s, and some historians adopted it to argue that the emergence of a mass-circulation press, an urban civic life, and an educated public formed the foundation for a functional democracy in Imperial Russia.[17] Many, however, remain skeptical that Russian civil society could ever have effectively opposed authoritarianism, noting the country's lack of a cohesive middle class, the seriousness of its social divisions, and the weakness of its public institutions and democratic traditions vis-à-vis the state. The view among many historians today is that

the Imperial Russian public was too frail to support a stable democracy, and the failure of civil society remains a major explanation for the coming of the revolution and the victory of Bolshevism.[18]

Yet civil society did not falter in wartime Russia; it continued to mobilize until economic and political events began to undermine it late in the war, a phenomenon that contradicts today's apparent consensus about the frailty of Russian public life.[19] In my mind, historical debates about the political failures of Russian civil society, with the outcome already known, have more to do with judging the historical inevitability of the Soviet Union than with understanding Imperial Russia. Civil society, after all, should be understood as one historical phenomenon among many, not as the deciding factor in the success or failure of democracy, and its essential quality is public self-mobilization, not political opposition to absolutism.[20] Jean L. Cohen and Andrew Arato, for example, take a broader, more institutional view of civil society than Habermas, defining it as "a sphere of social interaction between economy and state, composed above all of the intimate sphere (especially the family), the sphere of associations (especially voluntary associations), social movements, and forms of public communication," all social practices that are "created through forms of self-constitution and self-mobilization."[21] Social action in civil society, in this view, emerges from its constituent parts, not from the initiative of a hegemonic directive organization, be it a state, church, political party, or other institution with a monopoly over media and public discourse. From such a perspective, one cannot deny that Imperial Russia had a functioning civil society mobilized to conduct tasks in a public sphere made up of mass media, commercial culture, and nongovernmental institutions by the early twentieth century. Joseph Bradley has therefore proposed that we change our emphasis from what did not happen in Russia (a successful struggle of liberal democracy against authoritarianism) to what did happen, a change that allows us to see how Russian civil society emerged to help develop the country alongside a modern state bureaucracy.[22]

I believe that a broader, less determined concept of "public culture" can help us better explore the links between politics and culture in wartime Imperial Russia. In this context, a public is not a specific group of people or institutions but a "relation among strangers" self-organized through discourse; it is created by people who seek to address an indefinite and impersonal audience outside themselves.[23] Public culture is the institutional and ideological nexus that structures the real and imaginary space between individuals and public inside modern society; it consists of the institutions, ideas, and customs people use to perceive the world, communicate with others, and act outside the immediate environment of face-to-face communication and action. Modern states with socially heterogeneous and large, anonymous populations have an overarching public culture that is usually bounded by language, law, and media institutions: pluralist publics include many audiences, public ideas, and centers of cultural production, while authoritarian or totalitarian publics contain fewer available audiences, more limits on public ideas, and stronger central institutions. Smaller publics or subcultures, moreover, develop within the shared geographic, linguistic, or social space of this broad public culture as individuals interact with different audiences in the course of their work, leisure activities, religious practice, family life, and other life experiences. Whether open or restricted, large or small, public culture sets the parameters for public action: it governs the acceptability of public behavior, the individual's access to public institutions, and the content of public ideas. Since such boundaries vary through time and space as material conditions and human agency interact, public culture becomes a contested forum "where power in its various forms, including meaning and aesthetics, is elaborated and made authoritative."[24] Any successful public action thus has a role for both individual and public: individuals must have the ability and willingness to engage the public culture, and public institutions must be able to accept the individual's action. An individual's public behavior and speech therefore may or may not reflect his or her per-

sonal values; people often present different faces to different publics in order to meet the expectations of others.

Public culture mattered in the cultural life of late Imperial Russia because it framed the relationship between the individual artist and the public. I do not want to deny the importance of individual political ideology, aesthetic theory, or any expression of class, ethnic, or gender identity for our understanding of Russian culture. But Russia's art history, and by extension its cultural history, should also be understood in the context of an expanding public sphere that provided the institutions, language conventions, and cultural practices that enabled artists and other public figures to engage various audiences. Artistic connections to society were made through professional institutions, and the public activity of Imperial Russian artists was focused almost exclusively on resolving material problems and achieving professional aims, even when they or others assigned specific political positions or generalized aesthetic theories to their art. Painting thus became very political in an environment where artists competed for professional attention and status in a public culture that was changing, sometimes slowly over the course of a century, sometimes abruptly as in 1914 or 1917. The politics of art in Imperial Russia, I suggest, were not so much about who was left or right but about who was (or was not) mobilized, for (or against) what cause, and with (or against) whom for access to the public and its institutions at any given time. Although historians often focus on the importance of national identity, citizenship, and formal political ideology in twentieth-century Russia, the war experience of artists shows that these are probably less important than material and professional concerns for understanding most people's public behavior.

With this book I seek to resurrect World War I as a significant event in Russian history, explain its influence on public culture, and show how one of the most radical innovations in modern painting, the non-objective art of the Russian avant-garde, emerged during the war, a topic that has not attracted the attention of historians or art historians.[25] Chapter 1

explores the aesthetic principles, art institutions, and artistic culture that artists in Russia developed in response to changes in the public sphere before 1914, while chapter 2 examines the emergence of a new public culture of war in 1914. Mass mobilization changed the structure of the public for art professionals, which in turn transformed the public attitude of artists toward each other as well as toward broader society and politics. Chapter 3 defines the impact of these changes on the culture of the art world: how wartime conditions in civil society induced artists to change the form of their art and their public activity in reaction to new material and psychological demands. Chapter 4 shows how artists around Kazimir Malevich and Vladimir Tatlin tried to stabilize avant-garde culture through participation in mass mobilization and the invention of non-objective art, an art that no longer represented an object but simply was an object in itself. Chapter 5 discusses the politics of the art world as they developed inside Russian civil society and a mobilized wartime public culture, a mobilization that shifted with the revolution when a different public culture changed the focus of professional art activity.

Imagining the Unimaginable is in many ways a conventional cultural history, but it is also openly interdisciplinary and at times methodologically unorthodox. As a historian I use art and aesthetics, in the main, to answer historical questions, and I focus on artists not to valorize or criticize them but to observe how wartime disruptions in public life could have major implications for Russian intellectual and cultural history. Like historians and some art historians, I interpret quantitative data and primary written sources under the assumption that art practice was embedded in institutional, political, and cultural contexts, and I follow the history of the media, especially the press and the publishing industry, as a proxy for structural conditions in the public sphere. But unlike historians, who tend to use the content of visual culture to infer the author's intent or the viewer's reception, I sometimes consider formal changes in visual imagery as primary source evidence, a practice common in art history, and

I argue that we can find meaning in the forms of social institutions and public culture apart from the meanings that historical actors ascribed to individual actions. I do not claim to cover all significant aspects of the art world, supply the most authoritative readings of any work of art, or offer the only correct interpretation of the life of any artist, for there are many ways to find meaning in art, and I use reductive terms like *realist, aesthetic modernist,* and *avant-garde* as rhetorical conveniences that reflect Russian practice, not to define their essential meanings or to address theoretical debates about those concepts.[26] There are also many worthy topics that I do not treat at length, including the role of gender, ethnic, class, and regional identity. This book, in short, is not a comprehensive survey of Russian art or cultural politics; my purpose is to use art and the art world to trace changes that World War I brought to public culture so that we can begin to integrate Imperial Russia into our understanding of the shared European war experience.

Artists who lived through the dramatic time between 1914 and 1917, it turns out, lent that period significance even after the Russian Revolution had overshadowed the war experience. The revolution, of course, cannot be undone, and I do not want to minimize its importance in Russian history or argue that we should ignore its preconditions, causes, or consequences. But we should not limit our ability to understand late Imperial Russia by viewing its historical development only in relation to the emergence of the Soviet Union. Nikolai Punin, an avant-garde artist and early Soviet art critic, remembered World War I as an elemental force that acted upon artists quite independently of later events. "The war took its course," he wrote, "tearing from us pieces of the past that should have belonged to us. It shortened some things and drew others out, as a candle shortens and lengthens the shadows on the wall, and having brought the world up to a new speed, the war placed an evil backdrop on all our lives, against which everything seemed at once tragic and meaningless."[27] After 1914, avant-garde artists in Russia began to imagine many things that had

seemed unimaginable before the war: professional cooperation with aesthetic rivals, social and intellectual tolerance of the political and artistic establishment, and an exciting new definition of art. Years later, in far-off France, Marc Chagall still saw the First World War as an event that changed artistic life, and art and the war remained linked in his very speech. "Before the war of 1914," he told a critic in 1924, "we sought a plastic ideal, a *Somme* [*sic*] of plastic problems. The war was another plastic work that totally absorbed us, which reformed our forms, destroyed the lines, and gave a new look to the universe."[28] This book contains a story of that new look, the *Black Square*, at one time held up as the face of Bolshevism.[29] Punin, though, remembered that war had come first and only continued in a different form. "The war slowly turned to revolution," he wrote. "When the revolution began we don't know: the war had no end."[30]

1. The Wars against Tradition

The Culture of the Art Profession in Russia, 1863–1914

In the years before World War I, prominent members of Russia's artistic avant-garde declared war on the country's philistine Victorian culture and stuffy art world. "*We* alone are the *face* of *our* Time," proclaimed the notorious iconoclast David Burliuk in the 1912 manifesto *A Slap in the Face of Public Taste*, which contained a provocative challenge to the cultural achievements and institutions of Russian civilization: "The past is too tight. The Academy and Pushkin are less intelligible than hieroglyphics. Throw Pushkin, Dostoevsky, Tolstoy, etc., etc. overboard from the Ship of Modernity."[1] Burliuk and the young poets and painters who were his allies took their assault on conventional values into the physical space of the public sphere when they walked the streets with painted faces, attached spoons to their clothing, and gave scandalous speeches, lectures, and stage performances. Their art was the visual component of this attempt to undermine the authoritative institutions, public standards, and mainstream art culture of late Imperial Russia. "Modern art," asserted Olga Rozanova in 1913, "has upturned completely the conception of Art that existed hitherto."[2] Viktor Shklovskii, the noted Soviet literary critic, later remembered that the avant-garde was prepared for a radical change in Russian life: "It was a generation that would see war and revolution. For Russia, it was a generation that would see the end of the old world. And they had already rejected it."[3]

The avant-garde's public disparagement of educated Russia's great icons evoked shock, outrage, and ridicule in contemporary newspapers, but public attacks against aesthetic rivals had been a part of professional art life for more than a half century. Historians of Imperial Russia, in their quest to understand the revolution, have often emphasized the divisions within Russian society, the reliance of professionals on the state, and the weakness of the country's educated and middle classes.[4] But the history of the art world shows that professionalization could also involve an increase in institutional cohesion, material resources, and self-mobilization as civil society grew and became more pluralistic in the late nineteenth and early twentieth centuries. In this environment artists in Russia identified themselves as professionals and strove to shape a public space that was friendly to their ideas and their interests. Divergence, diversity, and conflict increased as contradictory philosophies of art, competitive professional goals, and distinct art audiences and buying publics emerged. In response to these challenges, painters organized themselves into groups, defined themselves aggressively against professional rivals, and became preoccupied with problems of individual, aesthetic, and national identity. The public action of artists in late Imperial Russia was thus dispersed, unfocused, and often mobilized against other artists even as a common set of values, institutions, and public behaviors suffused their occupational space and stabilized artistic life.

The Evolution of the Russian Art World, 1863–1914

The spectacular vitality and creativity of late Imperial Russia in literature, music, theater, and the visual arts was linked to the rapid changes in the economy and society that engulfed the country after the Great Reforms in the 1860s. In the early nineteenth century, Russia's official sphere— that is, its autocratic government, powerful aristocratic families, and high state functionaries—played a major role in the mobilization of the country's material and cultural resources. The political, economic, and social

changes that accompanied the Great Reforms at midcentury provided for an expanded public based on greater educational, economic, and social opportunities. In this atmosphere the intelligentsia cultivated a tradition of hostility toward the autocratic state, a valorization of certain political and philosophical ideas, and a moral concern for the broad masses of Russian people. This intelligentsia culture, in turn, faced cultural challenges as an industrial takeoff fueled high economic growth, cities swelled, and the public diversified around the turn of the twentieth century. After 1905 a new Parliament (Duma) gained limited budgetary power, greater press freedoms permitted wider public discussion and a measure of political criticism, and public education expanded. An extensive commercial culture based on mass-circulation daily newspapers and illustrated weeklies, cheap books and other popular publications, and cinema and popular theater smudged traditional social categories, cultural forms, and personal identities.[5] By 1914 this new commercial culture intermingled with the culture of the intelligentsia and the smaller official sphere inside a broad, pluralistic public space.[6]

After 1860 the art world also experienced tremendous physical growth. At midcentury it was dominated by a single institution, the Imperial Academy of Arts, an organization administered by the Ministry of the Court in St. Petersburg. At one time the Academy was an important vehicle for the Europeanization of the country, and under its tutelage Imperial Russia developed an art culture rooted in late-eighteenth- and early-nineteenth-century neoclassicism. Outside the Academy formal art institutions were limited in the mid-nineteenth century: there were few art journals (none long lived), a handful of art groups (around ten until the late 1880s), a tiny art market, and two centers for art (Petersburg and Moscow) (see graph 1 in the appendix). In the 1870s and 1880s, however, new collectors, including Pavel M. Tretiakov, the Moscow businessman whose personal collection eventually became the Tretiakov Gallery, started to patronize artists who focused on Russian themes, and the art world began to expand. New

consumers entered the market, new groups and publications appeared, and new styles arrived from abroad as Imperial Russia became more integrated into international cultural life. Around the turn of the century wealthy families such as the Riabushinskiis, Shchukins, and Morozovs collected modern Russian and international art, prestigious museums like the Hermitage, the Russian Museum, and the Tretiakov Gallery expanded their collections, and art groups, exhibitions, and museums spread to provincial cities. The number of art groups reflected the country's increasing public space, doubling to around forty groups between 1890 and 1900 and doubling again to over eighty groups by 1910 (see graph 1 in the appendix); after 1905 the tempo of group formation was faster in the provinces than in Moscow and Petersburg (see graph 2). Growth was so rapid that a lack of exhibition space became a chronic problem in the art world.

Russia's professional artists needed to compete and to cooperate with ever greater intensity as society and its public culture expanded. Professionals translate specialized knowledge and skills into social and economic status, and they seek to mobilize an occupational space to protect their credentialing power, products, and markets from nonprofessional sources of authority.[7] Economic, political, and social instability can intensify professional struggles and strain professional groups because they raise uncertainty over the ability of professionals to control their environment. Occupations such as art are especially vulnerable to such challenges because they typically do not professionalize as completely as medicine or law, which require considerable specialized knowledge and perform vital services that nonprofessionals cannot duplicate.[8] The technological change, diversification of media, and social transformations that accompanied industrialization in the late nineteenth and early twentieth centuries created new roles for visual culture and new methods for its production, which in turn destabilized the familiar roles of the artist in society. Imperial Russian artists, like other professionalizing groups, hoped to regulate their profession, yet shifting market forces, changes in patron-

age and artistic taste, and the development of new media put their status and power under constant threat.

Professional agendas played a fundamental role in defining the relationship between artists and the public. Painters did not fit the usual classifications that most historians often use to understand late Imperial Russian society; as a group, they did not form a legally defined social estate (*soslovie*), share any specific class, ethnic, or regional background, or consider themselves to be philosophers or intellectuals (with a few exceptions). Instead, the art world offered the prospect of upward mobility to people from various ethnic, religious, and class communities, and artists defined themselves as such when they chose to mobilize their lives as professionals. Any decision to focus on painters in modern society selects a group that has a strong occupational identity and seeks success in the profession, whether that success is defined in material, aesthetic, or personal terms. Many painters in this book have been identified by art historians and critics as significant artists, but they were, in a real sense, self-selected; those without talent, drive, or connections found other work, ceased to engage the public as professional artists, or dropped out of the art world.

A specific set of aesthetic questions became commonplace as the art profession developed inside Russian civil society. Artists, critics, and intellectuals sought new ways to understand themselves and their work as society began to change (in some areas haltingly, in others more rapidly) from an estate-based dynastic state with an agrarian economy and aristocratic high culture into a modern nation-state with an industrial economy and commercialized mass culture. They needed to define the role of art and artists in a place where the aristocratic institutions and neoclassical aesthetics of the early nineteenth century, the public structures, moral values, and political ideologies of the nineteenth-century intelligentsia, and the new commercialized mass culture all coexisted by the early twentieth century. What should art represent in an age of political strife, social turmoil, and cultural transformation? Who was an artist, and which

public should the artist serve? What was Russian art in an age of nationalism and cosmopolitanism? What, in short, did *art, freedom,* and *Russian art* mean in a changing world? These were the questions that filled the art, discourse, and professional activity of artists in Russia, problems that emerged not only from interaction with extra-artistic public opinion but from the tensions and disagreements that existed within the art world. Different artists found different answers, but the questions were the same for all.

Two kinds of art groupings emerged within Imperial Russia's pluralist public culture: the formal art group and the informal milieu. The art group was a professional association of like-minded artists who formed a well-defined institution, usually with an exclusive membership, written charter, and common stylistic or aesthetic approach. Painters met in groups like the Itinerants (*peredvizhniki,* also known as the Wanderers), the Union of Russian Artists, and the World of Art to organize exhibitions, form social connections, and address the broader political, cultural, or social issues that touched the group's members. Boundaries between art groups were not etched in stone, for smaller groups formed and dissolved, and artists often belonged to several groups at once, attracted by ties of kin, professional obligation, or friendship. The milieu was a less well-defined subculture made up of groups and individuals who shared similar aesthetic values. Unlike art groups, milieus were determined not so much by artists but by critics, journalists, and other commentators, who used general labels like *academic, realist, modernist,* and *avant-garde* to define, simplify, and explain the complexities of the art world to the public outside it.[9]

Imperial Russia's art groups served to mediate between individual artists and the public. In an evolving art culture, they provided the institutional structure, common culture, and professional community to identify and ensure access to an art-appreciating audience that was often fragile, undeveloped, or changing rapidly in the nineteenth and early twentieth centuries. An artist painted in the intimate sphere of the studio, but that paint-

ing became part of a public culture when it left the studio to emerge in a space bounded by specific institutions (whether a private gallery, a newspaper review, or a state institution) for real or imagined others to view, discuss, or purchase. We can find information about the painters, art groups, and milieus that formed the institutional basis for artistic communication with the broader population, but the contours of the art public as a well-defined group of people are usually impossible to determine empirically. Its significance, as Thomas Crowe argues, lies not so much in its true composition but how critics, artists, and other art figures struggled to define it.[10] The public was the consumer of the artistic product, and artists needed to meet its expectations to be successful as professionals, a difficult task when public tastes were not easy to determine.

In Russia, major art groups and their associated critics controlled access to exhibitions, markets, and criticism and therefore to professional reputations and fortunes. Individual artists and smaller groups had difficulty attaining professional success outside this system, for the large art groups were relatively closed and exclusive in their institutions and aesthetic beliefs. In the intimate sphere, lines were not so sharp, but in public, each group tried to maintain a distinctive aesthetic agenda, critical audience, and aesthetically consistent membership; artists from different milieus did not usually show work at the annual exhibitions of others (there were exceptions), and professional cooperation became rarer as the aesthetic distance between milieus increased. Modern artists did not exhibit at realist exhibitions, for example, while academic artists did not show their work at modernist events. The links between aesthetic philosophy and editorial line were sometimes soft in the press, but specific approaches to art criticism often lined up with specific newspapers, a trend that became more pronounced as newspapers and the art world became more sophisticated. By 1914 critics sympathetic to the modernist milieu, especially Alexandre Benois, Iakov Tugendkhold, Abram Efros, and Aleksandr Rostislavov, generally worked for liberal newspapers and modern-

ist art journals, while aesthetically conservative critics like Paul Ettinger, Gerasim Magula, and Sergei Glagol wrote mostly for the conservative, moderate, or boulevard press.

Imperial Russia's art world had thus developed well-known rhythms and predictable institutions by the early twentieth century. It consisted of the official Imperial Academy of Arts, several large, prominent artistic groups with specific aesthetic views, a number of state and private museums, and a patronage system based on certain rich merchants, interested aristocrats, and the broader public. This art culture was institutionally and culturally intertwined with the public sphere and civil society, for artists made connections to consumers outside the art world through the print media, exhibitions, and museums. Before 1914 the public presentation of art tended to be very predictable. Major groups put on annual shows at the end of December in Moscow and in mid-February in St. Petersburg, often opening their exhibitions in the same week (or even on the same day) in the same exhibition space year after year. Major dailies released reviews of exhibitions within a few days and usually placed those reviews in the same part of the newspaper. Even the boulevard or tabloid press published commentaries on art, if less frequently and in lesser detail, and prominent artists made their art available to the reading public through popular illustrated weeklies, notably *The Flame* (*Ogonek*), *The Field* (*Niva*), and *The Sun of Russia* (*Solntse Rossii*), which often reproduced images of major paintings from the annual exhibitions. In these ways, artists formed an overarching occupational group that shared public institutions and practices even though they were divided into groups and milieus.

A language of conflict became endemic in this pluralist art world despite its evolving institutional stability. Professional competition deepened as patronage and power over art devolved from restrictive institutions like the Academy to the new consumers, media, and art institutions during the nineteenth century. Artists needed to define a public for art and to distinguish themselves from competitors as more groups formed, and each new milieu upheld the superiority of its aesthetic vision as the best

answer to the traditional questions and aesthetic problems of the Russian art world. This discourse of conflict persisted in art criticism even when there was no real struggle because it became embedded in the culture of the art profession, not because art life was tumultuous or unstable. One critic, for example, described the art world as perpetually contentious and strife-ridden in 1908: "Ten years ago began an increased ferment in Russian art that gave rise to two tendencies: the old and the new, which immediately fell into battle [*v bor'bu*]."[11] But he went right on to describe that conflict's continuing stability: "This past year, which did not bring anything strikingly new, was a passive continuance of the above-mentioned tendencies and battles." In the history of Imperial Russia's academic, realist, modernist, and avant-garde milieus, we can see how the interaction between artists and the public bred a set of common professional ideas, institutions, and practices even as it fostered rhetorical conflict, professional tensions, and aesthetic warfare.

Art for the People: Realist Artists and the Imperial Academy in the Nineteenth Century

Competition between art groups for access to a growing public was openly expressed in political terms with the appearance of Russian realism in the mid-nineteenth century. The link between aesthetic realism and political radicalism was widely accepted in late Imperial Russia, canonized in Soviet art criticism, and long taken for granted in Western art histories.[12] The notion that Russian realists were dedicated opponents of tsarist autocracy, however, emerged largely after politically minded critics, artists, and pundits attempted to mobilize art to legitimize their civic role and authority in the politicized public atmosphere of the Great Reform era.[13] The struggle that began in the 1860s was different for others: to define art as a free profession independent of the power of the Academy and its official public. The attempts by realist painters to build an independent art world ran against Russia's autocratic culture, and their desire to expand the public for art was an institutional challenge to official cul-

ture; the Itinerants remained associated with radical political culture for decades, although they had no direct involvement in revolutionary politics.[14] Yet for most realist artists, professional interests took precedence over the production of anti-autocratic political art, and their hostility toward the Academy reflected hostility to its control over the profession, not to autocratic politics.

In the early nineteenth century Imperial Russia lacked an organized, well-funded "private sector" to support artists independent of the state and official culture.[15] The Imperial Academy of Arts oversaw most of the functions necessary for the country's formal art world: training young artists, administering libraries and museums, providing pensions and scholarships, and representing Russian art and artists to foreign art academies. The Academy required painters to follow specific themes and methods, usually based on neoclassical models that were considered to represent the highest universal standards of eternal truth and beauty, and the mastery of the artist and the worth of the subject matter were represented to the viewer through neoclassical conventions. There was no other officially recognized training or credentialing authority for professional artists; those who had completed the Academy's course of study received an official rank (*chin*), an official salary, and official commissions. The Academy, in short, "molded artists into servitors of the state" and "subordinated art to the needs and tastes of the Court."[16] There was almost no audience for professional painting outside the public of state, court, and high aristocracy, and no institution with the ability to mobilize major artistic resources outside the Academy.[17] Artists, patrons, and markets were thick in provinces, but there were few formal institutions such as journals, art groups, or long-distance trade in art to shape Russia's dispersed artists into an institutionalized public; local elites, for example, used local serfs to produce the paintings they needed.[18] Ambitious artists from the provinces and underprivileged classes made their way to the Academy to develop their talent if they were able to secure a place.[19]

Neoclassicism became entrenched in this official public culture as the state patronized a grandiose art style to emphasize victory in war and the power of empire after the Napoleonic Wars.[20] Academic paintings were figurative in the sense that they used perspective and modeling to mimic an external reality as the eye might see it, and as narratives they told stories to instruct the viewing public, but they were not realist in the sense that they were supposed to reflect direct experience. For the academic artist and public, meaning was communicated through artistic form (gesture, pose, and symbol) as much as content (story and setting). The young artists who were commissioned by the Academy to show the "faith in God" and "loyalty to the Tsar" of the residents of Moscow, for example, used conventionalized gestures and composition in paintings like *Execution by the French of Russian Patriots in Moscow in 1812* (1813) (figure 2) to represent the meaning behind the story (the ideals of patriotism), not to reflect a physical reality (how the subjects actually died).[21] Russian patriots are presented here as virtuous Romans, their devotion to state and fatherland signified by poses that would be familiar to viewers educated in the academic tradition; their Christlike sacrifice is exemplified in the painting's conspicuous imitation of a pietà. The great architectural projects that still adorn St. Petersburg are similar testaments to the power of the nineteenth-century state to mobilize neoclassical aesthetics to represent its might.

A notorious public challenge to the Academy's institutional and aesthetic authority came in 1863, when fourteen students rebelled against its restrictive entrance policy and control over subject matter to form their own institution, the Free Artists' Workshop or Artel (Artel' svobodnykh khudozhnikov). Many contemporaries interpreted the actions of "the fourteen" as a political challenge, as did the state, which censored announcements of its formation and monitored its activity. But it was the critic Vladimir Stasov who most of all helped shape the image of these artists and later aesthetic realists as political painters who sought an art that would remake society. For advocates of realism, art should contribute to the moral and

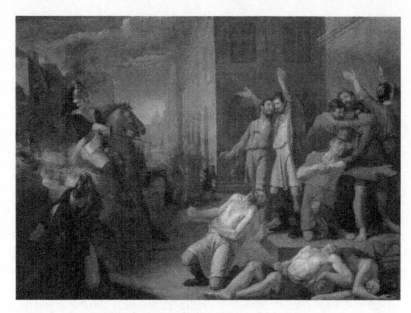

2. V. K. Sazonov. *Execution by the French of Russian Patriots in Moscow in 1812*. 1813. Oil on canvas, 140 × 188 cm. State Russian Museum, St. Petersburg.

social progress of the nation through didactic representation: it needed to be "popular" to expose the problems of common people, "national" to be different from French or German art, and "civic-minded" to achieve political results.[22] The idea that artists should improve the lives of the masses through the mobilization of art reflected the values of the nineteenth-century intelligentsia, who sought to motivate educated society and ordinary people to develop Russian life. Stasov's argument that Russia needed a national school of critical realist painting was realized, he and others believed, in the formation of the Association of Traveling Art Exhibitions (Tovarishchestvo peredvizhnykh khudozhestvennykh vystavok) (1870–1923), better known as the Itinerants.

The difference between the neoclassicism of the Academy and the aesthetic realism of the Itinerants lay not so much in technique, for both groups practiced a narrative, figurative art based on academic methods, but in their different content for different publics. In the eyes of Stasov and politically engaged realists, academic art was aimed at the wrong audience

because it served the needs of a small minority of aristocrats. Russian art had to reflect Russian reality, not the deeds of ancient Greeks and Romans or Russian elites, and it had to depict that reality in a visual language that ordinary people could understand, not present stylized, sentimentalized, or mannered visions that required knowledge of the academic syllabus or elite culture to recognize. In the culture of the nineteenth-century intelligentsia, Ilia E. Repin's *Barge Haulers on the Volga* (1870–73) (figure 3), for example, was democratic, progressive, and Russian, while works such as the *Execution by the French of Russian Patriots in Moscow in 1812* were aristocratic, autocratic, and European. Ragged, dirty, and beaten down, Repin's barge haulers find degradation and oppression in a reality that resembles a desert wasteland. They strain against the weight of a traditional barge while a modern steamship and its labor-saving potential plies the river far off in the distance. Only a young man, cleaner and taller than the rest, provides hope as he lifts his head to look ahead.[23] Here we can see that Repin did not aspire to paint a replication of sense experience; he combined allegory, symbolism, and narrative to craft images that, for critics like Stasov, would expose social problems and mobilize public support for reform. Through such utilitarian realist values, the art of the elite and the experience of the people could be linked and used to change public life.

Attempts by realist critics and artists to create a new aesthetic for a new public were very political in the atmosphere of the 1860s and 1870s, but the conflict between the official and the "popular" was more institutional than ideological. What made the artists of the Artel significant, as Elizabeth Valkenier argues, was not their paintings but their "attempt to practice art as a free profession, to reach the public independently of the official channels, and to be accepted as members of the cultural elite."[24] The call for painters to join "the fourteen" explicitly linked their secession to the need to create a new market that would support artists independent of the Academy and official public: "We think that there is a possibility to free art from bureaucratic control and to widen the circle of those inter-

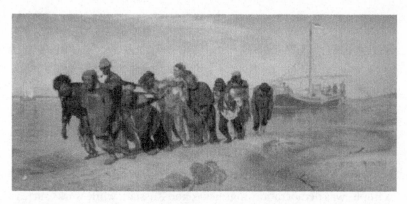

3. I. E. Repin. *Barge Haulers on the Volga*. 1870–73. Oil on canvas, 131.5 × 281 cm. State Russian Museum, St. Petersburg.

ested in art and, subsequently, to widen the circle of buyers."[25] Likewise, some members of the Itinerants had a mission to improve the moral education of the people through art, but the rationale for their association was professional and instrumental: to create an institution where artists could control their art.[26] Russian realists, in sum, rejected the Academy because they wanted to work as artists outside its control, but they did not want to join the ranks of peasant artists, artisans, and craftsmen who, in their minds, did not produce professional art. They were seeking a new public with new institutions and new ideas, a public wider in a social, geographical, and aesthetic sense than the official public surrounding the Academy.

Diversification in public taste in the 1870s led to conflict within the realist milieu as new collectors helped inject realism with a nationalist ethos that at times contradicted both the aesthetic values of the Academy and the more politically minded Itinerants.[27] The railroad tycoon Savva I. Mamontov, for example, encouraged one group of painters to explore themes and issues from the distant Russian past at his estate of Abramtsevo. The reaction of some realist critics toward the results of Mamontov's patronage shows how much Russian painting could drift under the influence of new patrons. Viktor M. Vasnetsov thus attracted Stasov's disdain when he painted warriors and epic battles from ancient Rus.[28] The dead medi-

4. V. M. Vasnetsov. *After Prince Igor's Battle with the Polovtsy*. 1880. Oil on canvas, 205 x 390 cm. State Tretyakov Gallery, Moscow.

eval heroes in his *After Prince Igor's Battle with the Polovtsy* (1880) (figure 4) are deliberately distanced from fact; these are no contemporary military leaders, nor do they represent patriotic virtue through classical convention and form.[29] For politically minded realist artists and critics, this type of painting was a conservative and backward-looking vision that did little to educate the viewer about the problems of the present, and it contributed nothing to the intelligentsia's project of mobilizing the public to change contemporary Russian life. Tensions inside the realist milieu intensified when two Itinerants threatened to resign if *After Prince Igor's Battle* were permitted to be exhibited with the Itinerants.[30] (They failed when the painting passed the exhibition jury.) Mamontov, Tretiakov, and other patrons of the 1870s had become a new base for professional support that allowed artists to resist the narrow definition of art that some critics hoped to enforce. Vasnetsov, with their help, became one of Imperial Russia's most successful painters.

Expressions of political radicalism in realist art moderated under the influence of the art market. Realists had to sell their work to someone, and their choices in the 1860s, 1870s, and 1880s remained limited. The original protestors of the Artel quickly compromised: by 1869 seven had received the title of Academician for paintings they sent to academic exhibitions.[31] Didactic political realism remained a part, albeit small, of the Itinerants'

oeuvre, but most did not reject official commissions. Repin sold his *Barge Haulers*, supposedly the archetypal criticism of the Imperial Russian order, to the grand prince himself, who hung it in his dining room.[32] In time, the Itinerants found that they could achieve commercial success with more intimate and noncontroversial landscapes and genre paintings. In 1871 some 20,000 people visited Itinerant exhibitions and bought around 30,000 to 40,000 rubles' worth of paintings, but the numbers rose to around 30,000 to 40,000 visitors and annual sales between 100,000 and 130,000 rubles in the early 1880s, levels that the group maintained (with some fluctuations) into the 1890s.[33] Aesthetic realism's original political resonance lay not in the politics of its artists but in their attempts to build institutions independent of the state; its radicalism receded once the public and art world had developed to the point where artists no longer needed the support of the state or the politicized intelligentsia to earn a living.[34]

The Academy, far from inert, also reacted to changes in the structure of the art public. In the 1840s students were no longer required to live on the grounds, and by midcentury they had gained some freedom to choose topics in the curriculum. With time, official circles began to patronize many different types of art, and artists of the Academy found success with a variety of styles, including neoromanticism and eclecticism. The formation of the Spring Salon (Vesenniaia vystavka) (1897–1918) was intended to give these artists an exhibition group to take advantage of greater public demand for art. It soon became one of Imperial Russia's largest and most popular art exhibitions, with a well-known brand of intimate genre painting, comfortable landscapes, and popular eroticism (in the guise of classical nudes). "Academic" art evolved into a milieu detached from the Academy as artists founded new groups and institutions, including the Saint Petersburg Society of Artists (Sankt-Peterburgskoe obshchestvo khudozhnikov) (1890–1918) and the Association of Artists (Tovarishchestvo khudozhnikov) (1904–24), to represent academic-style art. The Imperial Academy of Arts remained an important institution with a well-defined circle

of students, professors, and painters in the early twentieth century, and its associated artists had found, through the Spring Salon and other groups, an audience for their art in the public outside officialdom.

The early conflict between the Academy and the realists broke down in response to changing conditions in the public sphere. Realist artists wished to find a new audience to support their professional life, which led to the diversification of art institutions from one authority, the Imperial Academy of Arts, into two major groups, the Academy and the Itinerants, and two art milieus, the academic and the realist. The audience that the Itinerants reached with their art, however, was not the peasants or the downtrodden masses, but rich patrons and, later, more modest buyers of art. In the 1890s, some Itinerants, including Ilia Repin, cemented their professional success by joining the Academy, under the condition that they be permitted to restructure its syllabus and operations. This decision caused consternation among those who wished to maintain the spirit of critical realism embedded within the public culture of the intelligentsia. Stasov, for example, attacked Repin for his "betrayal of republicanism and democracy in art" and "desertion to the monarchical and autocratic camp."[35] The Itinerant embrace of the establishment, however, did not represent a change in personal politics (Repin remained a cultural nationalist and moderate liberal), nor did these artists resign from the Itinerants or leave the realist milieu. In the Academy, realist artists had an institutional basis to make good on their claim to represent a national school of art and to further their professional careers, just as a new group of artists emerged to challenge them.

Art for Art's Sake: Aesthetic Modernism and the Public in the Early Twentieth Century

The Russian art world became more complex amid the throes of industrialization in the early twentieth century, and the continued expansion of public space allowed art to reach a broad public whose tastes continued

to support academic and realist artists.[36] More room developed for a new group of artists, the aesthetic modernists, who in the 1890s rejected the realist ethos of the Itinerants and the classical aspirations of the Academy to advocate new European art styles and techniques. Russia's modernists portrayed themselves as artists who opposed the conventions of the art world and broader society, as the "defenders of art" against its "debasement by the academic professional, the socially-oriented critic, or the ill-informed public."[37] Yet the art and professional behavior among many in the aesthetic modernist milieu show that they wanted to improve public culture, not attack it. Modernists in Russia's Silver Age, like their counterparts in Europe, sought to create a new subjectivity for a modern world where individuals no longer felt stable in their social and personal identities.[38] Symbolists, for example, hoped to reunite art with life through an aesthetic sensibility of "life-creation" (*zhiznetvorchestvo*), a project that they believed would solve the problems of alienation created in modern society.[39] Russia's modernist aesthetes hoped they could reform, and save, a dying world, and the mobilization of art would be their means to achieve this reformation.

The aesthetic modernist milieu in Imperial Russia consisted of two major art groups by 1914: the World of Art (Mir iskusstva) (1898–1903, 1910–24) and the Union of Russian Artists (Soiuz russkikh khudozhnikov) (1903–23). Russia's fin de siècle aesthetes, art nouveau stylists, symbolists, and impressionists first congregated around the Petersburg art journal *World of Art* from 1899 to 1904, but the World of Art itself was only briefly a formal society. In 1903, the country's modern artists founded the Union of Russian Artists, a group that gravitated toward impressionism, *plein air* scenes, and Russian landscapes and favored mystical, folkloric, or allegorical subject matter. In 1910 a more cosmopolitan World of Art group re-emerged as a broad-based modern art exhibition society and lent its name to what became one of the country's most important art milieus. Alexandre Benois, the World of Art's most prominent publicist, critic, and orga-

nizer, described it as "a kind of community which lived its own life, with its own peculiar interests and problems and which tried in a number of ways to influence society and to inspire in it a desirable attitude to art."[40] Aesthetic modernists were by no means united in their aesthetic views or committed to engagement with the public, but in the World of Art Benois and others developed a public agenda that encouraged painters to address Russia's social and cultural problems through modern art and art institutions. They became engaged in a struggle to become art authorities and arbiters of public taste in a pluralistic art world.[41]

Modern artists had no unified aesthetic, but several elements distinguished their work from nineteenth-century realism, academism, and naturalism.[42] Generally, aesthetic modernists believed that art should reflect each individual artist's inner vision, not objects, events, or stories from the external world, for only the imagination and free creativity of the individual could discover and reveal the true, unchanging values of the human experience. "*Art* is eternal for it is founded on the intransient, on that which cannot be rejected," explained Nikolai Riabushinskii in the modernist journal *Golden Fleece* (*Zolotoe runo*) in 1906.[43] "*Art* is free for it is created by the free impulse of creation." This philosophy of "art for art's sake" was meant to realize autonomy for the individual artist from any external restraints, whether cultural or material, on artistic expression; the artist should not reflect any political or social idea to impart a lesson about contemporary life, nor satisfy the requirements of a restrictive institution like the Academy. Narrative, utilitarianism, and didacticism were thus anathema to most modern artists, who prized paradox, ambiguity, or irony in their work. Their art was also strongly self-referential, that is, modernist artists employed texture, simultaneity, and juxtaposition to draw attention away from a painting's subject toward the act of painting: perspective became distorted, colors stronger, and the picture plane flatter. In public, aesthetic modernists often expressed an open spirit of opposition to conventional society, established art values, and received culture; many

seemed so self-absorbed, nihilistic, or estranged from ordinary life that they were known (usually inaccurately) as *decadents*.[44]

Contemporaries understood the appearance of aesthetic modernism to be a rupture in the art world, a clash between the old and the new, and a rejection of the Itinerant tradition and the culture of the Academy. The modernist and the realist milieus appeared to follow contradictory aesthetic philosophies and definitions of Russian art, and the polemics between them were bitter and violent as both competed for legitimacy inside Russia's rapidly expanding public space. In 1903, for example, one critic divided the art world into two groups: the "old" realists of the Itinerant tradition and a "new, young" aesthetic movement that put "purely artistic tasks, color, *plein air* technique, motifs of light and shade, and so on, over ideological tasks."[45] Art critics used words like *World of Art artist* (*miriskusnik*) and *Unionist* (*soiuznik*) alongside *Itinerant* (*peredvizhnik*) to indicate artists, critics, and art figures who shared assumptions about art and its place in society, and military language indicated the serious differences between them. Serge Diaghilev, one of Russia's most prominent modernist activists, employed an intensely martial vocabulary in his 1899 article "The Eternal Battle," a conflict he described as a "Hundred Years' War" between "utilitarians" and "advocates of art for art's sake."[46] In 1909 the editors of the *Golden Fleece* described the "constant battle [*bor'ba*]" they had waged against publishing difficulties, tsarist censors, and "the campaign of newspaper criticism" while fulfilling their "mission" to bring their ideas to readers.[47]

Form, media, and subject matter were tools that Russian modernists used to attack the aesthetic values upheld by their opponents in the realist and academic milieus.[48] Most were not very radical in their formal aspirations; Janet Kennedy notes the obliviousness of the World of Art to the postimpressionists and their "serious, scholarly, and in many ways conservative stance" toward visual experimentation.[49] Still, World of Art artists eschewed the easel painting and strong perspective that reigned in

the Itinerant and academic exhibitions to work in new media like orna-
mental-decorative art and theater design. Aesthetic modernists resisted
convention by searching for subject matter that emphasized eternal val-
ues over the everyday in life, often recalling mythical, fantastical, and
imaginary pasts or the macabre, the violent, and the sexual in the hu-
man psyche. Some sought, in their art, museum work, and publications,
to revive traditions, like the Russian icon, that were not considered art in
the nineteenth century. Others, especially in the World of Art, valued the
look of the aristocratic culture of the eighteenth century, with its clean,
attractive lines, hints of universal culture, and atmosphere of good man-
ners, qualities they considered lacking in modern society. Modernist art
had a strong two-dimensional quality of surface and unconventional col-
oration that stood out from academic practice; for aesthetic realists, *dec-
adence* was defined by the use of a visual language that they did not rec-
ognize as legitimate.[50]

The depiction of eighteenth-century courtly life in Evgenii E. Lansere's
Empress Elizabeth Petrovna at Tsarskoe Selo (1905) (figure 5), for example,
satirizes the practices of both the Academy and the Itinerants. There is no
sense here from the point of view of an academic painter or a critical real-
ist, no example of royal virtue or representation of common people's lives.
Lansere shows a real historical personage in an actual setting, but he does
not tell a story to serve a public purpose; there is no event to communicate
meaning, be it a patriotic death or a struggle against an unjust lot in life.
The painting depicts the ruler who founded the Academy of Arts, yet the
artist does not use academic composition to present her to the viewer: the
angle of perspective is too low, focusing the eye toward the middle of the
painting, and one seems to be looking down a tube or a tunnel instead of
across a broad field of vision, drawn between foreground and background
instead of back and forth across the viewing space. The empress, more-
over, is not presented as the dignified lady, exemplary leader, or mother
of the nation that would be conventional in official portraiture. Lansere

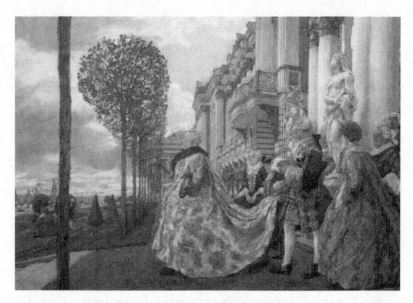

5. E. E. Lansere. *Empress Elizabeth Petrovna at Tsarskoe Selo*. 1905. Gouache on paper on board, 43.5 × 62 cm. State Tretyakov Gallery, Moscow.

instead depicts an unflattering moment, a fleeting slice of time, as Elizabeth, with courtiers in tow, leaves her palace in a scene that is a "deliberately ambiguous blend of the amusing and the grotesque."[51] The artist represents the culture of the eighteenth century through color rather than narrative or symbolic convention; the painting's cool, austere palette seems to project the essence of a marble column and the lack of emotion of classical aesthetics.

The aesthetic modernist rejection of the traditions of the art world and tastes of surrounding society, however, obscured the commonalities between the modernist and realist approaches to the public role of art. World of Art artists wanted to educate the public about the role of art in society and to communicate their understanding of the true nature of art, a mission not far removed from the traditional moral obligation of the nineteenth-century intelligentsia to educate and uplift the people. The modern artist was a priest of art, and art, as a medium of eternal beauty, could save humanity from a modern civilization where the ugliness of current

events, the banality of daily life, and the artlessness of mass production reigned. Some, especially those involved in the World of Art, wanted to change public attitudes, so they cultivated, encouraged, and popularized their aesthetic values through work in museums, journals, and art historical scholarship. This new modernist art culture and artistic language would combine aspects of Russian national tradition and contemporary international style to integrate the arts and the public into a common culture of universal form and artistic expression.[52] Many were attracted to art nouveau because they saw it as an ahistorical art that could overcome the division between art and mass consumer in modern society, and they embraced arts and crafts, theater decoration, and book illustration as a way to bring the values of modern art into daily life.[53] In this way, aesthetic modernists in the World of Art followed prevailing values in art culture that stressed the importance of art in the improvement of Russian life.

Aesthetic modernists, though, turned traditional views about the relationship of art and public upside down. They considered the public to be ill-informed, which is why they self-consciously produced art for an elite audience of collectors, connoisseurs, and art lovers with cosmopolitan tastes. Art, for them, needed to express the artist's individually inspired visions of beauty, truth, and freedom, and these could not be designed to match public taste; such an action would falsify the act of creation and defeat the purpose of educating the public in art's true meaning. To those who wanted to change Russian culture, the Russian people could be integrated into modern trends in art and contribute to European civilization only through artistic contributions to a new culture based on an international style, not by adding Russian content to European form.[54] They considered the Itinerants a failure precisely because the realists, in their view, had sought to develop a distinctive national style through imitation of European art with Russian content, an approach that World of Art modernists believed was self-defeating and intellectually bankrupt because it put the superficial (content) over the eternal (form). The modernist goal

would instead involve the aestheticization of the public, the refashioning of public space through the construction of a culture based on modernist art values. This new modernist public culture would emerge from the inspiration of professional artists, not from the lives of ordinary people (as realists believed), who were trapped in the ugliness, superficiality, and dreariness of contemporary existence.

The engagement of artists with the Revolution of 1905, however, shows how much the culture of the existing public could determine the form and content of modernist work in ways that contradicted their project to infuse modernism into broader public culture. Neither the World of Art nor the Itinerants were engaged directly, as a group, in party politics, social activism, or public engagement before 1905, but several prominent realist, academic, and modernist artists decided to depict the revolution as Russian political culture broke open. These works reflected moments of high drama: the shootings, pogroms, Cossacks, arrests, funerals, and demonstrations that had engulfed the country, especially in January and October 1905. The medium that modernists used to engage revolution, in contrast, was not the easel painting of conventional artists but the graphic arts of the street press, especially the caricatures, cartoons, and other forms of visual political culture that appeared in satirical journals, posters, and postcards in great numbers during the revolutionary era.[55] This political engagement often required an abandonment of modernist aesthetics and a return to figurative and didactic depiction of contemporary life: modern artists needed conventional techniques in narrative, subject matter, and composition to reach an audience outside the modernist milieu that would not understand the visual language of aesthetic modernism.

In 1905 the art of realist and modernist artists, bitterly opposed in their aesthetic views, converged as they attempted to communicate with an audience outside the art world. Mstislav V. Dobuzhinskii's *October Idyll* (1905) (figure 6), for example, uses standard perspective, familiar imagery, and open irony to illustrate a specific anti-autocratic political position. Dobu-

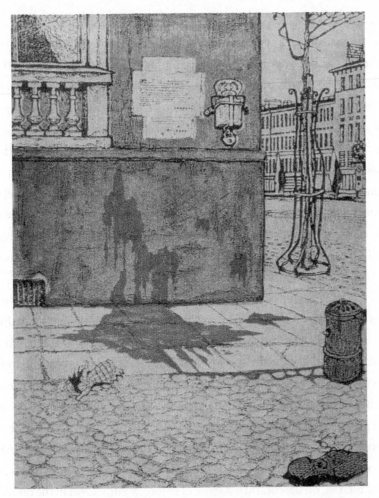

6. M. V. Dobuzhinskii. *October Idyll*. 1905. Illustration from *Zhupel*, no. 1 (1905), p. 4.

zhinskii, a painter in the Union of Russian Artists and, later, the World of Art, saw soldiers running with bare swords, witnessed a panicked crowd, and heard four salvos that killed several hundred people in Petersburg that October. To him there was no doubt who was to blame: "The *Government Herald* [*Pravitel'stvennyi vestnik*], of course, lies. Lies also that there was no clash on Monday. A horrid time! They are returning to earlier times. What blindness there is up there [*naverkhu*]!"[56] Such personal experiences are reflected in *October Idyll*. The blood on a sidewalk used by the ordi-

nary townsfolk, clear references to officialdom (represented by flags on the boulevard, Empire Style buildings, and official proclamations on the wall), and everyday objects like the child's doll and civilian shoe suggest that the government and its supporters are the perpetrators of violence upon ordinary people.[57] Dobuzhinskii was no revolutionary, but his *October Idyll* presents a pointed critique of the political order that all but the most reactionary Russians shared in October 1905. Modernists who produced political satire or anti-autocratic propaganda thus chose to accept the standards of the public culture of the nineteenth-century intelligentsia, a culture where artists were to engage the problems of the people through narrative representation and political ideas in art, not public activism, political organization, or professional mobilization in civil society.

Despite this convergence, 1905 did not remove professional tensions between modernists and realists, and important figures attempted to maintain the boundaries between the two milieus. Alexandre Benois had sharp criticism for his modernist colleagues who created illustrations for anti-tsarist handbills, street flyers, or satirical journals. He saw this engagement with the broader public and that public's aesthetic requirements as a waste of professional talent; it limited creativity by making the artist dependent on the outside world instead of inner inspiration: "Despite the proclamations of freedom made by all parties there is no true spirit of freedom in the air, but, on the contrary, a sense of enforced 'enlistment in the ranks.' We are no longer faced with mystic communion, but rather with orders from all sorts of 'Committees of Public Salvation' to sign up for one militia or another." For Benois, the only way artists could make a difference in Russian life was through the fulfillment of the modernist agenda to reeducate the public through the production of art, the cultivation of a more transcendent aesthetic sensibility, and the creation of a new art culture. "It is precisely at such a point that it is so important to remember that the artist's salvation lies in mystic communion alone," he wrote, "and that an artist must not join the militia and occupy himself with empty questions

of how life should be organised. Other, higher tasks call to him, which he alone is capable of achieving."[58] Benois was not apolitical, for he had a solution to Russia's political ills: artists should effect change by mobilizing their professional skills in art and aesthetic education, not through open political engagement or the production of art that reflected contemporary political conditions and therefore betrayed modernist principles. For this reason he advocated the creation of a Ministry of Arts to inculcate "beauty, power, and splendor" into public life.[59]

The hostile reaction of Vladimir Stasov to the new public activism of modern artists like Dobuzhinskii also shows how much their engagement with politics was linked to the older intelligentsia culture he wanted to protect, not the modernist approach advocated by Benois. In his article "False Art and False Artists," an angry Stasov chided the "decadent gentlemen" who adopted the goals of his generation to further their professional interests. He derided the political engagement of modern artists as a self-serving, opportunistic way to advance their professional status, to make room for more modernist art by stealing the aesthetic approach and public role of realist artists, calling them "cunning, practical-minded folk" who "immediately crawl out from all corners" to set up their "own wretched little stall" and "start to ply their profitable trade" whenever "any new, great, important matter" arises. The aged critic attacked these artists for ignoring the work of realists who had always engaged the problems of their day, a rhetorical strategy that dismissed the modernists as selfish, ignorant, and false artists and separated them from the intelligentsia: "But it is shameful and bad to be ignorant of and blind to what has long existed and shone forth in all its glory, and to imagine that 'our art will *become* a great, truly populist art of the future . . .' only at some subsequent point."[60] The Revolution of 1905 inspired realists and modernists to reflect political events in art, but their competition could disrupt the potential for making common cause, even if professional, against the tsarist regime.

In the end, modernist artists did not remake the public for art, but they did begin to find new audiences within the existing public culture. After 1907 aesthetic modernism became more widely accepted as Russians sought escape from political turmoil and economic stress in the commercial literature, new art styles, and cultural pessimism that characterized fin de siècle European cultural life.[61] Modernists devoted themselves to the practical work of creating a public for modern art through institution-building, art education, and publicity; defeat in war and revolution between 1905 and 1907 actually helped orient them and other intellectuals away from social and political engagement toward aesthetic problems, artistic mobilization, and personal deeds as the only way to effect change. The World of Art and the Union of Russian Artists thus followed the rhythms and traditions of the art world even as they opposed and resisted their aesthetic rivals: organizing regular exhibitions in the usual exhibition spaces, granting interviews in newspapers, and seeking patronage from the court and rich collectors. By 1914 the modernist milieu wielded considerable professional power; its artists, critics, and sympathizers wrote authoritative art histories, became influential critics, edited major art journals, and administered important museums, including the famous Tretiakov Gallery. They were recognized denizens of the art world, a world they often criticized, even if many rival artists, realist critics, and conservative pundits never fully accepted their professional legitimacy.

Art for the Future: The Avant-Garde and Public Taste, 1907–1914

After 1907 a new, combative modernist milieu came on the Russian art scene: the "wild ones" (*dikie*), cubists, and futurists of the avant-garde. Critics and scholars have long argued that a core quality of the European avant-garde was its confrontational challenge to political and cultural authority.[62] In 1913 the critic Abram Efros took for granted that these artists would declare war on other groups irrespective of their art agenda because

he knew that aesthetic warfare was deeply rooted in the culture of the art world. "Already there is a new generation of artists," he wrote, "who know about the struggle with the Itinerants only from the stories of the old-timers and books; this youth in turn sees its artistic task in victory over the former victors of the Itinerants, the 'Union' or the 'World of Art.'"[63] Avant-garde subject matter and style, though eclectic, reflected this milieu's rejection of contemporary society's expectations, and the violent rhetoric they often directed at conventional culture cemented their public reputation as radical iconoclasts. Olga Rozanova, for example, declared war (*bor'ba*) on her artistic "enemies," the aesthetic modernists, in 1913, and prewar avant-garde declarations were filled with references to "enemies," "battles," and "victories."[64] The futurist poet Aleksei Kruchenykh later described this hostility as a military attack against bad art: "We declared war on fat-bottomed sculpture, flattered by crowned all-crushing sugary painting and literature."[65] Today, ironically, Wassily Kandinsky, Marc Chagall, Kazimir Malevich, Vladimir Tatlin, and other avant-garde artists from Russia are the country's best-known artists in the West, their paintings canonized as great contributions to world culture.[66]

The avant-garde presented themselves to the public as the creative geniuses of the art of the future, and they attained public notoriety in the 1910s as *futuristy*, but they were not close followers of Filippo Marinetti and Italian futurism. The visions of modern technology, urban life, and cultural pessimism that filled the work of Italian futurists or European expressionists were rare in Russian avant-garde art, and the cult of technology, valorization of war, and proto-fascist politics inherent in Italian futurism were absent. Radical artists in Russia did share with Italian futurists an iconoclastic disdain for conventional public life and an interest in finding a way to bring dynamism and movement into art, but futurism in Russia did not constitute a specific art style or single aesthetic program. The Russian avant-garde was futurist in the sense that they wanted to replace existing art practices with new art institutions, aesthetic values, and

art forms that reflected modern life, not because they adopted specific futurist content in their art. The avant-garde embraced a variety of art styles and ideas, some imported from abroad (cubism and Cézannism), some developed in Russia (rayism), and some idiosyncratic, hybridized, or imprecise (cubo-futurism). Early Russian futurism was more an attitude of hostility toward existing public culture than an aesthetic line, and the Russian avant-garde, to underline their differences with the Italians, preferred to use Russian neologisms like *budetliane* ("futurians") or *budushchniki* ("futurites") to describe themselves before the war. When Russian rayists and "futurites" proclaimed themselves the "artists of art's future paths" in 1913, they put themselves on such a different artistic plane that they found no need to engage the old art world any longer, not even others in the avant-garde, whether in Russia or abroad: "We are not declaring any war, for where can we find an opponent our equal?"[67]

Critics and art historians today distinguish the avant-garde from aesthetic modernists by their different stance toward the public: symbolists, decadents, and aesthetes criticized previous art schools within the established art world, while futurists, Dadaists, and cubists challenged the practice of art itself as an institution in bourgeois society.[68] The aesthetic modernists in the World of Art and the Union of Russian Artists hoped to keep their art autonomous from public tastes, cultivate their individual values, and wait for the public to accept them, but the avant-garde attempted to create a new public space that would break down the boundaries between art and the world outside art. They envisioned a new relationship between art and audience that eschewed the conventional exhibitions, museums, and art journals that treated the public as passive consumers; futurists and others in the avant-garde milieu instead tried to turn the public into active participants in artistic creation. Audiences at futurist lectures were invited or provoked to participate in the presentation and to become, in a sense, artists themselves: the insults, radical pronouncements, and scandalous public behavior that futurists flung at audiences were designed to

evoke booing, shouting, and outrage, in other words, to induce in the audience the very behavior that the futurists themselves practiced onstage and in print.[69] As Kazimir Malevich later asserted, what defined Russian futurism best was the artist's role as a public agitator. "Futurism above all," he explained, "was expressed in behavior, in connection to the given condition of society. Therefore our futurism manifested itself much more in performances [*vystupleniiakh*] than in artwork."[70]

The avant-garde rejected many of the aesthetic values of the previous generation of modernists. Like their "art for art's sake" counterparts, they believed in the creative genius of the individual artist, considered subjective vision the true value in art, and hoped to redefine the human relation to art and to reality. But the avant-garde used art to demonstrate creative power through a continual process of innovation and experimentation, not to uncover the eternal, unchanging values of beauty in the universe.[71] Their quest to explore the act of painting brought the external world into the content and form of their art, unlike the aesthetic modernists, whose attitude toward the world outside art remained elitist. For radical modernists, truly vibrant art could not be found in the established institutions of the art world or a public that followed established critics and tastes. They embraced, instead, popular culture and peasant art as representatives of a more direct, intuitive, and authentic relationship toward art production. Avant-garde neoprimitives in the early 1910s modeled their work on traditional crafts, emulated visual culture outside the art profession (such as icons, village signs, and religious images), and depicted scenes from the daily life of ordinary people to bring the world of the peasant and urban folk into the art world (figure 7). Others destabilized formal conventions by emphasizing the sensory qualities of light, color, and texture in art; the rayism of Larionov and Goncharova (figure 8) was one of the earliest forms of European abstraction, while Malevich broke up the subject in "alogical" or "transrational" (*zaum*) works (figure 9). World of Art modernists hoped to meld art and life by making ordinary life more like art,

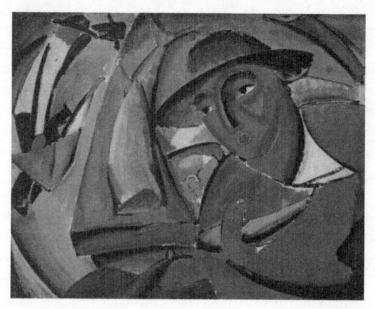

7. V. E. Tatlin. *Fishmonger.* 1911. Gum paint on canvas, 76 × 98 cm. State Tretyakov Gallery, Moscow.

but the avant-garde completed the equation by adding the goal of making art more like life. Russian futurism, wrote Olga Rozanova, fused two worlds: the subjective and the objective.[72]

This difference in aesthetic philosophy can be seen in a comparison of the work of Kuzma S. Petrov-Vodkin and Vladimir Tatlin. On the surface, Petrov-Vodkin's *Bathing a Red Horse* (1912) (figure 10) and Tatlin's *Fishmonger* (1911) (figure 7) share a modernist interest in the flat picture plane and strong color, but the two artists put these formal similarities to different uses. Petrov-Vodkin's subjects exist in an ideal, abstract golden age outside time and space; as subjects "far removed from everyday reality," they represent nothing in the real world.[73] There is no identification with a specific group, no cultural signs to identify the bathers, and no way to know if they exist beyond the artist's imagination. In the artist's eyes, the center of *Bathing a Red Horse* was the human being as "some kind of spiritual-willful energy."[74] Tatlin's *Fishmonger* evokes a similar otherworldliness, but his more explicit references to the formal qualities of the Rus-

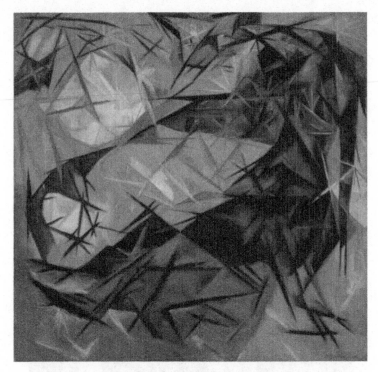

8. N. S. Goncharova. *Cats (Rayist Percep.[tion] in Rose, Black, and Yellow)*. 1913. Oil on canvas, 84.4 × 83.8 cm. Solomon R. Guggenheim Museum, New York. 57.1484

sian icon and depiction of everyday life bind ordinary experience into the painting's execution.[75] Petrov-Vodkin evokes the icon to pull viewers away from this world to an eternal nowhere of the imagination; Tatlin brings the mystical world of the icon into the world of the Russian marketplace and combines them into one aesthetic experience. Many viewers could understand paintings like *Fishmonger* even if they disliked them, but *Bathing a Red Horse*, with no easily accessible message, provoked a variety of responses when first exhibited, making friends and enemies among artists across artistic milieus.[76]

The avant-garde challenge to existing society became very public as they tried to fashion new institutions, constituencies, and aesthetics that would replace those dominant in mainstream culture.[77] Excluded from most exhibitions of the art world, radical artists made their own space in cafés,

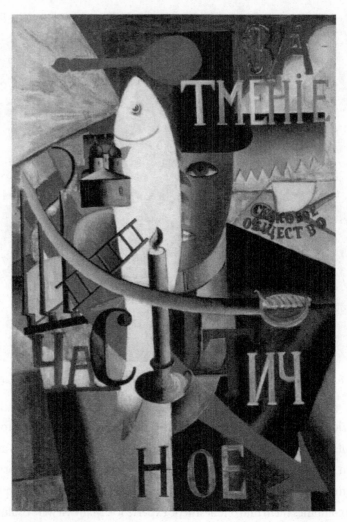

9. K. S. Malevich. *Englishman in Moscow.* 1914. Oil on canvas, 88 × 57 cm. Stedelijk Museum, Amsterdam.

rented lecture halls, or small galleries. They formed new groups and exhibitions with unorthodox names like the Jack (Knave) of Diamonds (Bubnovyi valet) (1910–17), the Donkey's Tail (Oslinyi khvost) (1912), and the Union of Youth (Soiuz molodezhi) (1909–13) and, prevented from participation in most art publications, cultivated a print culture based on manifestos, declarations, and collaborative projects with like-minded poets and

10. K. S. Petrov-Vodkin. *Bathing a Red Horse.* 1912. Oil on canvas, 160 × 186 cm. State Tretyakov Gallery, Moscow.

writers. Mikhail Larionov explicitly created an institutional space separate from the surrounding public when he planned his lectures and exhibitions in 1913; his refusal to register with local authorities and create a legally recognized association meant that his lectures would not be subject to police review.[78] Avant-garde public appearances themselves took on an atmosphere of noisy, urban cabaret that was very different from more formal gatherings in the mainstream art world. Futurist audiences also deviated from the artgoing public; diverse sectors of the urban population, especially the young urban intelligentsia and students, seem to have been especially drawn to the milieu.[79]

Avant-garde art culture contradicted prevailing public attitudes toward gender. Institutionally, the milieu was much more open to women than others in Russia or in Europe; women made up roughly 20 percent of the prewar Union of Youth and Jack of Diamonds groups and 50 percent of the wartime avant-garde exhibitions Streetcar V and 0.10.[80] Few women,

in contrast, exhibited with the World of Art (Z. E. Serebriakova and A. P. Ostroumova-Lebedeva were exceptions), and women made up only about 4 percent of the membership of the Union of Russian Artists.[81] Russian art criticism, unlike its European counterparts, generally avoided gendered language and sexual issues (although there were exceptions), whether because of the strong taboos that existed in a public culture dominated by the Orthodox Church, the presence of more egalitarian attitudes within Russian intelligentsia culture, or the watchful eyes of the censor. But gender mattered. In 1910 Natalia Goncharova's nudes were criticized in the press precisely because she was a woman who dared to depict women in unconventional, that is, non-academic, form; her subsequent trial for public pornography, as Jane Sharp writes, "exposed the hypocrisy of an academic tradition that silenced the female subject while regulating access to the female nude."[82]

Unorthodox conceptions of nationality in the avant-garde challenged conventional notions of Russian nationalism in the broader public culture. True to their iconoclastic inclinations, radical artists questioned the foundations of traditional national identity by emphasizing Russia's racial and cultural links to Asia, denying the heritage of Western Christendom, or praising the pagan nomads of the steppe. Proclamations of alternative national or racial origins for avant-garde art set the young artists off from other representations of Russian national culture, whether the more conventional nationalism in the Union of Russian Artists or the cosmopolitan, international style in the World of Art. A re-imagined cultural heritage could be used to make the classical Greek aesthetics of the symbolists and the aristocratic veneer of the World of Art seem pretentious, and it served to distinguish the Russian avant-garde from foreign modernist competitors. Goncharova, for example, used an alternative understanding of nationality in her work to reject the art culture of Western Europe, while the literary circle known as Hylaeans presented themselves as one-eyed Scythian archers in battle with the West, armed for war with Western civilization and the art of the French cubists.[83]

There were, in fact, many avant-gardes. This art milieu offered a place to practice art to individuals who would otherwise be marginalized in the art world or in broader society, including women, ethnic or religious minorities, and youths, and its members came from a variety of social backgrounds and geographical regions.[84] Radical artists were unable or unwilling to create permanent institutions, well-defined audiences, or consistent styles, and conflict was rife.[85] Nina Gurianova sees "aesthetic anarchy," the anarchy of "an endless process of renewal," in a culture that contained public iconoclasts, formalist theorists, utopians who wished to re-create human society through art, and more modest Cézannists and postimpressionists.[86] In 1911, at a debate on new art trends, Goncharova was noisily cut off when she objected to how her art was presented, while the futurist poet Vladimir Maiakovskii, "a disheveled young man in a shabby velvet jacket," was "literally thrown out" of the Jack of Diamonds exhibition in 1912.[87] The institutional instability, clashing egos, and often obfuscatory pronouncements that characterized prewar avant-garde public culture show that the mobilization of the avant-garde as a professional space was incomplete; it is often difficult, if not impossible, to draw conclusions about the milieu based on the experiences of individual artists. As Katerina Clark has put it, the Russian avant-garde was "gloriously decentered, split, and embattled."[88]

The avant-garde's attempts to create a new public culture for art encountered hostility from mainstream newspapers, established artists, and local authorities, a sign that others perceived their intent to challenge or replace established culture. Neoprimitivism did receive wider public recognition and attracted collectors, but the futurists remained isolated and estranged from mainstream art culture before 1914. Few critics supported them in public, major groups did not invite them to exhibitions, and the popular press ridiculed them. Avant-garde modernism was considered worthy of serious discussion only among a small number of critics, mostly associated with the World of Art, who nonetheless considered the avant-garde unprofessional and their art (with some exceptions) mundane, ugly, and

amateurish. The World of Art, for example, had room for all the latest modern art in 1913, but they formally excluded "extreme cubist and futurist trends."[89] Goncharova did exhibit with them in 1912, and six thousand visitors dropped by her individual exhibition in mid-1914, where one observer reported that she sold just two paintings.[90] When Vladimir Tatlin tried to join the World of Art, however, he was rejected.[91] Frustrated, he settled for a small private exhibition for his friends in May 1914. On the eve of war, Russia's most radical artists were ensconced in a small and internally divided milieu, a minority with little influence in the art world.

Narrative art histories tend to present the development of the late Imperial Russian art world as one group succeeding the other, and the rhetoric of contemporary art criticism emphasized its inherent tensions. But the constant war on tradition was a rhetorical strategy to define different groups and milieus from each other inside the public, and as such the war was never won. New groups did not replace the old, nor did major milieus dissolve and disappear. Instead, new artistic subcultures coexisted within a pluralistic art world that developed a common set of practices, institutions, and aesthetic concerns. The avant-garde itself reproduced some practices of this art world, especially its preoccupation with nationality, intragroup hostility, and group-based institution-building, as they subverted the prevailing art culture, but the milieu remained quintessentially modernist with its reliably unreliable institutional, aesthetic, and personal tensions. Russian art life thus seemed stable despite its diversity; its institutions, personalities, and art were predictable and, as some critics noted, boring.[92] In 1914 World War I suddenly overturned the conventions of this world as the public culture changed: institutional stability became instability, the language of conflict gave way to a discourse of unity, and the professional mobilization of the art world merged with the public mobilization of civil society. Real war, ironically, seemed to bring a professional truce. "Before the war there was division [*raskol*] among artists, parties appeared, circles," wrote a young modernist in 1914. "From impressionism to rayism. A cruel struggle. Everything quieted down with the war."[93]

2. In the Storm

Reshaping the Public and the Art World, 1914–1915

World War I struck Imperial Russia like a sudden and deadly natural disaster. Violent images of mass destruction, the war as deluge, fire, or storm, flooded the public culture, and within weeks the war had destroyed human life and property on an unprecedented scale. How Russians would meet the challenge of this human-created calamity was a crucial question from the very start. "Our minds and hearts," observed one commentator in August 1914, "are naturally riveted to the place where great military operations take place and our soldiers' blood flows. We live and breathe in war, for our future lies in its outcome."[1] Public figures knew the stakes were high, and they knew the Great War was something they had never imagined. Many understood that victory would require the cooperation and participation of the entire population. "This war is unprecedented, unique in world history," wrote the symbolist poet and newspaper commentator Dmitrii Merezhkovskii about warfare's new importance in public life. "All previous wars seem private, conditional, and relative in comparison, as if they weren't wars. This is the first war."[2]

Historians have cast doubt upon the idea, once common, that a total mobilization of the economy, society, and culture took place across Europe during World War I.[3] The assertions of national unity that calmed prewar political strife and social tensions, the *Burgfrieden* in Germany and *union sacrée* in France, today appear to be short lived or illusionary, while the intense mobilization of the industrial economy and sudden bureaucrati-

zation of government seem less real than historians once believed. These phenomena appeared to mark a sudden break with nineteenth-century politics, society, and culture, but specialists now suggest that such developments had roots in prewar trends or were not as significant as previously thought.[4] Many question the effectiveness of propaganda and the depth of the public patriotism that contemporaries and historians once took for granted.[5] This new historiography has its parallels in Russian history. Western and émigré historians used to consider the First World War the crucial event that wrecked the economy, destroyed social and political progress, and brought the Bolsheviks to power in 1917.[6] Now most agree that Imperial Russia was doomed to social disintegration and violent revolution long before 1914.[7]

This demotion of the war's place in European and Russian history, if perhaps accurate in a macroscopic sense, still obscures the ways the war could be an important agent for change. What matters, after all, is not whether total mobilization was achieved but how people's engagement with the war was expressed in the imagination (through collective representation and belief systems) and in institutions (through the state and civil society).[8] Human beings plan, fight, and end wars, but war itself, especially the large-scale warfare of the twentieth century, does have a kind of impersonal agency. Like a natural disaster, Arthur Marwick explains, total war was a "cataclysmic psychological experience." It inspired "a spirit of renewal and rebuilding," projected "people into new situations, and, sometimes, new opportunities," and provided an opening for subordinate groups to participate in the war effort, which enhanced their "bargaining position within society."[9] The First World War created havoc in ordinary lives and put existing institutions under great stress. It sent ripples through society that altered millions of lives, even those whom it did not touch directly, much as a tree blown down across a road can divert thousands of individual journeys.

Mass mobilization was a pervasive part of life in Imperial Russia throughout World War I, and the changes it brought to public institutions and culture could be profound. It formed a new kind of war culture, defined by Stéphane Audoin-Rouzeau as "the aggregate of representations, attitudes, practices, and literary and artistic productions which framed the investment of European populations in the war."[10] This culture of war was distinguished not only by its content (propaganda and war art) but also by its institutional form (how it focused public action on the war and war needs). The wartime reconstruction of institutions and re-imagination of public roles can be clearly seen in the Russian art world, where the requirements of mobilization brought artists with various motivations, expectations, and interests into common cause and aligned their public action, professional behavior, and art. New ways to engage the art world and civil society provided artists with new professional and personal opportunities as the old rhythms of artistic practice and representation shifted. The participation of Russian artists in war mobilization was therefore not primarily a matter of individual patriotism; it was vital to their development as professionals in the public sphere, especially as the customs and habits of Russia's group-based art system destabilized. After 1914 civil society's self-mobilization not only expanded, its public culture changed, and the art world changed with it.

The Cold Spring: War and the Art World, 1871–1914

Before 1914 the Russian art world was scarcely touched by the colonial conflicts surrounding the country, and the isolation of Russian artists and their art from great international events seemed complete. War painting had an important position in the official public of the state and high aristocracy served by the Academy of Arts, and Imperial Russia was a European Great Power, expansionary imperialist state, and ambitious military competitor on the world stage. But war was not prized in the intelligentsia culture or the art public, and Vasilii Vereshchagin was the only prominent Rus-

sian painter in the nineteenth century who came close to reaching a wide audience for war art. The main forum for Russia's visual culture of war was not the art world but the mass media, especially the popular prints (*lubki*), posters, pamphlets, and illustrated journals that flooded the book market with wartime images during each new conflict. War and art were seen to be mutually exclusive activities. The noted painter Mikhail Nesterov even canceled a personal exhibition during the Russo-Japanese War (1904–5) because he felt it would distract the public: "War is a serious matter, and now is not the time for artists to take up the attention of society."[11]

War art did exist in the official sphere. Battle painting was taught in the Academy, unveiled at officially sponsored exhibitions, and displayed in palaces, government buildings, and other official spaces. To meet the needs of this public, academic battle painters created depictions of war that celebrated the heroism, energy, and bravery of the country's military forces, especially its commanders. This official war painting communicated the positive values of heroism, order, and noble endeavor that its audience and patrons used to validate military victories, legitimize rulers, and display power. In nineteenth-century Europe such academic war art reached its height with the growing importance of scientific history, the emergence of the nation-state as the fundamental unit of society, and the expansion of political participation to include broader segments of the population.[12] This tradition seems to have been weaker in Imperial Russia (perhaps because the conditions that made it important in Europe were also weaker), where war artists preferred more intimate genre painting over the large canvases characteristic of history painting (figure 2). Official battle art did have noted practitioners in A. I. Zauerveid, A. E. Kotsebu, and B. P. Villevalde, but painters of the Russian realist school, who sought to reach a different audience, generally ignored contemporary war in their work.[13]

The Balkan revolts of 1876 and Russo-Turkish War (1877–78) introduced wartime mobilization into the culture of the nineteenth-century intelli-

gentsia. Weakened after its defeat in the Crimea twenty years earlier, the tsarist government at first sought to avoid war when tensions in the Balkans erupted. Journalists rushed to support the Balkan Slavs in their conflict with the Ottomans, and this pressure helped push the Russian government to intervene. These conflicts marked the first time that public opinion, represented by the press, exerted a decisive influence in the making of government policy.[14] The response of the educated public was a burst of civic activism that included charity concerts and clothing drives, and patriotic culture filled newspapers, illustrated journals, commercial media, and concert halls.[15] Several Itinerants painted the war, including Ilia Repin, whose *He Returned* (1877) depicted the reception of a proud soldier on his arrival home.[16] Such paintings were part of the general evolution in realist art toward nationalist and patriotic themes, but the wars in the Balkans in the 1870s had no lasting effect on the institutional development of the art world or on the work of Russian artists as a whole.

Vasilii Vereshchagin alone achieved success as a war artist in the 1870s and 1880s, largely because he was able to find a new audience for war art beyond the official public. Vereshchagin's aesthetic sensibility was closely aligned in form and subject matter to a new, popular war literature that emerged across Europe after the Crimean War (1854–56), a way of writing about war that focused on the day-to-day experience of ordinary soldiers, not the national destiny, personal heroism, or glorification of leaders usually found in official representations. For Vereshchagin, the hero of art was the truth about war, and he depicted warfare as an ugly, horrific event, something seldom seen in the conventions of nineteenth-century war painting. "Before Vereshchagin," wrote Alexandre Benois, "all battle paintings, which could only be seen in palaces and at exhibitions, in essence represented grand parades and maneuvers where the field marshal raced with his retinue on a magnificent steed."[17] As a contemporary French journalist noted, Vereshchagin "restored, with terrifying accuracy and epic realism, the real image of war: blood, ruins, fire, the naked in-

famy of slaughter."[18] His paintings were more akin to Leo Tolstoy's *Sebastopol Sketches* than Repin's *Barge Haulers* (figure 3), Vasnetsov's *After Prince Igor's Battle* (figure 4), or academic history paintings (figure 2).

The sharp disjunction between conventional war imagery and Vereshchagin's conception of the reality of war is demonstrated in his most famous canvas, *Apotheosis of War* (1871) (figure 11), which was intended to be a conscious challenge to popular conceptions of war, a "satire most evil and unflattering."[19] In *Apotheosis* Vereshchagin aims to communicate an actual scene that he witnessed directly to the viewer without the didactic allegory of Repin (figure 3) or the imaginative fantasy of Vasnetsov (figure 4). As the painter made clear to Vladimir Stasov, his intention was to confront the public with a different kind of war: "The artist has consciously decided to let another take a look at the negative details of war, details unknown and overlooked . . . having decided not to sentimentalize where it is necessary according to the taste of the public and the critics."[20] *Apotheosis* subverts the practices of official war art because it shows the consequences of war, not its prosecution, and, strictly speaking, it is not a battle painting at all: there are no human figures or human actions, just the static, impersonal aftermath of Central Asian violence. The painting's form is itself an ironic representation of contemporary battle painting; its title, inscription to "all the great conquerors of the past, present, and future," and size suggest an official war painting but clash with the ignominious end presented in the image.[21] An official painting entitled *Apotheosis of War* would depict bravery, skill, and self-sacrifice of great military leaders, but the apotheosis of war, in Vereshchagin's view, is human savageness, presented in his art with quasi-photographic exactness for all to see.

Vereshchagin's popularity grew as he countered the conventions of war imagery embedded in contemporary public culture. His challenge to traditional representations of battle art lent his paintings an air of political danger that thrilled the nonofficial public and increased publicity for his exhibitions, but his unorthodox views of war evoked government mistrust

11. V. V. Vereshchagin. *Apotheosis of War.* 1871. Oil on canvas, 127 x 197 cm. State Tretya-
kov Gallery, Moscow.

and at times official disapproval or harassment. The critic V. I. Nemirovich-
Danchenko, for example, saw "victims of mistakes and ambition" in the
dead Russian soldiers in Vereshchagin's painting *Defeated* (1877–79), "and
that explains the animosity with which some attacked him, and the delight
which others expressed."[22] Many viewers appeared attracted to his art for
its shock value and expressions of violence that deviated from sanitized
representations of war; his "plain and unadorned" images of war "as he
had seen it" were, in the words of a foreign observer, "totally different to
what the public had been accustomed to gaze upon in the Hermitage and
other galleries."[23] The sense that one could experience the danger of com-
bat and expose the fictions of official culture from the safety of the urban
gallery helped Vereshchagin's popularity outside the official public. His
1874 Petersburg exhibition was so popular that entrance lines overflowed
into the street and visitors had to enter in small groups, scenes that had
never appeared at any Russian art exhibition.[24]

Yet Vereshchagin remained an anomaly in the Russian art world, and
no realist school of war painting emerged from his popularity. His en-
gagement with the public was based on personal idiosyncrasies and indi-

vidual ambitions, for he refused to play by the rules of the emerging art profession. His birth into a gentry family, enrollment in the Cadet Corps, and early career as a naval officer set him off from contemporaries in the Artel and the Itinerants, who were usually of common birth and middle- or lower-class background. Vereshchagin was close to Stasov and the more politically oriented Itinerants, and he shared with them a view of the role of art as a didactic exercise and a distrust of the autocratic state, but he refused to accept membership in the Artel, the Itinerants, the Academy, or any group. Unlike Russia's other realists, Vereshchagin had ambitious plans to reach an international public, and he became the most famous Russian artist known in the West after organizing personal exhibitions in Britain, France, Austria, and the United States. His insistence on painting, exhibiting, and selling as an individual, his desire to paint war, and his international ambitions all isolated him even at the height of his fame in the 1870s and 1880s. In the end, Vereshchagin developed no institutional basis to maintain demand for his expensive paintings in the art world; once a favorite, he was on the margins as tastes shifted in the 1890s. His unique brand of art eventually killed him. In an attempt to revive his career, Russia's favorite artist of war traveled with the battleship *Petropavlovsk* to witness the Russo-Japanese War but died when the vessel exploded and sank in 1904.

Public response to the war against Japan was more restrained than in 1877, but it began with similar excitement.[25] To Colonel Moulin, the French military attaché in St. Petersburg, the surprise Japanese attack on Port Arthur in February 1904 turned what would have otherwise been viewed as a colonial expedition into a "national war" with a "great outburst of national vigor" and a "grim determination" that animated "particularly the lowest classes."[26] The city government of Moscow voted a million rubles for the war effort, while patriotic student unions staged demonstrations in support of the war.[27] Russians reached out to learn about the conflict: audiences flocked to the cinema, newspapers and magazines filled

with war news and patriotic articles, and popular prints, postcards, and journals published war images in great numbers. The number of war-related images in the illustrated weekly the *Flame*, for example, soared to 83 percent of all images at the beginning of the war and remained close to 100 percent for six months.[28] Yet the Russian public had never placed East Asian imperialism at the center of its understanding of Russian foreign policy.[29] The radical press scarcely discussed the war in 1904, and the percentage of war-related images in the *Flame* dropped to about 75 percent in December 1904 and 38 percent in August 1905.[30] In March 1904 Kuzma Petrov-Vodkin observed that daily life had already calmed: "the mood has become a little more normal among ordinary folk [*obyvatelei*]. But at the beginning everyone gave oneself up to thoughts about the war, about victories and defeats. That was especially true in Petersburg."[31]

The rhythms of the art world continued undisturbed.[32] The Petersburg exhibition season opened just as war broke out, but reviews do not betray any disruptions caused by the war or even mention the conflict at all. The regular exhibitions of important groups like the Itinerants, the Spring Salon, and the Union of Russian Artists ran as normal, and the growth of the art world paused only briefly: the number of art groups leveled slightly between 1904 and 1906 but began to grow again in 1907 (see graph 2 in the appendix). Attendance held steady at Union of Russian Artists exhibitions (see graph 3). Some critics expressed surprise that the war did not affect the public more or have greater impact on the art world. "The peaceful arts are forgotten in a time of war and for them will come a cold spring," wrote one. "Nonetheless the Spring Salon is opening in its usual way."[33] Art journals do not show evidence of extensive mobilization on the part of artists, whether in charity work, battle painting, or other public activity, and the war had limited effect on the art market. "According to the number of visitors of the periodic exhibitions and the number of paintings that were sold," wrote a critic in 1905, "one can conclude that the war has not affected the art market in Moscow as ruinously as one could have

expected."[34] The exhibition he reviewed was visited by an "acceptable" thirty-five hundred visitors, and sales, though weaker than usual, were "not bad": fifty-two paintings sold for a total of five thousand rubles. Early in 1904 the critic Aleksandr Rostislavov concluded that "in the end our artistic affairs take their normal course."[35]

No significant paintings about the war were painted or exhibited. In this area art culture differed from literary culture, where the war appeared in the work of important authors, including symbolists and other modernists.[36] No modernist painter seems to have depicted the war in any form. The academician I. A. Vladimirov, a prominent war illustrator and painter, did produce several war scenes, and in 1906 some battle painters presented their work at the Spring Salon (which included Vladimirov's *Final Minutes of the Cruiser Suvorov*).[37] Ilia Repin, for his part, exhibited a canvas called *On Patrol* in 1906. Such war paintings, however, were few in number, panned by critics, or ignored by the public. A critic for the newspaper *New Time* (*Novoe vremia*), for example, considered the Spring Salon of 1906 and its war paintings to be "strongly disappointing and unsatisfactory."[38] Critics devastated *On Patrol*. "There is no thought, no technique, [the things] which [previously] separated Repin from his colleagues," wrote one critic, who noted the painter's failure to devote to the war the energy that it demanded.[39] Elsewhere, the lack of war paintings demonstrated the isolation of artists and public from the fighting: "the war and its everyday side are weakly reflected in the works of those who, at one time and even very recently, roused up everyone and filled the exhibition halls with thick crowds of people."[40]

The pattern of artistic mobilization shows how distant most artists were from significant professional engagement with the public concerns of war in 1904 and 1905. Official state organizations mobilized more than private artists, who tended to participate in charity work as individuals rather than as part of professional groups. The Imperial Society for Encouragement of Arts (Imperatorskoe obshchestvo pooshchreniia khudozhestv) was appar-

ently the only major art institution to host war charities in 1904. In February the society donated funds for the sick and injured, in April its drawing school raised some 2,500 rubles from a "lottery-bazaar" for the families of soldiers, and in December a two-day auction raised 1,253 rubles.[41] In 1905 the society again held an exhibition, this time to raise money for widows and orphans of those who fell in battle.[42] Other art groups remained disengaged from the war effort. Individuals did help: Ilia Repin donated several portraits to the Red Cross, while Mikhail Nesterov gave proceeds from the sale of his painting *Golgotha* to charity.[43] But the Itinerants did not advertise charity work in their exhibition announcements in February 1905 or a year later, and the Spring Salon mentioned nothing about donations in February 1905.[44] Charity work was the realm of individuals; the country's art groups did not change their routine but remained focused on professional concerns. One group that did raise money in 1905, for example, gave it to a fund for indigent artists, not a war charity.[45]

This lack of attention to war shows how much public culture had changed since the heyday of Vereshchagin. By the early twentieth century, most artists and critics, regardless of their aesthetic philosophy, despised art that smacked of illustrative journalism, pandered to common tastes, or represented formal political positions. An "art for art's sake" philosophy, moreover, required that the depiction of war be avoided to protect the public from the ugliness, barbarity, and valorization of the immediate that destroyed one's contemplation of eternal truth. As Benois argued in his 1904 obituary for Vereshchagin, popularity in the ill-informed public did not automatically turn a skilled painter into a true artist: "Naturally, for the Russian public Vereshchagin's tales are infinitely more interesting than the portraits of Dmitrii Levitskii or the 'still lifes' of [Frans] Snyders, but there can be no doubt before the court of beauty that one sleeve painted by our noted master of the eighteenth century or a basket of fruit painted by the great Flemish mage is greater than many, many of the most noteworthy works of our artist-preacher [Vereshchagin]."[46] War had no place in

the art world after the eclipse of the nineteenth-century autocratic public, the modernist rejection of didactic realism, and the lack of interest among art buyers, and the Russo-Japanese War brought no changes to the structure or practices of the art world. Iakov Tugendkhold noted that the best evidence for Russian culture's aversion to war was demonstrated, ironically, in the one case where war art was popular: "It is curious that Russian art generally is little interested in war, and when, in the person of Vereshchagin, it did deal with war, then it was not to praise it but to discredit it."[47] When Russians wanted to see war in 1904, as in 1877, they turned to the mass media, while artists remained focused on their professional and personal concerns, not the great conflict taking place in the remote East. In August 1914, war was back on the art agenda after years of neglect. This time, however, it appeared in a different public environment.

Everyone a Warrior: Mobilization and Militarization in Russian Public Culture during 1914

The First World War brought striking changes to Russian public culture. War reached from the front lines into the lives of the millions of people who were far from its mud-filled trenches, poison gas, and whistling bullets as the media literally shrank the space between audience and war.[48] "The far fields . . . but how near they are to us!" explained an observer in 1915: "The small hamlets of Poland, the narrow creeks, the little Carpathian paths, and the previously unknown towns of Northern France—this is all brought so near to us. It is as if a magic hand removed the space between them and us."[49] No medium was spared as a complex visual culture of war diffused throughout public and society, and never before had warfare pervaded the lives of the Russian people as in the war's first year.[50] "The war has captured us," wrote one commentator, and he described the power of the war to mobilize people's attention: it "consumed all other interests so much that we look for it and connect it, or its reflection, to any public [*obshchestvennom*] phenomenon."[51] Bursts of wartime civic activism had oc-

curred in 1877 and 1904, but the scale and social pervasiveness of public mobilization in 1914 was unprecedented. Everyone became a warrior.[52]

A wave of patriotic unity swept the country after war was declared in August 1914. Politicians and journalists announced a sacred union of domestic political peace, while liberal deputies in the Duma swore to support the government and promised a policy of political cooperation. Prominent revolutionaries gave up their domestic enemies to adopt a defensist stance against the external enemy, and labor unrest dissipated. The Russian senator Baron Taube remembered those early days and (rhetorically) rubbed his eyes in disbelief: "Enormous masses of people, including recently revolutionary students, sing the national anthem and promenade in the streets with icons, portraits of the Tsar, and national flags. No, this was not a dream, nor a mirage."[53] Prince G. E. Lvov, a prominent liberal politician, noted how radical this unity seemed in September 1915. "This national war has turned upside down all the old notions, traditions, and the old standards," he declared. "In reality, we have no longer those old divisions and cells."[54]

The state did little to mobilize the public for an extended conflict, but civil society responded immediately. Educated society, local politicians, and leading industrialists founded new institutions in the cities and in the zemstvos (Russia's regional institutions of self-administration) to help the wounded, care for refugees, and mobilize resources for the war effort. Society women ran charities and volunteered to serve in hospitals, while the slogan "all for victory," according to one photographer, "mobilized and directed to a single goal" all Russian scientists and technicians.[55] The artist Konstantin Kandaurov marveled at Moscow society's frenetic pace in October 1914: "Our life is running at full speed. Everyone is occupied by the war, with care for wounded and the arrangements for the future of Polish refugees. The mood is wonderful, with a total belief in success and in victory. Moscow is donating colossal amounts of money."[56] The Union of Zemstvos, a national zemstvo umbrella organization created right

after the war began, soon controlled 1,667 hospitals.[57] One journalist was proud to see that civic mobilization had reached the provinces in January 1915: "If today a public revival has begun in the great cities, then society in the regions has also awakened and put behind it the lethargy that was temporarily shrouding Russian life."[58]

The mass mobilization of ordinary people is less well known, but no one could escape the personal impact of war on this scale. Older school-children in several regions formed voluntary agricultural organizations to help in the war effort, an innovation in school life.[59] Enrollment in the Student's Hospital Organization peaked in November and December 1914 (when conscription reduced membership), and reports circulated about young children who volunteered to help the wounded and collect money for the war effort.[60] Priests and local zemstvo leaders organized charity events in the countryside, but peasants also did their bit. One foreign trav-eler, for example, noted that peasants in 1915 gave refugees who passed through "everything they could. You need it more than we do, they said— what's the difference?"[61] Villagers in Chernigov province raised 4,180 ru-bles for the wounded, while nineteen cantons (*volosti*) gathered 23,460 ru-bles for other war charities.[62] In the Cheliabinsk area country people took refugees into their homes.[63] Near Kaluga peasants gathered linen, and in Lavrovo (Orel province) they raised 6,000 rubles for a hospital.[64] Mil-lions of country folk traveled to foreign lands or Russian cities, fought or learned to fight a distant enemy, and returned home to tell of their expe-riences. In 1914 and 1915 peasant conversations, according to one punc-tilious investigation, dwelled on the war 77.4 percent of the time, while agriculture came in a distant second at 12.4 percent.[65] Peasants, excited commentators noted, were becoming more aware of current events and civic obligations.[66]

In 1914 and early 1915 public culture immediately went to a war foot-ing. Patriotic spectacles were suddenly popular, and almost half of Rus-sian movies dealt with the war in its first five months.[67] Circuses, puppet

shows, and theater repertoires added anti-German and patriotic themes. In August 1914 there were eighteen patriotic plays (22 percent of all theater productions), in September seventy-three (27 percent), in October sixty-three (26 percent), and in the first half of November twenty-four (20 percent) throughout Russia.[68] Urban Russians were inundated in militarized culture.[69] Militarized posters, postcards, and advertisements appeared on street corners and in shop windows, and passersby crowded around newsstands and newspaper offices to catch the latest reports. Cheap lithographs, according to observers, played a large role in popularizing the war among peasants.[70] These battle prints provided textual information of military events, and their frenetic action scenes suggested the chaos of combat (figure 12). But they were not accurate depictions of any specific battle; within these generic images of war were small scenes and narratives that taught lessons about old-fashioned masculine bravery, human pathos, and modern violence.[71] Such information, for example, reached everyone in one village. "When in S—vka the book peddler appeared," wrote a teacher, "his pictures and booklets (lubok and all war) sold instantly. Which house didn't have pictures about 'the war'? And portraits of Nikolai Nikolaevich, the Belgian king, General Ruzskii and Radko-Dmitriev were the favorites, each house had one of those."[72] Villagers dramatically increased their consumption of periodicals in Moscow province, and the city's papers and weeklies managed to reach peasants in the surrounding countryside.[73]

World War I exploded into bookshops as philosophers, publicists, and novelists flooded the book market with war-related books, pamphlets, popular prints, and postcards. Publications about the war reached huge proportions in late 1914. Statistics showed six hundred titles were published about the war for a total of eleven million publications (a figure that includes five government brochures with a combined printing of 5.3 million copies).[74] In response to these changes, book industry statisticians began to track a new category, "War," which by 1915 contained 1,954 titles and a total pro-

12. Popular print. *Battle at Przemysl*. 1914. Color lithograph, 44 × 58 cm. Slavonic Library, National Library of Finland.

duction of 18,836,000 copies, almost equal to the number of schoolbooks printed in the country.[75] The "War" and "War and naval matters" categories included about 14 percent of Russian-language book production and around 6 percent of all titles published over the entire year 1914, a huge increase from 1 percent in 1913.[76] Periodical circulation skyrocketed. The popular illustrated weekly *Flame* reached an unprecedented circulation of 700,000 in late 1914, which meant that perhaps six million people read, viewed, and imagined the war in its pages each week.[77] Its competitors likewise expanded their print runs: the illustrated tabloid *Twentieth Century* (*Dvadtsatyi vek*) claimed a weekly circulation of 180,000 in 1914.[78] Circulations of many important newspapers, including the *Russian Word* (*Russkoe slovo*) and *Russian News* (*Russkie vedomosti*), increased sharply during July and August 1914, and publishers printed special bulletin editions on Mondays, the normal day off, to satisfy public needs for the latest news.[79] In 1914, 19 percent of all newspapers were devoted to the war.[80]

The form, layout, and design of newspapers, journals, and magazines changed radically as the information media became a virtual monocul-

ture. Journalists made good copy with reports from the front, human-interest stories from allied and hostile nations, and articles about military history. Advertising fell sharply, and subject matter became simplified as new war-related rubrics and columns appeared in the newspapers and journals. The liberal daily newspaper *Speech* (*Rech'*), for example, reduced coverage of cultural news and replaced it with military reports.[81] In the *Flame* images with references to war zoomed from less than 10 percent in early 1914 (when the United States conducted incursions into Mexico) to over 90 percent in the first six months of the war. The percentage of images that referenced the war in the illustrations of the *New Time* likewise shot up from almost zero to between 60 and 80 percent by mid-1915. Even the most "civilian" publications turned into war publications filled with war poetry and literature, war summaries, and incessant discussions about war.[82] Editors for the magazine *Argus* showed a typical reaction toward society's mobilized condition when they announced five special war editions in August 1914: "The main focus in coming issues will be on war questions because now all the interests of Russian society are focused on war."[83] They promised to employ only the best artistic, literary, and military specialists to satisfy those interests.

Is this frenetic civic activity and militarized culture strong evidence that widespread patriotism and war fever existed in Russian society in 1914? Nothing was surprising about the appearance of strident patriotic culture in the commercial media; public opinion makers wanted to mobilize the population to fight a victorious war, and the militarization of public culture, its culture of war, was designed to serve that end. Public discourse in the first year of the war thus presented an imaginary war of overwhelming "hurrah patriotism." This mixture of naive propaganda and conscious falsification in the news and entertainment media presented Russian people with a constant string of victories, brave heroes, and weak or comical enemies. Many people were no doubt enthusiastic, patriotic, and excited about the prospects for a victorious war against the Germans, the Austrians, and

the Ottomans and willing to accept this imaginary war. Yet the rest, certainly the majority, merely tolerated the war as a new reality in their lives and acquiesced to its existence. As one foreign visitor remarked, educated and uneducated Russians alike in one village were unsure about the war's causes but were resigned to the conflict as "a fact to be accepted."[84] Workers did not greet the news of the war with "cheerful support," but neither was there great opposition.[85] The educated public remained largely defensist, according to the liberal politician and historian Paul Miliukov; they accepted the war but searched for a compromise between their "pacifist convictions and sad reality."[86] War was not a joyous time, one writer noted dolefully, but a burden: "Yes, the motherland is dear to all, even to those for whom it is not a mother but an evil stepmother."[87] Defensism, civic activism, and muted toleration, not defeatism, apathy, and war enthusiasm, were the feelings that united most Russians in 1914. Only in the public culture was hurrah patriotism real.

Foreign observers, émigrés, and historians later constructed a myth of the war experience to suggest that the country's failure to mobilize led to military failure and revolution in 1917. In the eyes of most, ordinary folk had no sense of national consciousness, no enthusiasm for the war, and little clue about wider events, and their strong local identity weakened national unity and resolve at this pivotal moment in history.[88] The religious and political philosopher Nikolai Berdiaev, for example, argued that the very concept of nationalism itself was fundamentally alien to Russian thinking.[89] On the other hand, the Trudovik leader Vladimir Stankevich (Vladas Stanka) suggested that the intelligentsia was more to blame; he later believed that the "droves of drunken deserters" in 1917 had only wanted something the intelligentsia could not or would not give them: peace.[90] The myth of defeatism has proven to be a powerful explanatory story for the revolution, and only very recently have some historians suggested that World War I might have strengthened national identity and feelings of active citizenship.[91] Today it is probably still more common to

believe that the Russian people gave up when patriotism dwindled from the public sphere in 1915.[92] Still, such debates about the nature of nation identity, patriotism, and citizenship in wartime Russian society are really about who (or what) is to blame for the revolution. They tell us much less about the actual war experience itself.

In truth, the Russian engagement with World War I was intense in 1914 and continued after 1915 (chapter 3). People wanted to know what was happening, and they looked to the media to find out.[93] Experts in child psychology noted children's great interest in the war, especially their desire to read about it and act it out through play.[94] Peasant boys, wrote the British Russophile and travel writer Stephen Graham, followed trains and shouted at travelers to throw them newspapers from the windows.[95] Nikolai Punin and his avant-garde friends, for their part, were well connected to mass culture. "We read the same magazines that were being read everywhere," he remembered.[96] Mikhail Le-Dantiu, a cubist, asked Olga Leshkova in 1916 to send him periodicals at the front. She made up several packets with satirical journals, popular weeklies, and newspapers.[97] Artists followed war news because they, like others, found current events fascinating and directly relevant to their lives and the lives of their loved ones. The landscape painter Arkadii A. Rylov scanned the papers for news of his brother: "With eagerness and fear you look in the paper for telegrams from the army. You mark our positions and allied armies on the map with little flags."[98] The war was a great historical drama and the most important event in most people's lives. It captivated, all at once, the interest of people from diverse backgrounds.

There is no need to postulate a wave of patriotism, nationalism, or militarist enthusiasm to explain the unprecedented outpouring of public activism, for engagement with patriotic public culture does not tell us about an individual's personal attitude toward the war. Patriots no doubt did support the war effort from inner conviction, but public action in the culture of war converged around mobilization because it could accommodate

diverse goals and satisfy many different motivations. One could mobilize for many reasons: patriotism (an expression of loyalty to state or political community), nationalism (an expression of loyalty to nation or ethnicity), or altruism (an expression of loyalty to humanity). Compulsion helped the population to mobilize, for tsarist police were vigilant in their suppression of antiwar sentiment or suspected subversive activity, and the peer pressure of neighbors, relatives, and acquaintances no doubt forced some individuals to participate. Mobilization was also sustained by opportunism and self-interest; when public space opened, many used war enthusiasm and economic mobilization to advance financial, professional, political, or personal agendas. Book publishers and magazine writers flooded the press with patriotic culture when it was profitable, while liberal political activists spurred public mobilization to strengthen their institutions on a national level, actions that the government found "impossible to repudiate."[99] Even revolutionaries could organize cells in factories "in the aid of war victims" and find their illegal activity suddenly acceptable.[100] Skeptics participated in charities alongside chauvinists and enthusiasts, while reactionaries and subversives raised money to help the wounded and to aid war refugees. People fought different wars, but they did so inside the same mobilized public space.[101]

Public mobilization in wartime Russia, whether in the guise of social work, charity activity, or participation in militarized culture, thus distorted public space as it created an overarching, institutional basis for support of the war effort, a patriotism of social action.[102] Before the war, individuals in civil society self-mobilized to accomplish a variety of public goals, and events such as the Russo-Japanese War or even the Revolution of 1905, with its civil strife, political divisiveness, and localized violence, did little to unite the dispersed nature of individual action within public space. In 1914 a culture of mobilization permeated the public sphere, and it tended to attract the public action and monopolize the public expression of almost all individuals and groups whom it reached. This war

had such a broad effect not because it had a special mystical or spiritual attraction (although it may have for some) but because it was a problem that many individuals had in common. In this atmosphere of help and self-help, people engaged the war effort, the aims of the government, and broader society whether or not they were personally patriotic. Total war, as manifested in public mobilization in 1914, bound Russians to the political establishment, the status quo, and the war whether individuals believed in them or not. The politics of public culture became part of the politics of mobilization.

Clinging to War: Russian Intellectuals and the Mobilization of the Art World

The First World War disturbed the usual rhythms of life in the creative intelligentsia.[103] As a catastrophic event it posed existential problems and material challenges that intellectuals, like others, could solve with personal engagement and public action. In response to the new needs of total war, they began to engage in practical social work and to use their professional talents for the war effort. Berdiaev noted a dramatic change in the attitudes of the intelligentsia as they began, in his view, to abandon the "theoreticism [*sotsiologizm*] and moralism" in their "abstract and doctrinaire" consciousness to focus more on the "historical and the concrete."[104] Symbolists and aesthetic modernists suddenly began to take an active part in a literary mobilization; few could focus on "art for art's sake" in the atmosphere of public excitement and mass mobilization. Artists became swept up in the general expansion of public activism and engagement with war, but they were also responding to sudden changes that distorted and destabilized the institutions and public culture of their professional life. The writer Mikhail Prishvin noticed a complete revolution among his friends as refined "decadents" met and discussed contemporary problems and issues, a practice they had earlier rejected. "Aestheticism," he wrote, "clings to the war."[105]

The art world seemed on the verge of dissolution as a personal and intellectual atmosphere of crisis gripped almost everyone during the war's early months. Most artists, critics, and art professionals believed artistic life would immediately stop. For them, a simple maxim expressed the incompatibility of art and war: When the cannons roar, the muses are silent. In an apparent confirmation of these pessimistic expectations, the art market slumped, journals closed, and visitors avoided museums. Conscription took millions of people, including painters, museum workers, and administrators, from their former lives, while material difficulties and public distractions weakened institutions and made professional life difficult. Artists who lived abroad, including Marc Chagall, Wassily Kandinsky, Nathan Altman, and El Lissitzky, suddenly found themselves in Russia again, forced to adjust to new personal and professional conditions. What could an artist do when familiar audiences, institutions, and culture seemed to be collapsing? Many no longer felt like painting as mobilization, excitement, and fear overtook them. "I am no longer a painter," wrote Vasilii Perepletchikov, an impressionist in the Union of Russian Artists who served on six war committees. "I have almost forgotten that I used to paint."[106] Konstantin Kandaurov, a painter in the World of Art, comforted a colleague with the assurance that his professional difficulties were not unique. "Don't let it bother you that you can't think about painting," he confided. "Sarian can't either and isn't working."[107]

The material and institutional conditions necessary for art practice became uncertain as artists had problems finding supplies, venues, and material necessities. War disrupted everyone's routine, especially those in the free professions.[108] Painters no longer had access to high-quality oils, which often came from Belgium and France. "Thanks to the war it is now impossible to get good paint," wrote one newspaper commentator, who likened the artist's situation to that of a wounded soldier: "Several artists who are used to painting only with Belgian paints feel as if they now are dis-armed."[109] German photographic supplies and cameras, for many

artists a necessity, were unavailable once hostilities began. Exhibition organizers had trouble finding enough vehicles to transport art in 1914 after trucks were requisitioned for the war effort, and hospitals took up so much space in December 1914 that one fall exhibition was delayed.[110] Regular exhibitions by the Itinerants and the Union of Russian Artists were in disarray as visitors stayed away, sales were down, and general confusion made the logistics of exhibition organization difficult. Some art groups experienced significant drops in sales and visitors (see tables 14, graph 3 in the appendix). In January 1915 one newspaper reporter estimated that two-thirds of the paintings in Petrograd remained unsold.[111]

Public art institutions in Russia, as in Britain and France, were hit hard by the war.[112] Daily visitation to the Russian Museum dropped by half on average in the first months of the war, and for the year 1914 total visitation fell about 12 percent from prewar levels.[113] Attendance at the Hermitage also declined, and so many employees left for the front that management closed parts of the museum temporarily.[114] The art journal *Sofia* closed in 1914, never to return, while publishers of the glossy art journal *Bygone Years* (*Starye gody*) stopped production in 1914 (it restarted in 1915) in the belief that readers were turning away from art to focus on war: "the Fatherland War has captured all our thoughts and feelings, life in all areas of art has stopped, and interest in it among readers has therefore also naturally died down."[115] Material and financial problems plagued the Imperial Academy of Arts, which was an important source of grants, overseas trips, and professional prestige. Trips abroad were cut, Russian artists were trapped in distant lands, and foreign artists stranded in Russia needed monetary support. In 1915 only 47 art books were published, 35 percent of the 135 titles published in 1914.[116] Another blow came during the anti-German pogrom of May 1915, when Muscovite mobs trashed the Knebel and Grossman publishers, demolished several art books in press, destroyed two hundred original works, and burned some twelve thousand photographic negatives.[117]

Yet the 1914–15 art season was not a disaster, just different. The number of art groups leveled off in Moscow and Petrograd (and dropped slightly in the empire as a whole), but the art world did not collapse (see graph 2). Intellectuals found new ways to be useful to society and to support themselves as institutions deteriorated. One reason that the regular art exhibitions were so disorganized was that the war became a focal point for new institution-building. Special war charity exhibitions and auctions appeared where artists blended patriotic social activism and professional self-interest to meet the sudden need for social mobilization; these new institutions competed for space, artists, and customers with traditional group exhibitions. For Mikhail Nesterov, who had canceled an exhibition in 1904 because he felt the public environment was not right for his work, such wartime events allowed him to remain active as normal public life became difficult: "Even I am taking part in all these exhibitions. I am giving a thousand and half things (trifles). I've already sold around 450 rubles' worth at home before the opening of an exhibition (such are my things on 'the market'—rarities, which is why they are taken gladly). In this way, with all your infirmities and disability you somehow bear your 'civil duties.'"[118] In December 1914 the art critic Viktor Nikolskii observed that "the mobilization of Russian art is almost complete: seven exhibitions at the same time and six of them charities."[119]

Intellectuals and cultural figures felt the call to patriotism, social activism, and self-mobilization like the rest of society, and many jumped at the chance to help their country, their fellow citizens, and themselves. "Patriotic feelings began to bubble," remembered the artist Valentina Khodasevich, "everybody mobilized themselves. My parents organized . . . the sewing of underwear for the wounded."[120] Some transferred personal energy from social and political work to the war effort. "The other women working in our train," wrote one observer, "are mostly Russian intellectuals who can find no satisfaction in their ordinary life in the provincial corners of our immense Russia, and are seeking an outlet for their moral energy and

their social aspirations. The war has the same attraction for them as the struggles and sufferings of the people used to have."[121] Actors responded to the needs of the war with charity activity, while cinema distributors and studios donated profits to military hospitals.[122] The graphic artist A. P. Ostroumova-Lebedeva felt the urge to participate in surrounding events, to be useful to anyone. "But how? How?" she asked herself.[123]

Russian artists reproduced wider civic unity in the new institutions that appeared in their corner of public space. "All classes of society, from plowman to tsar, and all nationalities combine under the powerful wings of the double-headed eagle," proclaimed Gerasim Magula in the *New Time*, "and are ready, each according to its power and capabilities, to serve the fatherland. Even artists bring their talent and do their bit in this great era."[124] The special wartime exhibitions gave this professional unity institutional form, for critics and journalists understood such exhibitions, which usually accepted all styles of art, to be the artistic version of the political sacred union. As one critic suggested, "The war has pacified and united even the most irreconcilable: the most conservative Itinerants appear next to the most rebellious sectarians of cubism."[125] The large charity exhibition Moscow Artists for Victims of War became a microcosm of a unified Russian society inside the art world. "The war has unostentatiously united inimical art circles," wrote one critic. "Everyone has forgotten old scores while working for one goal: to help the wounded."[126] Mass mobilization served to bring Russia's art milieus, the broader artistic public, and the mass culture closer together, not further apart as many had feared when it seemed that the art world would dissolve.

A "completely new" institution in the Russian art world was the war charity.[127] Artists had put on occasional charity exhibitions before 1914, but few war charities had appeared during the Russo-Japanese War. In 1914 and 1915, special onetime exhibitions dedicated to the war effort sprang up next to the regular annual exhibitions. They enjoyed great success with the public; visitors stayed away from regular institutions but seemed to

thrive on war charities. Moscow Artists for Victims of War, for example, attracted ten thousand visitors and sold seventy paintings for 12,000 rubles, a very respectable sum.[128] The auction on November 30, 1914, in the Society for Encouragement of Arts sold 4,142 rubles worth of art; they made a profit of 2,500 rubles and donated their entrance fees plus 10 percent of sales to charity.[129] The Exhibition for the Artists' Hospital raised 7,856 rubles and 56 kopecks.[130] Other charity exhibitions included an Exhibition of Allied Peoples (For Poland), War and the Press, Artist Aid, Artists for Comrades at War, and an Exhibition for the Belgians. These events had no material impact on the war effort, for the state spent 38.6496 trillion rubles on the war between August 1914 and September 1917.[131] Instead, war charities gave artists access to the art market, critical recognition, and wide publicity that regular institutions could not provide in the early months of the war. They show how painters became enmeshed in an atmosphere of public mobilization that connected the art world to wider culture. One newspaper writer testified to the unavoidability of such mobilization: "Here is new evidence about how generously our artists and art figures have reacted to the needs of war, to the essential cause of helping the wounded."[132] Through the charity exhibition, it became a patriotic duty to buy art.

The patriotic culture of war provided new public space for war illustrators to make their work available to a wide audience outside traditional art institutions and audiences. Academic battle artists and lesser-known illustrators capitalized on the public's intense demand for war images in magazines and newspapers.[133] War illustrations like those by V. V. Mazurovskii, a journalist argued, did not "count as pearls of Russian art" but were "as necessary as the newspaper page," since they provided a "fast, immediate response to events that were interesting to everyone."[134] Mazurovskii, a noted war illustrator, academic professor, and battle painter, noted the public's "unusual interest in battle art" in October 1914. "It is enough to walk around the streets of Petrograd to discover how much the

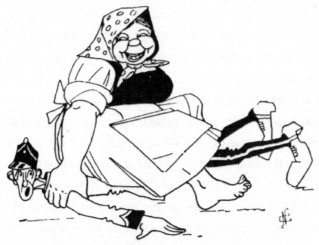

Когда австрійцы бываютъ джентельменами.
— Сдаюсь вамъ, вамъ, дамѣ!..

13. N. S. Samokish. Postcard. n.d. Slavonic Library, National Library of Finland.

public thirsts for pictures depicting various battles," he told a reporter.[135] Stephen Graham found one war poster by Mikhail Nesterov "exposed in every city" as a "postcard reproduction on every bookstall in Russia."[136] Special war art exhibitions likewise provided artists with opportunities to show their work to the public.[137] Russia's Historical Society, for its part, sponsored a large art show about the war in 1915, while the Museum of the Great War contained a special section on the war in art.[138] Nikolai Samokish, another war illustrator, painter, and professor at the Imperial Academy, used caricature to make fun of the Austrians in his contribution to a wartime postcard series (figure 13). The distribution of these artists' work by the media and other public institutions brought the war to ordinary Russians, many of whom might never have attended an art exhibition or seen an original painting.

The distance between the art world and the mass media narrowed as the demand for war images rose in 1914. Paintings with war-related subjects provided opportunities for artists to create and sell their work in the new expanse of patriotic culture. The visual language of artistic contributions to the war effort corresponded to the motifs and interests of the mass

media's photographs and illustrations, not the conventions of traditional battle art, Vereshchagin's war realism, or the regular art world. Famous posters by Leonid Pasternak, Viktor Vasnetsov, and S. A. Vinogradov appeared in newspapers and on the streets.[139] Modernist artists and traditional illustrators also created popular images for postcards, caricatures, and popular prints that extolled Russian soldiers and denigrated the enemy, while well-established genre and realist artists decided to depict daily life on the home front. Unlike Imperial Russia's battle painters and war illustrators, these artists had no expertise in war art; their views of war and life entered the mass media because they fulfilled vital propaganda, entertainment, or documentary functions. Paintings and illustrations that showed peasants reading newspapers or listening to war news, for example, were common at exhibitions early in 1914 (as in previous wars), and magazine editors published them to show that peasants were interested in the war (figure 14). A critic for the *Petrograd Newspaper* (*Petrogradskaia gazeta*) used one such painting to engage in self-promotion: "The painting 'News from the War' is not bad. It depicts a country lad reading the *Petrograd Newspaper* to his fellow villagers."[140]

In 1914 mobilization was so strong and the war so compelling that even some modernists created war-related images, often incorporating institutions, symbols, and visual strategies from the culture of war to communicate their ideas. Such images were not easel paintings and did not appear at art exhibitions; they belonged to the patriotic culture of the mass media, with its huge volume of postcards, posters, and popular prints that depicted heroic warriors, evil Germans, and proud generals. Some modernists found a way to uphold an elitist orientation even as they interacted with the commercial patriotic culture. G. I. Narbut, A. O. Sharleman, and several other World of Art painters, for example, imitated the visual design of graphic prints of the Napoleonic Wars (a style that Narbut had used before 1914) to represent the commander in chief of Russian armies, Grand Prince Nicholas Nikolaevich, as an early-nineteenth-century war

14. I. A. Vladimirov. *News from the War*. 1914. Illustration in *Niva*, August 23, 1914, 677.

leader (figure 15). In 1914 these artists supported the government's war aims, and through such anachronistic artistic forms Narbut could link the Fatherland War (Otechestvennaia voina) of 1812 to the World War of 1914 (which was sometimes called the "Second Fatherland War" in the press).[141] But the artist also adapted the genre to the times by depicting heroes of common social position, not just the military elites who filled nineteenth-century engravings. His postcard of the Cossack hero Kriuch-kov, with its static composition, emotionless human figure, and simpli-fied, abstract background, contrasted sharply with more emotional, il-

15. G. I. Narbut. *Commander-in-Chief Grand Prince Nicholas Nikolaevich*. 1914 or 1915. Illustration in Vladimir Denisov, *Voina i lubok* (Petrograd: Novyi zhurnal dlia vsekh, 1916), plate 36.

lustrative, or narrative images of the celebrated Kriuchkov that filled the early patriotic culture.[142] The stylization of these and other artistic contributions to the media war suggest that they were targeted at urban audiences or educated collectors; critics suggested that ordinary folk preferred "realistic" modern lithographs (figure 12).[143] Narbut resurrected an obsolete form of visual culture to mobilize readers for a Fatherland War, but

his use of contemporary content and distribution kept it consistent with the iconography of wartime culture.

Modern artists had various motives to join wartime patriotic culture, and artistic form could serve different purposes within it. Nikolai Rerikh, a famous painter in the Union of Russian Artists and the World of Art with a strong interest in the philosophy, religious life, and aesthetics of Asia, produced a very popular image of Wilhelm II as the Antichrist that fit well the war's early public culture (figure 16). The shelling of Reims cathedral, the destruction of the Belgian city of Louvain (Leuven), and the damage to architectural monuments in Poland and Galicia all evoked public horror in 1914, and the text and images in Rerikh's widely distributed picture links his work to those events, the symbols of German barbarity in the Russian press.[144] In its composition (if not in style), Rerikh's image evokes the work of a foreign artist whose highly gendered depiction of a grinning German soldier standing over slaughtered civilians appeared in postcards and newspapers at the same time (figure 17). This image attempted to evoke rage and hatred against the German enemy, who is presented as a modern colonialist showing off his trophies, the violated women and children and destroyed cities that men should defend as the treasures of civilization. Its caption in the newspaper made a strong distinction between "them" and "us" to reinforce Allied virtue and demonstrate enemy barbarity to readers, while the title of a postcard version, "Germans in Belgium," likewise differentiated between enemy and friend.[145] Rerikh, however, had a different goal: to raise awareness for the preservation of cultural monuments in wartime, a cause he took up with the tsar and the Russian military.[146] His satanic Wilhelm II threatens but cannot destroy the beauty of the medieval cities, which are presented as indestructible, idealized forms, and the artist adopts a different tone for his depiction of "the enemy of the human race," identified as "the evil German" personified in the Kaiser. Rerikh, like others, participated in the patriotic culture that washed over public space in 1914, but he sought to mo-

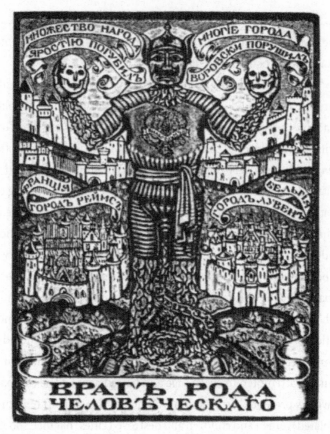

16. N. K. Rerikh. *Enemy of the Human Race*. 1914. Illustration in *Polveka dlia knigi* (Moscow: Sytin, 1916), 191.

bilize viewers to protect the treasures of human civilization, a strategy in line with his aesthetic principles, personal values, and public advocacy for wartime cultural preservation.

In 1914 artistic life in Russia did not stop, as many had feared, but became a part of the culture of war. The practices, institutions, and ideas about public engagement in the art world were dramatically different from those in 1904, when war had made little impact on the structure of civil society, art, or the behavior of artists. At that time art had seemed irrelevant to war, but in 1914 artists believed they could make a difference through participation in the general mobilization that gripped civic society, in some

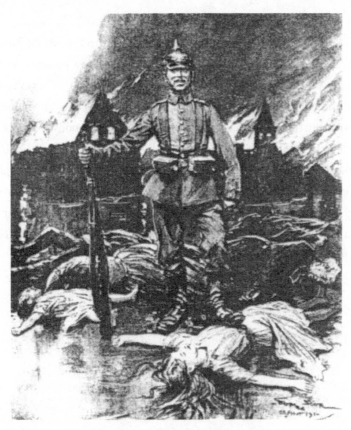

17. *How* They *Fight*. 1914. Illustration in *Novoe vremia*, September 6, 1914, 11.

cases at the expense of their normal professional routine, and they altered
institutions in response to changes in public life to find outlets for their art
where the public supported it: inside special charity exhibitions and com-
mercial culture. This engagement became a political act that supported
the war effort as mobilized culture determined the content and form of
public art.[147] Even aesthetic modernists who participated in this patriotic
culture changed their art and professional activity to match the needs of
mobilization when less-altruistic opportunities arose. But unlike in 1905,
when modernists used graphic art to attack the government, their con-
tributions to the mass media in World War I served to support social and
political unity. As one foreign commentator observed, "The saying 'Art

for Art's sake' has been changed by the Russian patriot to 'Art for Russia's sake.'"[148] When Iakov Tugendkhold praised artists' new professional solidarity, he linked it directly to mass public mobilization. "The unity that is connecting Russian society in one harmonious rush has also touched the stratum that in normal times is most full of disharmony—artists," he wrote in December 1914, and he hoped this change would be permanent: "Consider the proximity of the 'Jack of Diamonds' with the Itinerants [and] Konchalovskii with Repin first as a sign of that long-awaited and so necessary mutual respect. Let's hope it isn't just ad hoc but becomes a permanent fixture of our daily life."[149] By the end of 1914 artists had adapted to the new conditions of wartime.[150]

3. Love in the Time of Cholera

Russian Art and the Real War, 1915–1916

Imagining the unimaginable became a necessity for artists in Russia as they struggled to redefine their lives and their work amid the intellectual and material disturbances of the Great War. Public culture had changed, and modern war's existential challenges posed great paradoxes to artists who wanted to uphold the idea of art as a representation of reality and the artist's role as the creator of culture in modern society. How could art be relevant to modern life when modernity meant destruction, not creation? What was the role of the artist when the art world seemed trivial and artificial compared to the great human suffering of war? How could an artist remain autonomous during days that demanded personal sacrifice, common cause, and dependence on art buyers with bad taste? A shifting public environment for art against the background of tremendous death and suffering led many to despair that their work had meaning in time of war. "When blood is flowing on the fields of battle, who feels like art?" wrote one young painter.[1] Some aesthetic modernists began to leave aside prewar aesthetic principles when faced with such questions, and their search for professional and personal stability led to more figurative, narrative, or traditional styles amid the new public structures of war. With some guilt, perhaps, Dmitrii Merezhkovskii noted the problematic position of the artist during the Great War: "Two lines of a war bulletin are more important than the works of Goethe and Pushkin. Culture in the time of war is love in the time of cholera."[2]

Scholars have noted how European art changed during the First World War, but the causes of these changes remain unclear. On the one hand, World War I seems to have been an incubator of modern art, an event that encouraged, validated, and intensified the irony, fragmentation, and iconoclasm inherent within modernism.[3] Kenneth Silver has challenged this long-held view by showing how the Parisian avant-garde "capitulated" to the "forces of 'order' and reaction" in the intense atmosphere of patriotism, right-wing political pressure, and public antimodernism that emerged after August 1914.[4] Cubists in France, he demonstrates, abandoned their cosmopolitan values, iconoclastic culture, and revolutionary sentiments to adopt patriotic or nationalist imagery and more conventional forms, changes that helped make cubism a conservative force in the art world after the war. Jay Winter has argued that World War I increased the appeal of traditional art, not modernism, as a way for people to comprehend mass grief and suffering.[5] Richard Cork, for his part, suggests that changes in art form during the war were linked to aesthetic challenges. The European avant-garde attempted to paint the war, he writes, but "advanced modernist abstraction soon proved an inadequate starting-point for developing a viable approach to the conflict."[6] The Imperial Russian case suggests that these divergent interpretations exist because each exposes a different facet of the war's more general effects on the artistic environment. The common denominator that underlay such changes was the role that a mobilized public culture played in aligning audience and artistic activity, a totalizing culture of war that, paradoxically, touched different individuals in different ways.

In wartime Russia modern artists used the content and form of their paintings to define, stabilize, and reinvigorate their personal and professional lives in a time of flux and uncertainty. Modernists did not abandon their fundamental aesthetics, philosophies, or art styles. Instead, the demands of the mass media, art market, and the individual psyche all encouraged the production of more figurative art as artists attempted to reach a

different audience or to use art in a different way than they had before the war. When the futurist poet Benedikt Livshits looked back at the avant-garde's reaction, he could only wonder how painters and poets could have bidden "farewell to abstract form, to shattered syntax, to zaum [transrational or alogical poetry]—and without regret?"[7] Vladimir Makovskii, a member of the Itinerants, was positively gleeful as he tracked an antimodernist backlash among the public in August 1915: "It is fun to read attacks on decadents, futurists, and so on. It is too much to think that art finds itself on the right path in this nightmarish time."[8] But conservative critics and artists who celebrated the end of modernism could not point to the success of aesthetic realism as the source of cultural rebirth, for realist artists themselves failed to find inspiration in great events, turning to satisfy the tastes of the art world instead of educating the Russian people about the great conflict through their art. If aesthetic modernism, to some, appeared defeated during the war, aesthetic realism did not emerge victorious. The problem of how to represent reality when reality seemed unrepresentable remained intractable in Russia's mainstream art world.

A Great Retreat? The Continuation of Mobilization in Russian Public Culture

In mid-1915 the Great War was no longer a natural disaster that had struck quickly and left behind a time of reconstruction and consolidation. In April the Germans forced Russian armies into a humiliating Great Retreat from Poland, and prospects for a short, victorious war dimmed. As the war's novelty wore off, the initial wave of excitement and public patriotism subsided, but war did not disappear from public culture. Mobilization had installed new institutions, social needs, and habits into daily life, and the necessity to find a way to live in wartime, to comprehend the war and cope with its economic, social, and political problems, persisted. Civic activism in public institutions to support the war effort continued and even increased in some areas of the public sphere, including the art

world. Engagement with the war did not cease in 1915; its public contours and expressions shifted as Russians refocused their efforts away from public patriotism toward coping with war as a permanent problem in life. People settled down to a long conflict. The war became routine.[9]

The sublime heroism, colorful patriotism, and loud bravado of the early patriotic culture seemed ridiculous and false as people learned about mass defeats and horrid conditions at the front. Russians took later difficulties so hard, wrote one journalist, because newspapers, especially the boulevard press, had presented such unbelievable and fantastic accounts about military successes in 1914.[10] Editors for the *Blue Journal* (*Sinii zhurnal*) exposed press fictions openly when they published the divergent captions that different publications had made up to describe the same war illustration.[11] The Ministry of Interior itself admitted that "military reverses brought the masses to a clearer understanding of the problems of war."[12] Public patriotism in the entertainment industry fell sharply, the flood of war *lubki* subsided, and patriotic films almost disappeared from production.[13] War-related literary anthologies dropped from 33 percent (21 of 64) in 1915 to 8 percent (5 of 61) in 1916 to 3 percent (2 of 70) in 1917.[14] The famous singer Fedor Shaliapin returned to Petrograd after the excitement had died down. He saw "no trace of either enthusiasm or depression. Life seemed to have resumed its normal course."[15]

The waning of patriotic entertainment culture shows that the war had become part of a reality that people wanted to avoid, not that they were uninterested, pacifist, or unpatriotic. Urban consumers turned to cinema, popular theater, and novels to escape everyday life, not to relive it; they began to reject patriotic entertainment when the war no longer seemed novel, adventurous, or escapist.[16] The director Constantine Stanislavsky remembered how obscene the patriotic war was in comparison to the real war: "Can theatrical, pasteboard war vie with what was felt on the street, in the souls of men, in their homes, with what thundered and destroyed them on the front? . . . Theatrical war at such time is only a caricature, in-

sulting and harmful."[17] People lost interest in naive, unreflective hurrah patriotism as the war became a prolonged and difficult conflict, and they altered their public behavior accordingly. As one artist noted, "the Moscow audience [*publika*] changed its habits under the power of fear. Fewer went to the theater. . . . War-flushed hands reached out to more lighthearted entertainment."[18] People adopted calmer attitudes toward the war, without hurrahs, noisy demonstrations, or patriotic élan.[19]

In this reaction people in Russia shared a general European sense of weariness, apathy, or dissatisfaction, for a "simultaneous diminution of initial enthusiasm" and "relative lack of protest" characterized European public opinion from September 1914 to early 1918.[20] Book production about the war rose in 1914 and then dropped almost everywhere in 1915.[21] In Berlin patriotic theater had already subsided in mid-1915.[22] German patriotic film production also fell drastically as the public turned to light entertainment, and German studios made few war movies after 1916.[23] In Britain war films peaked at 13 percent (66 films) of total production in January 1915, had fallen to 6 percent (22 films) in July 1915, and dropped 1 percentage point every six months before rising again to 4 percent (only 2 films) in January 1918.[24] In France, domestic morale faded as a "patriotic gloom" came to reign in many areas by 1917.[25] Imperial Russia was not alone in experiencing a drop in patriotic culture but followed a pattern common in all combatant nations, and popular dissatisfaction would become a growing concern for all those across Europe who sought to mobilize their populations for victory.

The patriotic content of wartime culture in Russia, as elsewhere, retreated in 1915, but the country did not return to business as usual, nor did it dissolve into revolution or defeatism. The front contracted, shortened, and straightened to become more easily defended. Military conscription was more difficult, but men (and some women) continued to enter the army and fight. The social tasks linked to the war, especially the need to take care of refugees, run hospitals, and mobilize the econ-

omy, increased in intensity as local government leaders and public figures realized they would have to take a more active hand in the war effort.[26] The formation of War Industries Committees by industrialists and other public figures, in partnership with the government, attests to continued attempts to mobilize the country's social and economic forces. By mid-1916 the activity of the Union of Zemstvos was so extensive and sprawling that the union was a virtual "state within a state."[27] Inflation, shortages of goods, and labor unrest existed, but industrial production increased, corporate profits skyrocketed, the stock market boomed, and economic growth continued.[28] Harvests were generally good, and land under cultivation increased by some thirty-five million acres.[29] The war experience was not an unmitigated disaster for many individuals, and Russian perseverance and resilience in the three years after 1914, as Roland Stromberg has pointed out, "suggests the weakness rather than the strength of opposition" to the war.[30]

World War I, in fact, did not vanish in public discourse but changed to another form: the "real" war. Editors considered it their business to show current events and to report important news from around the world, and nothing was more current or important than the Great War. Images of the war continued to fill the print media long after other forms of patriotic culture fell from public space. Over 90 percent of photographs and illustrations were war-related in the *Flame* and the *Twentieth Century* in late 1914, stayed between 70 and 90 percent through 1915 and most of 1916, and fell to little more than 60 percent in December 1916. In the *New Time* the number of images that referenced the war fluctuated between 50 and 80 percent, and war caricatures held steady at about 10 percent of all images in the satirical journal *New Satyricon* (*Novyi Satirikon*) throughout 1916. The illustrated journal *War* (*Voina*) stayed in business until January 1917, when its publisher converted to a true crime format, a change that signaled, perhaps, not a lack of interest in violence but its transference to a domestic context. The *Russian Word*, for example, achieved dominance in the news-

paper business (and served a million readers by 1917) in part because of its extensive news reporting and connections to important sources.[31] The war was still an important presence in the media on the eve of revolution.

The continued presence of documentary war images and war news suggests that readers wanted to see the "real" war long after they became disillusioned with hurrah patriotism. The "War" category vanished from the publishing industry statistics in 1915, but the "War and naval matters" category encompassed 4 percent of all Russian-language book production, sharply down from 1914 but still three times more than in 1913, and 8 percent of newspapers still focused on the war as a topic.[32] Demand for war news in the countryside outstripped supply in mid-1915, and images of peasants reading (similar to figure 14) could be found in illustrated magazines long after patriotic culture faded.[33] Several commentators noted that peasants were especially interested in facts about the war and that they did not always believe propaganda hype.[34] True, there was little enthusiasm for war in the villages, but people were interested in the war there as elsewhere because it affected their lives. One country lad described how the war was on everyone's lips despite their misgivings in 1915: "The village women talk at the wells about the war, about their husbands, who was ordered where, and so on. The peasant men and women are not happy, as if it were already fall."[35] "As in England and France," wrote Stephen Graham, "every family has its personal stake in the war, and for many that stake has become the wooden cross over a grave."[36]

World War I remained, in Imperial Russia as in other countries, a war of "maintained consensus" that held people's cooperation despite its violence and destruction.[37] People in Imperial Russia experienced a continual need to react to the problems the war posed in the public sphere and in their personal lives. Wartime public opinion was always volatile, and public perceptions of the war were not exclusively negative after 1915. Maurice Paléologue, the French ambassador, noted many mood shifts over the years. The public, in his experience, followed the fighting closely and was

confident in victory in mid-1915. Later that year the mood was more pessimistic, but by August 1916, he found, "the attitude of the Russian people toward the war is in general satisfactory. With the exception of the Social-Democratic party and some members of the Extreme Right of the reactionaries, there is no one who is not determined to continue the war to final victory."[38] Graham found Russians enthusiastic in 1914, desperate in 1915, and "remarkably cheerful" in 1916.[39] The boisterous imagery of the initial patriotic outburst had largely disappeared by 1915, but publishers and readers kept the war prominent in the information media after public interest in the war's entertainment and patriotic culture subsided. The continued state of public engagement with the Great War shows that the war was still capable of mobilizing or occupying people's imaginations long after most historians have assumed it could not. The case of the art world shows that individuals maintained their public engagement with the war long after they realized its awful reality.

The Demand of the Times: War and the Boom in Art

In 1915 and 1916 the art world had recovered from its initial shock and uncertainty, but artists, dealers, and buyers continued to alter art institutions as the war's social, economic, and political disturbances warped public space. They took advantage of a renewed interest in art and new disposable income that appeared among some segments of the population, and wartime charities and special exhibitions became routine, permanent fixtures instead of one-off events. This expansion of the public and emergence of new art institutions devolved control over art to individual artists, who could take their work directly to buyers much more easily than in prewar art culture. Imperial Russia's well-defined groups and traditional art institutions began to lose cohesion and institutional power, but the number of existing art groups held roughly steady throughout the country (see graph 2 in the appendix). Far from shrinking or falling apart as the destructive war raged, the art world continued to expand, grow, and

change. As Abram Efros noted in 1916: "Our artists are already beginning to make a concession to the demands of the times but they do it unwillingly, as if somehow forcing themselves. They feel that all the old art parties have lost their raison d'être, former slogans are obsolete, new groupings are not yet making their mark, and no new flags are unfurled. Now the best way to appear before viewers is the intergroup [*mezhdupartiinaia*] art organization: the organization of exhibitions where the best of all parties appear with the best works."[40] Iakov Tugendkhold laid early fears about art's demise to rest in 1916: "contrary to the adage that the muses are silent when the cannons roar: there are more art exhibitions than in peacetime."[41] Art was finally more than just a dessert in Russian cultural life.[42]

Established institutions did not return to the prewar status quo, however, but continued under a new routine: increased demand for services but limited resources made precarious by the war. In 1915 visitors began to return to the Russian Museum at about the prewar annual pace.[43] Yet all was not the same, for the war introduced a new audience to the museum: convalescing soldiers and garrisons who had been transferred to the cities. The modernist art journal *Apollo* (*Apollon*) reported that 18 percent of visitors to the Hermitage were wounded soldiers in early 1916.[44] "Never has such a democratic public visited museums, it seems, as now, and many interesting observations when it comes to artistic perception could be made about nurses and soldiers," wrote one commentator.[45] Like museums, art schools experienced continual war-related problems but faced higher demand. Many provincial schools depended on subsidies from the Imperial Academy of Arts, which were frozen or dropping through much of the war, and in 1916 their situation worsened.[46] Yet enrollment rose due to the effects of the war. High demand for art education came from Polish refugees who hoped to continue their studies in Russia, and Russian draft dodgers sought refuge in local art schools. "The war has not cooled the love for art, but just the opposite," explained an observer of the art education scene.[47]

The war changed the structure of the art public as new buyers revived the market with new money and increased demand. Aristocrats, entrepreneurs, and ordinary people found more rubles in their pockets as limits on alcohol, foreign travel, and imported goods expanded personal budgets, and inflation spurred investment in hard assets. Money that would have been "squandered" in taverns, observed one artist, fell instead into artists' pockets.[48] Many Poles fled to the Russian hinterland after the Germans took Poland, and anti-Semitic tsarist policies and Cossack behavior in the western borderlands forced Jews to seek refuge in large cities. In December 1915 a reporter noticed how one auction "attracted a large audience [*publiku*], among whom predominated completely new faces, apparently 'refugees.'"[49] Art was an inflation hedge, and it was an expense necessary for new households.[50] The critic Aleksandr Rostislavov linked the war to the changing composition of the market and noted its social leveling effect: "The war somehow has stirred up in the ordinary milieu 'an interest in art' of the very latest sort. The common person [*obyvatel'*], according to friendly newspapers, likes to visit the fall exhibitions . . . and 'nouveaux riches' line up to buy products at these exhibitions."[51] One banker from Iaroslavl, for example, spent 100,000 rubles on art to found a museum in his hometown.[52] Stephen Graham noted the prosperity among Moscow merchants and rich refugees who had started new businesses. One made a fortune selling boots in Archangel (the "Russian Klondike"), joined the city council, and bought art with his profits.[53]

The war's second art season, in the winter of 1915–16, exceeded all expectations after the difficulties of 1914–15, and the third season, in 1916–17, was the most successful in Russian history (see tables 1–4 in the appendix). The total number of exhibitions increased from around forty to more than fifty from the first to the second wartime art season.[54] Collectors bought smaller works and cheaper paintings in greater quantities at the Itinerants exhibition in Petrograd, while buyers stood in line at the Union of

Russian Artists to pay premium prices.[55] "Some merchant" treated art as a pure commodity when he purchased, sight unseen, a landscape painting for 3,000 rubles because it was the only one left.[56] Paying visitors to all exhibitions in Petrograd topped 70,000 in February, March, and April, and Wassily Kandinsky had lost count of all the exhibitions in May.[57] During the 1916–17 season economic ruin loomed across the land, but the art market boomed. Organizers had already set up four exhibitions in November 1916, several weeks earlier than usual, to meet demand. Sales were tremendous, often at a pace faster than inflation (see tables 5–7). Wrote one critic: "The Union of Russian Artists sold 90,000 rubles worth of paintings. So much has the demand for painting in Moscow society grown, and so much has its 'purchasing power' increased."[58] Said one artist who earned more than 25,000 rubles in two weeks in January 1917: "I have exhibited and sold paintings for around twenty years in Russia and abroad, but I have never had such a 'fertile' season."[59] There were not enough halls for all the exhibitions planned in 1917.[60]

Public patriotism and enthusiasm for the war had faded in the popular culture, but artists and buyers continued to display their patriotism and satisfy their self-interest in wartime charities. Charities, auctions, and special exhibitions reappeared with vigor after the summer break in 1915 and became routine. One auction, for example, raised 5,500 rubles in October 1915, while in 1916 the World of Art group donated 3,500 rubles to charity causes.[61] Latvian artists who fled German occupation put on charity exhibitions for their dispossessed fellow country folk, while Jewish artists formed charity groups for Jewish refugees and organized Jewish art exhibitions. Charity auctions took place in the Imperial Society for Encouragement of Arts, the Red Cross, the Women's Architecture School, and among the students of the Academy. In the 1916–17 season auctions were again wildly successful. One special exhibition in December 1916 was termed a "smashing" success.[62] Another sold 60,000 rubles' worth, a huge sum that rivaled popular regular exhibitions like the Itin-

erants and the Spring Salon, and gave 10 percent to charity.[63] In early 1917 there were as many war auctions as ever.[64]

The structure of the art world changed as the bull market for art encouraged artists to meet the new market conditions. Artists and dealers reacted to the increased demand for pictures with more personal exhibitions, special sales events, and unconventional events like raffles and lotteries, which individual artists could use to get their art directly to the public. Intergroup charity exhibitions of the early war years were replicated in commercially oriented institutions like the innovative First Summer Exhibition in 1916, which broke the Russian tradition of organizing exhibitions in winter and early spring. The Itinerants and the World of Art took advantage of the Christmas gift market to put on extra exhibitions that offered sketches, prints, and other small works. Famous and lesser-known artists began to exhibit outside the bounds of the traditional groups. An obscure independent impressionist, A. Manevich, for example, set up an individual show, generated a lot of press, and sold paintings worth 6,000 rubles.[65] Visitors could see a Salon of Humorists in Petrograd in October 1915, while one organizer planned a "large and serious" exhibition of graphic works from Allied countries in mid-1916.[66] This fragmentation eclipsed the traditional group system; the total number of art groups leveled during the war years despite the growth of the market (see graph 2).

A new public structure for art was emerging, a system linked to the war directly through the mass mobilization of public patriotism or indirectly as a by-product of economic change and internal migration. Genre and aesthetic boundaries blurred as art from all milieus appeared in charity, intergroup, and open exhibitions. Control over art was passing from established authorities toward individual artists as outsiders and artists from the established groups bypassed traditional art structures. In new intergroup, individual, and specialty institutions, artists could avoid the scrutiny of juries, who approved submissions at the traditional exhibitions of the major groups. The First Summer Exhibition was organized

specifically to be a profitable way for artists to get paintings to the public without intermediaries.[67] In 1917 one young artist told a friend she could raise prices to take advantage of ignorant buyers who did not know that she had no reputation: "the buyer, seeing the low price of paintings, begins to doubt its worth and doesn't buy. The public [*publika*], especially today's public, isn't informed as much about names as we assume."[68] One critic celebrated the market's tremendous expansion and the enthusiasm of the art public shortly before the February Revolution in language that was optimistic, colorful, even sparkling: "The number of art exhibitions grows and amount of exhibited works in our capitals increases with every year. The public does not remain passive toward our artists, especially the painters. Before the eyes pass the works of renowned and new artists, the nuances of all styles flash, and the incessant disagreements of irreconcilable professionals appear in artistic circles and in the pages of journals."[69] Another preferred the new exhibitions because they allowed insight into the creative work of individual artists, which underscored the "motley inconsistency and passéism of the usual 'seasonal' exhibitions!"[70] Abram Efros implied that the old system was dying in November 1916: "To find the living flow of art we must look not in 'societies,' not in 'groups,' but in separate artists of diverse groups."[71]

The magnificent 1916–17 art season overshadowed structural changes in the art world that reflected the country's economic challenges. Exhibition sales rose to record highs for most groups (except the Union of Russian Artists) (see tables 1–4), but economic hard times and other distractions reduced the purchasing power of the new wartime buyers. Critics noted that exhibition visitors were lethargic, and in many places the number of visitors dropped to 1914 levels or lower, even in Moscow, where the revolution did not disturb the regular art season (see tables 2 and 4).[72] Structural change continued. Exhibition activity began earlier, and three distinct types of exhibition now existed side by side: major groups, individual artists, and exhibitions that did not have a specific "brand" affil-

iation.[73] The old art world with groups at its foundation had faded; critics and artists now discussed plans to create exhibitions that would unite artists from all contemporary art styles under one roof.[74]

The strained ties that developed between critics and artists were a sign that artists and art buyers were challenging the conventions of Russia's art culture as they bypassed traditional institutions during the war. Critics grew uncomfortable as the private art market flourished, new artists enjoyed material success, and wider sections of the population entered the art world. "Artists don't think about in whose hands their pictures fall," wrote one columnist, "they are only interested in the material side."[75] A writer in the newspaper *Moscow Broadsheet* (*Moskovskii listok*), for his part, warned artists not to "rob" ignorant refugee buyers.[76] In the *New Time*, Gerasim Magula argued that charity auctions degraded the overall quality of art production: "In wartime the number of art auctions has greatly increased. Often all sorts of useless junk were sold in them, finding buyers attracted by the 'fervor' of the auction 'game,' and from this point of view we must recognize that auctions are harmful."[77] Russia's prewar system of distinctive art groups, professional critics, and traditional collectors seemed to give way to open capitalism, hucksterism, and commercialism.

Conservative and modernist critics alike believed the new public threatened their professional role as arbiters of public taste. The word they used for market-oriented art, *shablon* (stencil or template), implied that it was a mass-produced artifact, not the inspired work of an individual artist. Established critics wanted to bolster the traditional powers and practices of the regular art world in a public environment that rewarded individuals, interlopers, and any artist who broke professional ranks. "The sale of paintings," sniffed a writer in *Apollo*, "doesn't prove that those works are artistic."[78] Exhibitions that catered to naive or ignorant buyers harmed the profession, one columnist claimed, because they took away the distinction between important and unimportant artists that critics wanted to uphold: "what type of audience [*publiku*] are these exhibitions count-

ing on? If the name of the artist says nothing to the public, then even if he is a genius, it is unlikely that someone will be interested in him outside a dozen good friends and acquaintances. The result—a loss."[79] The amusing stories about ignorant buyers that appeared in wartime art commentary were entertaining, but they also served to reaffirm the critic's professional position. Critics who characterized the wartime buying public as inexpert and ignorant hoped to discredit their ability to make market choices. "We already have spoken about those collectors who have bought paintings like wood or sugar," wrote one. "They, of course, know nothing about art."[80] Another recognized the threat from one external source of authority, the tabloid press and its critics, to warp the artistic taste of the public.[81] Liberal and conservative critics both called for artists to show restraint or lamented the market when it removed important paintings from public view.[82] All were powerless to prevent the destabilization of the art world, and its transformation, as artists reacted to new opportunities for professional support in the wartime boom.

Modernist "Capitulation" and the Reemergence of the Subject

During the First World War, elements of modernism faded from the Union of Russian Artists, and artists in the World of Art began to abandon their most esoteric aesthetic styles.[83] In 1915 the conservative critic Sergei Glagol celebrated this "obvious trend toward realism and clear, lush painting."[84] To him it seemed that "the war is everywhere creating a wave of great renovation. It is again turning art toward reality and its honest appreciation," even among the avant-garde.[85] The avant-garde artist Vera Pestel simply woke up one morning and felt like abandoning abstract art. "I will lock myself in the house and paint nature and won't exhibit," she wrote in 1916. "But what's the use? That would mean a complete break with the innovators. You've gone backwards, [Liubov] Popova would say."[86] Different pro-

fessional and personal experiences led artists to change their art, but a new need during wartime to reach outside the modernist milieu, or even outside the modernist self, was the context they shared. Feelings of patriotism and the wish to communicate ideas, personal expressions of homesickness or nostalgia, and desires to take advantage of a conservative art market all helped modern artists move toward more conventional or figurative art. Engagement with war caused a convergence of artistic form just as it had aligned professional art activity with broader civic activism.

The new art buyers who entered the market during the war years flexed their market power with conservative preferences. These new Medici, as they were sometimes derided in the press, bought all types of art but preferred landscapes and genre painting of an aesthetically conservative cast. In the words of one critic, the Academy and its associated groups were well equipped to supply these buyers with clear, simple, and "understandable" pictures.[87] Their conservative tastes eclipsed the work of modern artists.[88] The Spring Salon, for example, grew its sales more rapidly than the stagnating Union of Russian Artists, the most established highbrow Russian art group (see tables 1–4, graph 3).[89] The critic Paul Ettinger relished the new public's antimodernist taste: "They do not like the Sarians, Larionovs, and Kanchalovskiis [*sic*]. They like the Trofimenkos, the Arkhipovs, and all those who paint and 'see' like humans."[90] He interpreted the phenomenal success of an exhibition by the academic V. D. Orlovskii, which took in a large sum of about 50,000 rubles, as more proof that "the good past will always be in demand. New and ugly trends in paintings have sung their swan song."[91] The war even witnessed an increase in historicist and conservative tastes among traditional patrons and connoisseurs.[92]

The uncertain financial situation and new public opportunities to exhibit in charity exhibitions encouraged modernists to adopt a more traditional aesthetic. David Burliuk, one of the loudest prewar iconoclasts, is a clear example of how artists changed art to sell paintings in wartime. The art market was a powerful incentive to produce crowd-pleasing art,

and Burliuk began to paint portraits for wealthy customers. He produced such conventional paintings during the war that otherwise hostile critics could only be pleased. After visiting a charity exhibition, one admitted that "Mr. Burliuk surprised us. He has forgotten about affectations [*krivlian'iakh*] and painted a beautiful, powerful, sunny landscape that has nothing in common with his previous futurist performances."[93] Burliuk hoped to arrange a showing of his landscapes with a leading charity organizer. "If you see Vasilii Vasilevich Perepletchikov," Burliuk wrote to Andrei Shemshurin, "draw his attention (please) to the fact that I worked like an ox all summer. I have solid (real) sketches and ask the deeply respected Vasilii Vasilevich to fix me up somewhere."[94] Burliuk was so far from provocative art in 1916 that one critic found him unexpectedly "moderate and able" with his "kitschy, dry landscapes."[95]

Conservative groups did not rule the market, for World of Art artists experienced a sharp upswing in popularity during the war. Sales at their exhibitions seem to have been the fastest growing among the major art groups (see tables 5 and 6), and they caught up or overtook the Itinerants and the Union of Russian Artists in absolute terms. A sympathetic Aleksandr Rostislavov admitted that new buyers were not as muddleheaded as many modernist critics and artists had assumed.[96] Yet the market helped change the characteristics of art presented at World of Art exhibitions, as it did for Burliuk. In early 1916 the taste of frenzied art buyers at war-related exhibitions appalled the artist Konstantin Somov: "at the auction for refugees where I donated three things the prices were: 500 rubles for a marquise with a devil-shaped beauty spot, a monstrous price for such junk, a vignette of yellow roses 250! A study 150! All three trifles." He grudgingly obliged to sacrifice his artistic values after an art dealer wanted more "frivolous" works: "I gave up about twenty things that I should have burned. Sold my conscience for 600 rubles. Two or three were respectable."[97] The World of Art enjoyed stunning wartime success despite the predictions in the realist camp that the new market would destroy modernism. That

success emerged, however, from their ability to proffer art that was acceptable to the buying public.

There was also something in the air, a psychological aspect to this war, that led some artists to return to conventional aesthetics. War's stark and unpleasant reality challenged those at the front and the millions left at home to consider existential questions. Thinking about war fostered an atmosphere of sobriety and reflection. The writer Boris Zaitsev, for example, observed that his colleagues felt war's inner pressures, which led them to consider life more seriously and to feel tragedy with greater sensibility.[98] Traditional motifs allowed viewers and artists to comprehend the trauma of mass war and the mystery of mortality, and the presence of familiar classical, romantic, or religious images in the popular culture of the war in Europe attests to a universality of sorrow and bereavement.[99] Russians at all stations in life expressed feelings of nostalgia and grief through symbols that echoed the past in content and form. A saleswoman at a monastic bookshop linked the war to the popularity of pictures of the Last Judgment: "There is a great demand for this particular subject and the sale of this picture has gone up. The war is making people think of death."[100]

The war's emotional impact was important in changing the art of Marc Chagall. The young artist resided in Paris before the war but became trapped in his hometown, Vitebsk, while visiting family in the summer of 1914. There he began to drop the cubist and expressionist leanings of his Parisian work for a series of pictures that used more conventional perspective, color, and composition.[101] The critic Fannina Halle later observed that Chagall's work became "somewhat more accessible [*greifbarer*], clearer, quieter" in wartime. She explained this shift in "the joy of the Prodigal Son," home again after a long separation.[102] The great conflict itself attracted his eye and inspired him to engage war through his art. In a striking series of ink sketches, the artist memorialized wounded soldiers whom he saw around him (figure 18). Iakov Tugendkhold, Chagall's first critical cham-

18. M. Chagall. *Wounded Soldier*. 1914. India ink and pen on paper, 22.3 × 17.2 cm. State Tretyakov Gallery, Moscow.

pion in Russia, suggested that these images captured the war's modernity better than other modern art because of the tremendous emotion that they communicated. "Chagall's soldiers," wrote Tugendkhold, "his 'war' works, may not please, but they are precious because he feels the face of humanity when other artists praise iron and wooden beauty."[103] In Vitebsk Chagall's art literally helped him to protect the Jews of his home town from the war: "I longed to put them down on my canvases, to get them out of harm's way." After Chagall went to Petrograd, the war, through his imagination, continued to influence his concentration and art. "Poison gases choked me even at Liteiny Prospect 46, headquarters of my military bureau," he wrote in his autobiography. "My painting grew dull."[104]

Wassily Kandinsky's life and art also took a new course during the war, and the emotional and nostalgic experiences of an abrupt return emerged in his embrace of more traditional forms in painting.[105] Kandinsky felt disoriented and distracted in 1914 after his hasty flight from Germany,

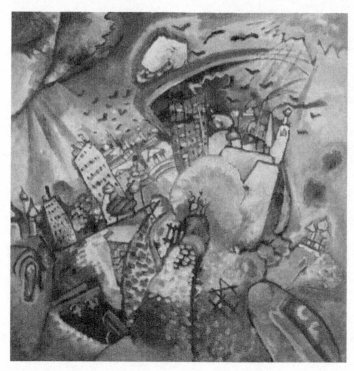

19. W. Kandinsky. *Moscow I.* 1916. Oil on canvas, 51.5 × 49.5 cm. State Tretyakov Gallery, Moscow.

where he had long resided, and he was so disturbed that he produced no major paintings at all in the war's first year. In Moscow his watercolors and sketches lost the highly abstract, improvised style he had developed before 1914.[106] Clear references to soldiers and war entered his paintings, while houses, churches, birds, and trees appear in works like *Moscow I* (figure 19).[107] After so many years abroad, Russia brought back memories of his youth, and youthful art, so strong that he almost forgot the generation to which he belonged.[108] A sentimental attraction for the homeland and the nostalgia for a former life strengthened the artist's desire to produce art that recreated both worlds, and he returned to styles that dominated his art in Russia before 1908.[109] In Kandinsky's case, a return to more figurative art was a way to stabilize a sudden instability in a personal life brought on by war. His wartime works betray a fundamental shift from

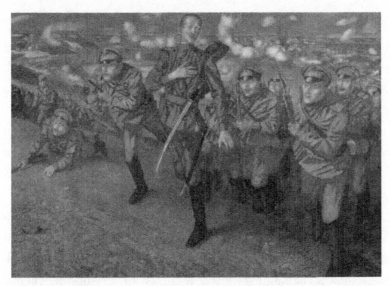

20. K. S. Petrov-Vodkin. *On the Line*. 1915–16. Oil on canvas, 196 × 275 cm. State Russian Museum, St. Petersburg.

the frenetic, turbulent composition of his early abstract improvisations toward geometry, more defined forms, and subdued harmony.[110]

A turn to narrative and figurative composition was required for modernists who hoped to communicate war stories to the broader, nonmodernist public. Kuzma Petrov-Vodkin was one of the few modern artists who attempted to paint the war directly. He recognized that the world crisis had sparked a return to a real-world theme for his monumental canvas *On the Line* (figure 20), which combined "'almost' real landscapes and 'almost' real figures but all in a kind of mystical poetry of heroism," according to one conservative critic.[111] "Maybe it is weak, maybe unconvincing," said the artist to explain his adoption of narrative, but visions of the external world had inspired his art: "I only had this sincere wish to paint exactly this picture. I saw in Samara how the echelons left for war and felt the indestructible, black earth Russian power, a force bashful, not knowing itself, and unbounded."[112] In this way, *On the Line* represents a sharp break with the prewar "realist symbolism" of *Bathing a Red Horse* (figure 10), despite the artist's cryptic assertion that *Bathing a Red Horse* was

painted "exactly" for the moment of social unity created at the beginning of the war.[113] It fit much better the iconography of patriotic culture with its clear story: as Russian infantry struggle to advance over a small hill, a young soldier in the lead is shot (bloodlessly) in the chest as the shells fly and fires burn in the background (compare with figure 12). Petrov-Vodkin wanted to tell of the bravery, perseverance, and heroic sacrifice of Russian soldiers in the face of great power. A more direct style was needed for this painting of war to reach viewers.[114]

The response to *On the Line* shows that the artist's foray into more conventional narrative did not match the expectations of the World of Art and suggests that the intended audience for the painting was outside the modernist milieu. The painting was a clear break with the World of Art's disdain for narrative paintings and sociopolitical engagement in art, and the criticism it evoked was a form of "iron discipline" from a group seeking to uphold its aesthetic consistency and values as one member moved beyond its boundaries.[115] Reports surfaced that the painter had trouble getting the canvas into World of Art exhibitions.[116] Alexandre Benois and others, including Petrov-Vodkin's friends and associates, criticized the painting; Somov attacked *On the Line* so harshly in private that Petrov-Vodkin felt "it would be better now to shoot or hang me."[117] Benois and Somov, both consistent opponents of the war, objected not only to the painting's content (open patriotism) but also to its form (a narrative portrayal of current events). Conservative and antimodernist critics, who supported both goals, noted Petrov-Vodkin's dilemma and reveled in the modernists' discomfort with their "realist" backslider and his "patriotic" painting.[118]

The trend toward more narrative and less abstraction in modernist art emerged from artists' need to engage a public environment changed by war. Realist artists employed narrative to help them tell visual stories, and they used widely understood symbols, common iconography, and familiar composition to control meaning. Modern art, as it became more abstract, invited multiple meanings and multiple interpretations. Its ambiguous

form, unfamiliar visual language, and arcane symbols were often incomprehensible to those uninitiated in its culture, and the uninitiated were the majority of people in Russia. Modern artists who wanted to communicate and connect with the general population had to conform to the expectations, taste, and understandings of art among audiences outside their customary milieu. When Pavel Filonov painted realistic portraits during the war, he did so certainly at the wish of patrons for "purely worldly reasons."[119] Whether modernist painters wanted to communicate grief, express patriotism, or sell paintings, they could reach the greatest number of people outside the modernist milieu only if they used artistic forms the audience could understand. Style and content changed to match new conditions inside a market distorted by war.

No Long-Awaited Renaissance:
Modern Warfare and the Failure of Aesthetic Realism

Many in Russia and in Europe expected the destructive war would cause a new Renaissance in art and a renovation of a moribund fin de siècle culture. But the turn by some Russian modernist artists toward more traditional forms did not mean that their realist competitors could claim the mantle of professional leadership in the art world. Material and intellectual obstacles, the contradictory expectations of the media, art world, and critics, and the taste of the market all worked to discourage realist artists from painting the war or developing new subject matter that would renovate cultural life. Strong demand for war art did not exist within the boundaries of the art world and remained weak in the broad public, especially after 1915. Painters who hoped to take advantage of the art boom returned to familiar styles, while war illustration flourished in the information media and public propaganda, not the art exhibition.[120] For frustrated advocates of realist, figurative, and conservative styles, Russia's finest artists turned away from war at a moment when it was the supreme reality in daily life. World War I thus contradicted the claims of realists that

their art was the only means to represent reality in modern times even as the war, ironically, encouraged their professional rivals, the modernists, to adopt more figurative and narrative styles.

Public propagandists, conservative critics, and populist journalists believed that realism, with its technical attention to detail and narrative bias, was the perfect aesthetic to immortalize the war in art. Art had to reflect life more than ever in wartime, and only Russia's realists could bring the war's true meaning to the Russian people. Artists, argued one critic, needed to educate the nation on the history of a great country, not waste time on boring paintings.[121] Only the artistic imagination could provide the inspiration and the variety of expression necessary to inspire the public to understand the war.[122] Photography, with its documentary detail and visual incidentals, could not provoke emotion like painting; war correspondence and documentary photographs lacked, as one commentator wrote, the "living image" that art provided.[123] In the eyes of many critics and commentators, a return to the realistic art of nineteenth century, reinvigorated by the dramatic war, was the logical way to prove the superiority of Russia's art traditions, bolster the war effort, and unite the nation. One critic pointed out that careful technique in composition and design was necessary for the proper representation of reality in war art. "Impressions, dabs, and colors alone," he wrote, "will not get you far."[124] L. R. Sologub, an artist and architect who decided to travel to the front, suggested that life there was the best training an artist could have.[125]

Artists and critics all over Europe soon discovered that artists did not want to paint the Great War. In Germany, artists worked on a few war paintings but soon returned to conventional themes, while critics complained that the war produced no good art.[126] In Britain, the war, on the whole, did not inspire many artists or writers, and war genre remained a tiny portion of painting in the Royal Academy.[127] In Russia, the exhibitions of aesthetically conservative groups like the Spring Salon, the Itinerants, the Academy graduation class, and the Petrograd Society of Artists

contained few war paintings in 1915.[128] The Union of Russian Artists and the World of Art also showed little interest in the war as a subject of art, and in 1916 only ten or fifteen of five hundred Salon paintings reflected "contemporary life" (less than 3 percent).[129] Artists were clearly avoiding the war as a subject. One reviewer discovered only a single war painting (V. E. Makovskii's *The Germans Have Gone*) at an Itinerants exhibition, and he was confused and perplexed by this lack of interest. "The situation is strange," he wondered. "Our disturbing days have had almost no influence on artists."[130]

Some critics and artists argued that artists had no business painting war. Art for them was a contemplative exercise that should not reflect the everyday, the immediate, or the material. Inside the art world there was little intellectual justification for war art, and artists who worked in milieus where these ideas were widespread were encouraged to avoid it. "Past art shows," wrote Alexandre Benois, expressing sentiments he repeated often, "that war was not useful for artistic creation but simply alien to art."[131] Others suggested that the great art of the Great War would not come during the war itself but in peacetime, as it had with Leo Tolstoy's *War and Peace*, written decades after the events of 1812. Artists, they suggested, had to create for "all time," not for the moment, and good painting required time and concentration.[132] From this perspective, there was no reason to paint the war or any other current event.

Artists found it impossible to depict the war because material problems hindered their ability to work directly from nature. To satisfy realist critics, artists had to visit the front if they wanted to paint the war, but many factors made such trips difficult. Government bureaucracy and regulation restricted movement to combat zones. Arkadii Rylov tried but failed to reach the front and gathered no material for a planned war painting.[133] Long-range artillery, devastated battlefields, and mass violence presented extraordinary problems for the artist. To make sketches or take photographs, painters had to approach the scene without getting killed, not

easy in an age of machine guns and trench warfare. At the front, distances were great, colors were muddled, and human subjects were far away. Artists had difficulty observing battle; many relied on news reports and visits to rear areas to get around the war's physical obstacles.[134] The war painter Mazurovskii admitted that the real war did not provide good material. "In battle nobody thinks about drawing," he said. "There is literally nothing left to paint when it is over."[135]

Painting the war, moreover, threatened to destroy the aesthetic values that shaped the boundaries of the art profession. Conventional artists could not depict the routine, everyday war and uphold the important distinctions between art and mass illustration. War artists were expected to reflect contemporary reality and create representations that were by definition the product of fantasy and imagination. They had to make convincing, realistic war images if they wanted to stay true to public expectations, yet when they were too detailed and too documentary, disappointed critics argued that they undermined the sublime wonder of the artistic imagination. Easel painters and poster artists whose work approached illustration therefore suffered intense criticism from art critics and colleagues. "The narrow treatment of war of artist-moralists," complained Gerasim Magula in 1915, "that great effort of physical and spiritual human power, has killed war's idealistic side, its poetry, and led only to a depiction of bloody paintings, grief and suffering, and murder and destruction."[136] Realists who attempted to depict the war had their paintings condemned as phony, irrelevant, or just plain bad. Rostislavov poked fun at the war artist wannabes who presented work painted from a fake reality at the Spring Salon: "It is not difficult to copy Russian soldiers from the streets of Petrograd, and they get the Germans (usually in an unpleasant position) from illustrations."[137] War and art practice seemed impossible to reconcile within the boundaries of Russian art culture.

Public expectations were a serious impediment to direct, uncomplicated representations of war. The public in 1914 was much broader and

more diverse than the old official audience for war art. Painters could not use the conventions of traditional battle painting or the images of cheerful public patriotism to represent something that millions of people knew was destructive, violent, and ugly. "The battle art of the old Vilevald [*sic*] school," one critic argued, "is completely foreign to reality."[138] Machines and technology had replaced knightly honor and human deeds.[139] As Iakov Tugendkhold wrote in his 1916 book *The Problems of War in World Art*, modern war was no longer the heroic adventure that existed in conventional war painting.[140] Alexandre Benois pointed out in his review that modern perceptions of war, not material conditions, prevented artists from reproducing the war in art: "True, he [Tugendkhold] makes several common references to the 'non-painterliness' of modern war—to the remoteness of the participants from each another, the lack of clear coloration in military uniforms, the lack of beautiful cloudiness with gunpowder smoke. I am convinced he knows that all these causes are not the real ones and not the decisive reasons. There are others indeed. They turn the 'emotions of war' into a choking nightmare."[141] A prominent pedagogue and psychologist put it more pointedly when she wrote that "the victories of poison gas and large artillery shells, with their bloody fountains of human bodies torn apart and thrown into the air, do not cry out to be painted."[142]

Artists who hoped to serve the private art market had to match the public's expectation that art should provide an escape from war, not represent it. Private art buyers did not want war paintings that depicted events that were too close to home.[143] Instead, they sought beauty in art to avoid turbulent times.[144] People could escape war's hideous reality through artistic contemplation. One Polish refugee wept before a beautiful landscape in an art exhibition, her refuge from the outside world. "Blood, blood, everywhere blood," she cried, "*but here* it is so nice."[145] The World of Art artist Boris Kustodiev, from the artist's side, viewed painting as a "salvation" from depressing war news.[146] War genre and romantic images of war were

not attractive to an audience that demanded information about the war in the media but wanted to see beauty in the art exhibition.

The experience of Evgenii Lansere illustrates the material and intellectual difficulties an artist could face when trying to find a relevant war art for modern times. Lansere, an artist with close ties to the Union of Russian Artists and the World of Art, hoped to produce a sketch album to capture the "truth about war" while on a trip to the Caucasian front in late 1914 and early 1915.[147] "It should be necessary to record methodically everything as it happened factually," he wrote in his journal. "What I did, what I saw, and what I heard."[148] From the outset, he believed that traditional battle art could not capture the essence of modern warfare.[149] The artist spent most of his time, however, hanging about mountain fortresses, and the war he experienced, the routine between campaigns, did not correspond to the war in his imagination:

> It disturbs me that I myself have "experienced" very little. I confess I want very much to have some kind of adventure. Want to simply fall "for a minute" under fire. And I must see, besides "the everyday," more "events" for the sake of my album, which I am thinking about more and more. It's beginning to become clear to me that what earlier seemed enough for the album, local characters and scenes, is not enough. I need the so-called "horrors of war": the burning, the bodies, the war's seriousness. But as before I am far from "battle paintings."

Lansere returned to Petrograd with sketches of Caucasian folk types, mountains, and fortifications, which he presented at a special exhibition in April 1915, but Alexandre Benois, though a friend and relation, argued that they proved only that war art was pointless: "even such a wonderful collection of documents . . . does not resolve my doubts: is it possible to expect fruitful artistic activity from war?"[150] Lansere could not find a way to produce an artistic, yet still true-to-life, representation of the reality of war that would

please him and the World of Art milieu; he succeeded in "satisfying the passionate, excited interest of society for all kinds of fresh impressions of war," but the artistic tasks related to war remained unsolved.[151]

Realist standards were so high that even Ilia Repin, Russia's premier realist painter, fell short. Repin's supporters and detractors alike ridiculed his war-related paintings *King Albert* (1914) and *Attack with Nurse Ivanova* (1915). Some boulevard papers and conservative critics praised Repin's work, but many panned the master's naive, unskilled, and unrealistic attempts at war painting. *Nurse Ivanova*, wrote one critic, was "the worst canvas at the whole exhibition. A dry, official report of Nurse Ivanova's death."[152] Repin failed, in the critical eye, because the artist could not resolve a tension between the need to make propaganda yet still impart a realistic view of the war. He tried to use Albert and Ivanova as symbols but also wanted them to be accepted as real.[153] The blend of figurative style and symbolic representation in *Barge Haulers* (figure 3) were a hit in the politicized intelligentsia culture of the 1870s, but when Repin tried to engage patriotism, critics, and the art world during the war years, public culture was so different and complex that the task was impossible. In the end he failed to please almost anyone.

Final proof that the war was unrepresentable in realist art under the public conditions of World War I was the utter failure of professional battle painters. The official public remained undermobilized in 1914, and the state appears to have commissioned little, if any, war art. War artists showed their work at the Petrograd Watercolor Society, the Petrograd Society of Artists, and small personal exhibitions, but most critics panned their work. "Kravchenko is an artist of the battle, an artist of blood," wrote one. "Most of his things are battles, echoes of battle, and the hunt. But in essence they are not his real calling. Here he gives journalism its due."[154] Vladimirov's war was defective because it did not show war's true face. "The war is felt," wrote a commentator, praising the artist's talent but lamenting his hasty and superficial illustrations, "but its drama and its hor-

ror are unnoticed by the artist. He quickly trotted off to the front, saw a lot of pictures and scenes, but the horror, the horror of this inhuman war he did not notice."[155] Critics ridiculed the Academy's battle-painting class, which painted cows instead of war. "Somehow it doesn't ring true that you are living during the European war!" exclaimed one boulevard writer in despair. "Why is there a battle art studio if they paint everything there except 'battle'?"[156] They were amazed that Mazurovskii's major work in 1916 was *Tango*.[157] One writer judged it better than his war art.[158]

If aesthetic modernism appeared to be in formal retreat during the war years, aesthetic realism did not emerge victorious. The wartime festival for art diverted artists in all milieus away from prewar practices to meet the demands of the war and the wartime public. In 1915 Vladimir Denisov, an artist, critic, and caricaturist with an interest in popular visual culture, made the widely held case that a wartime cultural revival would destroy Russian modernism. The "great exertion of all forces that the country feels in the great world struggle" was a great, cleansing force for change in the culture and psychology of the Russian people. "It is natural to assume that some type of sharp change [*sdvig*] will occur in art," he wrote. "Aren't these the notes of the long-awaited renaissance?" For him, a new art would replace the moribund practices and ideas of modern aestheticism. "Obviously the war is producing a great change in our consciousness," he explained. "Before our eyes the ordeal is rejuvenating and sanitizing many aspects of Russian life. Our artists, even those stuck in soulless aestheticism, will get a new, healthier, and more living creative impulse."[159] But Denisov warned that Russian art culture was stagnant and derivative. No living school, not even the realists, could provide the basis for a national renaissance. Aesthetic conservatives, if they followed Denisov's argument, could not assume that conventional realism would emerge as the dominant aesthetic. In the end, only the avant-garde found a way to make an art that could represent modern reality. They did so by making art represent nothing but itself.

4. Masters of the Material World

*World War I, the Avant-Garde, and
the Origins of Non-Objective Art*

Kazimir Malevich's *Black Square* (figure 1) and Vladimir Tatlin's *Corner Counter-Relief* (figure 21), today recognized as great achievements of European modernism, were created in an intellectual and institutional environment made unstable by war. Before 1914 the avant-garde used rhetorical confrontation, unorthodox public behavior, and unconventional art to mobilize a new artistic culture, but they also sought recognition and status in an art world that isolated them from the profession. This position changed when World War I opened public culture, for professional unity seemed real as an overarching public mobilization brought together antagonistic artistic milieus. Radical artists joined the country's culture of war and revealed their willingness to cooperate with society: they seemed to abandon their antagonism toward the public, attempted to enter conventional institutions, and participated in the propaganda war. At the same time, the war destabilized the avant-garde's prewar public culture and unleashed a scramble to find a new basis to justify radical art. The creation of non-objective art in Russia was linked to this search for order; its form and meaning were defined as radical artists tried to bolster their status, invigorate an avant-garde milieu, and proclaim their contributions to Russian culture inside a mobilized civil society.

The invention of non-objective art was a striking moment in the intellectual history of Europe because it marked the abandonment of several

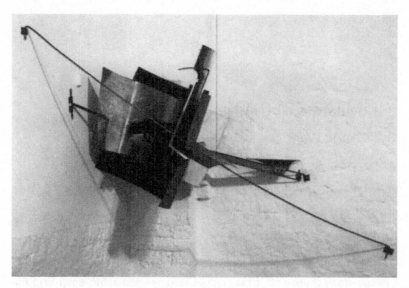

21. V. E. Tatlin. *Corner Counter-Relief.* 1915. Reconstruction no. 5 (edition of five), 1982, by Martyn Chalk. Paint, iron, aluminum, and zinc, 78.8 × 152.4 × 76.2 cm. Courtesy of Annely Juda Fine Art, London, and the artist.

hundred years of aesthetic theory that defined art as representation. The non-objective artist dissolved conventional distinctions between "art," an object created to represent something outside itself, and "artifact," an object created to exist as itself. Yet the steps toward this new art have long remained obscure, despite its importance in the history of European intellectual life.[1] Formalist art critics have generally understood Tatlin and Malevich to be part of a century-long European project to reach the absolute in art, that is, to shed all non-artistic elements from the process of artistic creation, while contextualist art historians have located the origins of the *Black Square* in Malevich's fin de siècle spiritualism, interest in other dimensions, and quest to realize the intuitive.[2] There has been little specific contextualization of Tatlin's counter-reliefs, and no explanation for the simultaneous development of non-objectivity by Malevich and Tatlin in the midst of World War I. While no one can say for sure that the *Black Square* would not have existed without the war, the reaction of Malevich, Tatlin, and other avant-garde artists to the wartime changes in

civil society and public culture had important implications for the formal development of the new art and, even more, for the intellectual justifications behind its creation. The appearance of non-objective art in Imperial Russia, as it actually happened, cannot be separated from World War I and its culture of war.

Working Assiduously: The Avant-Garde and the Profession before 1914

The relationship of the avant-garde milieu to the art world and broader society remained uncertain before 1914. On the one hand, radical artists cultivated an artistic culture where hostility, iconoclasm, and disdain toward other artists were normalized. Some, like Mikhail Larionov, appear to have had consistent aims to challenge the established political, social, and cultural order.[3] Others, like Kazimir Malevich, seem to have focused on the maintenance of their individual aesthetic goals with a Nietzschean disdain toward society. Yet many, including Vladimir Tatlin, had aspirations to become professionals inside the art world, to be taken seriously as talented artists with sophisticated aesthetic values, and they faced the same problem all Russian painters faced: the artist's need to be free yet have an institutional framework to mediate between individual and public.[4] The avant-garde struggled for years to build the art culture of the future, but they had to operate inside the existing public sphere to communicate their ideas to people outside the milieu. They never found a way to resolve this contradiction before the war, and their continual attempts to mobilize a new public for their art intensified the conflict, instability, and incoherence characteristic in their milieu.

Radical artists, of course, publicly sought to subvert art institutions and attack conventional values, yet their behavior fit well into the traditions of the very art culture they rejected. The hope of the avant-garde to destabilize mainstream art and art institutions, deny the aesthetic claims and institutional legitimacy of established groups, and build a new public

were all strategies that furthered their professional interests. Outrageous public behavior, unconventional art, and iconoclastic speech actually betray the importance that futurists placed on interaction with the public; these acts served to distinguish radical artists from other groups, attract new or existing audiences for art, and build a space for radical art inside the public sphere. The avant-garde's face-painting, for example, existed for the street; its purpose was to provoke passersby, attract publicity, and demonstrate unconventionality. As Mikhail Larionov and Ilia Zdanevich explained to the middlebrow readership of the journal *Argus* in 1913, "The painting of our faces is neither an absurd piece of fiction, nor a relapse—it is indissolubly linked to the character of our life and of our trade."[5] The avant-garde's public rhetoric of iconoclasm and hostility toward received culture obscured the reality that many maintained strong ambitions to engage the public and access markets, art groups, and museums.

Many avant-garde artists in Russia sought professional success inside the existing art world, and their individual behavior and private aspirations sometimes contradicted the public culture of their avant-garde milieu. If Larionov, according to one colleague, was not a "mercantilist" who made business the definition of success in his artistic career, Tatlin, according to another, showed a distinctly "commercial character," planning lectures and events with an eye toward income.[6] Tatlin was one of the country's most aesthetically radical artists, but he was also one of its most ambitious. In 1913 he wrote a polite letter to Alexandre Benois and promised to follow the discipline of the World of Art group "with pleasure" if they let him participate: "I wanted to tell you that, if my paintings as well as my drawings should be accepted for the World of Art, I'd like to join the World of Art societies on the usual conditions, i.e. I should not take part in other exhibitions."[7] Nadezhda Udaltsova documented in her diary their common intent to reach the art public: "At the moment Tatlin and I are trying to make a reputation for ourselves and to attract serious critics. We have a journal that has already reviewed Tatlin's work."[8] Other

avant-garde artists were happy when critics noticed them. Aleksandr Osmerkin equated such recognition with professional success when he looked back to the beginning of his career: "I was noticed in the press and recognized as an artist."[9] Burliuk found it "especially gratifying" when "so important a figure and writer as Maxim Gorky" wrote an article that treated the futurists with sympathy.[10]

The appearance of nationalist values in avant-garde art discourse shows that radical artists followed important trends in surrounding society despite their anti-establishment stance. A concern with national traditions was a fundamental component of public life in the early-twentieth-century Russian art world; like other artists, the avant-garde did not, and could not, deny nationality's importance in art without facing scorn from critics and journalists.[11] The poet Benedikt Livshits made clear that avant-garde nationalism was necessary to demonstrate their professional credentials to the public: "The Russian Cubists, who occupied the dominant position in the Knave of Diamonds, decided to prove that they were not upstarts in art, that they had ancestors, a genealogy and that, if needed, they could also present their passport for inspection."[12] The offbeat genealogies that the avant-garde created for their art thus served to show that it was not new at all but part of a legitimate, if different, Russian past.[13] Such a national pedigree was necessary for legitimacy in a public culture that greatly prized nationality; the symbolist writer Georgii Chulkov still stigmatized cubism as a demonic French art in early 1914.[14] When Natalia Goncharova distanced her work from the West she was able to "neutralize—even reverse—the critical prejudice that cast Russian art as a failed mimesis of Western (French) modernism."[15] An emphasis on non-European nationality could also validate avant-garde art as a contribution to the profession and to Russian cultural life. Larionov, Goncharova, and others presented their alternative nationalism as a cultural improvement in 1913: "Long live nationality! . . . We are against the West, which is vul-

garizing our forms and Eastern forms, and which is bringing down the level of everything."[16]

Most artists in the Russian avant-garde were, in the end, not much different from other art groups in Russia or their counterparts in Europe, whose alienation from society, as Robert Jensen has put it, was, "at least as far as the market was concerned, largely a fiction that served rather than denied the commodification of art."[17] Most had some formal training, whether from the Academy, the Moscow School of Painting, Sculpture, and Architecture, or private teachers, and many were skilled in conventional technique. Some studied face-to-face with the established artists whom they professed to detest in public. Leonid Pasternak, a professor at the Moscow School of Painting (and father of the young futurist poet Boris Pasternak), noted this paradox as he watched Burliuk, the public iconoclast, work hard to learn his profession inside the Moscow School. "Who could have believed," he recalled, "that D. Burlyuk, after giving his Petersburg lecture in which he vilified utterly the reputations of Pushkin, Tolstoy, Raphael, Repin and Serov, returned to Moscow to take up his place again in my life-drawing class, where he worked assiduously, if unsuccessfully, to finish his study of a model."[18] Ordinary folk and students may have attended futurist lectures and exhibitions, but radical artists sought material support from the middle- and upper-class buyers familiar to the art world. The organizers of the first Jack of Diamonds exhibition in 1910, for example, recruited S. A. Lobachev, a rich collector with "a fortune of twenty million," to bankroll the project.[19] Petrov-Vodkin, a member of the World of Art, remembered how the avant-garde's culture of opposition conflicted with their personal wishes to participate in the World of Art: "The modernist youth griped at those exhibitions, secretly hoping to enter their walls."[20]

Before the war the tension between the desire to create a new public but accept the old was not resolved in the avant-garde milieu. Radical artists sought public recognition; they just wanted to be recognized as profes-

sional artists on their own terms, and aesthetic revolution was part of their public speech, but it was not a goal in itself for those artists who wanted their art to be recognized as legitimate. Did the avant-garde want to destroy the existing art world, or did they want to join it? Perhaps they themselves were not sure. In a certain sense, the question is moot because radical artists seemed to be unwilling to join mainstream society, and most people in the mainstream public and art culture rejected them and their art. The intense public fear of the avant-garde and modernism generally among the newly educated and the urban population shows the power of the modernist threat to prevailing values in a time of social insecurity and unstable personal identities.[21] This lack of synchronization between the culture of the avant-garde and the broader public culture was reduced in wartime as radical artists became caught up in war patriotism, tried to enter mainstream culture, and self-mobilized alongside the rest of civil society. World War I was an important moment in the history of the Russian avant-garde movement because it helped clarify the uncertain place of the avant-garde in public culture.

The Amusing Masquerade:
The Avant-Garde Joins In, 1914–1915

The integration of radical modernism into Russian public life began in August 1914 as war changed the attitude of the avant-garde toward public action. Wartime public culture, with its public patriotism, expectations for charity work, and new institutions, opened the door (in some cases literally) to new professional opportunities. In reaction, radical modernists decided to participate in broader art institutions and public mobilization. The distance between avant-garde culture and the public contracted as the avant-garde dropped its alternative, anti-Western nationalism in favor of more conventional patriotism and sought to join war charities and patriotic exhibitions. Mobilization in civil society during the war aligned the small avant-garde milieu, as it did so many others, with the concerns of

the wider public sphere, and in reaction the avant-garde shed much of the public antagonism toward conventional life and traditional culture that they had expressed before 1914.

Modern artists, in some respects, were more subject to mass mobilization than others. Young artists did not enlist in the army en masse, but neither did they, as a group, evade conscription more than their peers: deferments or light duty were easier to get for the educated, well connected, or politically unreliable. Many served at the front, including Pavel Filonov, Mikhail Larionov, Aleksandr Shevchenko, Petr Konchalovskii, Georgii Iakulov, Vasilii Rozhdestvenskii, Aleksandr Osmerkin, and Mikhail Le-Dantiu.[22] Others, including Marc Chagall, Velimir Khlebnikov, Pavel Kuznetsov, and Kazimir Malevich, got desk jobs or were posted in rear areas. Alexandre Benois and some in World of Art circles were consistently against the war on principle, but they remained a minority inside the milieu, while nationalism and patriotism were common in avant-garde and futurist circles in 1914. Like their European counterparts or Russian contemporaries, most supported the war, accepted its inevitability, or acquiesced to its prosecution. At his conscription, the cubist Kliment Redko thought only of war and himself, not art, as he pondered his fate: "time to forget my brush and take up arms. Just not in the infantry. Aviation! I want to be a pilot."[23] Mikhail Larionov "was very happy and enthusiastic [*bodr*]" when he left for the front. "See you in Berlin!" he told fellow conscripts.[24]

The wartime atmosphere of patriotism and mass mobilization in 1914 opened a window of opportunity for the avant-garde in public culture. Previously marginalized art suddenly became acceptable; one critic could tolerate bad art at a charity just for the sake of the war effort: "Only the charitable goal allows one to reconcile oneself with that slightly irritating genre where each artist tries to top the other in copying this or that antiquity or primitive."[25] Public space opened for female artists as the first women architects were credentialed, the first exhibition of the Society of

Women Artists took place (it was a charity), and the Academy of Arts admitted female members.[26] In 1914 several newspapers dropped their public attacks on futurism after Larionov and Georgii Iakulov were wounded at the front.[27] The publication of their military portraits in several newspapers visually placed these previously ridiculed artists on the same level as others wounded in fulfillment of their civic duty. "In peacetime they used to call you and me crazy, mentally ill," wrote the futurist poet Velimir Khlebnikov sarcastically to a friend in mid-1916, "as a result most government jobs were closed to us. But now in wartime, when every action is especially crucial, I become a full-fledged citizen."[28] Avant-garde artists argued that their patriotism and military service obligated wider society to accept them. Pavel Filonov insisted that modern artists take their rightful place in Russian public culture: "Now is the time for the new art. Our time! Demand places in museums. We have won [*zavoevali*] the right to hang in museums next to the venerable and we will not yield it."[29]

A startling about-face came from David Burliuk, one of the fiercest of the prewar iconoclasts, who suddenly preached aesthetic tolerance and public engagement. Burliuk jumped on the Sacred Union bandwagon when he argued for a united artistic front in early 1915. In an article entitled "From Now On I Refuse to Speak Ill Even of the Work of Fools," he suggested that a loyal avant-garde would participate in mainstream public life to strengthen Russian culture during the great conflict. Patriotism was perhaps a motivation for Burliuk to publish this article, but he also suggested that Russia would need the avant-garde's professional help to win victory. "After all the confusion—*necessary, invigorating*," he wrote, "Russia, Great Russia will need (and this has already begun), a sufficient quantity of Culture, as well as a 'dense railroad network.'"[30] The futurists belonged to Russian culture, and Burliuk volunteered them for service in common cause against the enemy, but in return the public was obligated to accept them. "Oh, public!" he exclaimed, "oh, crucible of fireproof china! You, too, can be fairer in a more conscious way. Love art! Love complete artistic free-

dom. . . . *Do not fear the original*."[31] Burliuk, like many others in the avant-garde, expected to receive professional recognition in exchange for participation in broader public life.

In some respects the avant-garde was successful in gaining respect in the art world as boundaries between factions blurred. Artists from the Jack of Diamonds group started to creep into the World of Art milieu, and critics and commentators noted that the sharp edge between futurists and "former decadents" began to disappear.[32] Natalia Goncharova seems to have joined the World of Art formally during the war, while liberal critics began to recognize redeeming qualities in the futurist milieu, a trend that was weak before 1914.[33] The Jack of Diamonds gained respectability and praise from formerly hostile critics, and Udaltsova noted that the futurists received strong press criticism in early 1915 but more serious treatment a year later.[34] An important symbol of aesthetic reconciliation was itself an institution of mobilization: the 1915 literary anthology *The Archer* (*Strelets*), a collaborative effort of futurists and symbolist writers to raise money for charity. For Burliuk, *The Archer* represented the literary establishment's official recognition of futurism: "They accepted us," he wrote, "they have agreed and are agreeing to listen to us."[35] Contemporaries and later critics agree that 1915 was the year futurism was recognized in the world of literature.[36]

Avant-garde war charity activity demonstrates that radical artists remained engaged in public mobilization throughout the war. Artists in the Jack of Diamonds group contemplated their own charity exhibition in 1914, while Goncharova showed her work alongside conventional artists at an exhibition for Belgian charities.[37] Ilia Mashkov, Natalia Goncharova, and Pavel Kuznetsov were all part of a charity exhibition in 1915, and Malevich and Tatlin showed work at a charity exhibition of theater design in December.[38] Almost all the famous wartime avant-garde exhibitions supposedly donated proceeds to charity. Artists at the First Futurist Exhibition Streetcar V in April 1915 gave entrance proceeds to the Artist's Hospital,

almost thirteen hundred rubles.[39] Organizers of the Last Futurist Exhibition 0.10 in December 1915, where Malevich first showed the *Black Square*, promised to send 50 percent of the door to charity.[40] Participants at a suprematist lecture in January 1916 donated 25 percent to charity.[41] Public pressure made it unacceptable for artists not to raise money for charity. The critic Sergei Glagol was disturbed to find no mention of donations in the catalog for the avant-garde exhibition called "1915" and publicly chastised its organizers.[42] It is unknown, of course, how much of this money reached its stated destination, but the fact that these artists felt obliged to advertise their participation shows that they had no problem altering their public behavior to match broader expectations.

This public enlistment was an act of patriotism and enlightened self-interest, for it allowed radical modernists to participate in mainstream art culture. In December 1914 Vladimir Tatlin called for a special avant-garde exhibition of war images. He described his high hopes that artists could overcome prewar divisions to build artistic unity, suggesting that the avant-garde had always sought to be an accepted part of the conventional art world but felt frustrated when blocked from major professional institutions. For Tatlin, the war offered a new way for the avant-garde to access conventional art institutions. "It has been my constant aspiration, my dream," he declared, "to find a way out of the present unhappy artistic reality and into new conditions of artistic life by uniting artists of all directions into a harmonious family, bound together by mutual respect on the basis of its service to art. When you realize that over 40 percent are not accepted for exhibitions and thrown overboard, it becomes clear why such resentment and impatience reign amongst artists."[43] Critics expressed wonder at the juxtaposition of radical artists showing paintings next to their aesthetic antagonists at special exhibitions and war charities. The 1915 exhibition Artists for Their Comrades-in-Arms, which united futurists with aesthetic conservatives, was, in one writer's eyes, "an amusing masquerade that left the public very puzzled."[44]

Tatlin tested the limits of tolerance in the first wartime art season, when new institutions gave him the chance to bring his work to a major exhibition and wider public for the first time in his career. The ensuing scandal shows how the avant-garde could use the new institutions and atmosphere of patriotic mobilization to integrate radical art into the conventional art world. In early 1914 Tatlin was working on "painterly reliefs" (*zhivopisnye rel'efy*), three-dimensional collages made from wood, nails, and everyday materials attached to picture frames. He decided to use the large charity exhibition Moscow Artists for Victims of War to present this radical art in a broader public forum. Several members of the World of Art had apparently invited him to join the exhibition, but the organizing committee did not know exactly what he planned to display when he showed up with painterly reliefs under his arm.[45] Vasilii Perepletchikov, who was on the committee, found out and ordered the reliefs removed. Tatlin responded that he had a right to exhibit and, in retaliation, removed a Perepletchikov painting from the wall. Public pressure helped reinstate Tatlin's work, as one newspaper reported: "the exhibition artists and many of the audience [*publiki*] intervened, and the majority took Tatlin's side."[46] Patriotic unity, the good cause of charity, and public expectations meant that even the most radical art could not be excluded from the war effort.

Avant-garde war painting, moreover, dissolved aesthetic boundaries between radical modernism and the rest of public culture during the war. The poet Vladimir Maiakovskii directly equated mass militarization, mobilization, and futurism in 1915: "Today, everyone is a Futurist. The entire nation is Futurist. FUTURISM HAS *SEIZED* RUSSIA IN A DEATH GRIP."[47] Avant-garde war art witnessed a turn toward representing social themes in art because war was part of the daily reality that touched their lives.[48] Some artists adopted war themes because they were stationed at the front; comrades would ask them to paint the war, or they painted just to pass the time. Others integrated popular media into their wartime art. Larionov made a "war toy" that represented "an iron battle" when he "took a board,

glued pieces of war maps, candy wrappers, and national flags to it, forti-
fied it with a child's toy fort and black sticks symbolizing cannons, and
installed a bloody river and mountains."[49] Olga Rozanova, for her part, il-
lustrated Aleksei Kruchenykh's 1915 poetry collection *War* (*Voina*) with
designs that incorporated newspaper captions describing German atroc-
ities.[50] Goncharova's apocalyptic *Mystical Images of War* resembled tradi-
tional prints (*lubki*), complete with angels and allegorical figures herald-
ing Russian soldiers into battle to face their grim fate.[51] Other avant-garde
artists created more conventional war art that fit the romantic, unrealis-
tic imagery of the patriotic war culture that surrounded them.[52] Aristarkh
Lentulov, for example, painted several cubist-influenced canvases with na-
tional themes in 1914; one depicted the tsar as a war leader charging into
battle. Avant-garde art, perhaps, could represent war's physical and psy-
chological fragmentation, juxtaposition, and discontinuity more realis-
tically than conventional aesthetics.[53]

The world war had a great impact on Kazimir Malevich and his work.[54]
Violence and destruction pepper the artist's writings, apocalyptic notes
fill his manifestos, letters, and poems, and his art is filled with references
to combat and battle. His "alogical" (*zaum*) paintings *Englishman in Mos-
cow* (figure 9) and *Soldier of the First Division* contain clear military refer-
ences, including swords, cannons, and bayonets.[55] One sign that Malev-
ich may have painted *Englishman in Moscow* at the beginning of the war
(the precise dating is uncertain) is the phrase "Partial Eclipse of the Sun"
scattered across the painting. Critics have interpreted these words to be
a satirical reference to symbolist aesthetes, for whom the sun was an im-
portant representation of the eternal, but it could also be a reference to
the solar eclipse that took place in Moscow on August 8, 1914 (August 21,
New Style), an event that filled the papers and brought part of the east-
ern front into darkness. "Englishmen in Moscow," moreover, was a head-
line in the edition of the illustrated weekly *Sparks* (*Iskry*) that reported on
the assassination of Franz Ferdinand on June 22, 1914.[56] Such "alogical"

paintings might also represent the war's destruction through their frag-
mentation of the painting's subject, scattering of material culture across
their surfaces, and overt references to conflict; that is, they could be, as
one art historian writes, the visual fulfillment of Maiakovskii's quip that
"one may not write about war, but one must write with war."[57] Malevich's
sketches for a new production of the futurist opera *Victory over the Sun* are
clearer examples of how the war militarized his work. The 1915 version of
his design for the "Futurist Power Man" carries a new implement, an artil-
lery shell, and seems more hardened and mechanistic than its 1913 counter-
part.[58] These examples suggest that Malevich's early wartime works were
probably not ironic, antiwar representations; they certainly demonstrate
that the culture of war directly infiltrated his life and work.

The Today's Lubok (Segodniashnii lubok) venture marked the avant-
garde's greatest absorption into the public culture and visual language
of war patriotism. In late 1914 Maiakovskii, Iakulov, Malevich, Lentulov,
and other avant-garde artists created a series of popular prints and post-
cards that were among the most violent, jingoistic, and anti-German im-
ages produced by any group of Russian artists (figure 22). These prints,
with their boisterous emotions, catchy rhymes, and dramatic action, de-
viated strongly from traditional woodcut *lubki*, the popular combat lith-
ographs that were also called *lubki* (compare figure 22 to figure 12), or im-
ages designed to replicate early nineteenth-century style (compare figure
22 to figure 15). Instead, Today's Lubok prints were almost indistinguish-
able in composition, style, and text from commercial cartoons and cari-
catures, even those created by established artists.[59] The use of the strong,
courageous peasant woman to defeat the weak, spindly, and unmanly Aus-
trians united Nikolai Samokish and Kazimir Malevich with the gendered
language of wartime visual propaganda (compare figure 22 to figure 13)
even though they worked in different parts of the aesthetic spectrum.[60] In
Today's Lubok the narrowest segment of Russian visual culture, the avant-
garde, joined the widest, the mass media; indeed, the identification of To-

22. K. S. Malevich. *The Austrian Went to Radziwillow.* 1914 or 1915. Illustration in Vladimir Denisov, *Voina i lubok* (Petrograd: Novyi zhurnal dlia vsekh, 1916), plate 16.

day's Lubok as art lies mostly in the eyes of today's art historians.[61] These images were in fact often presented in the *Flame* and other periodicals as popular prints with no mention of their origins.[62] Maiakovskii's "curious" and apparently sympathetic image of Nicholas II represents the irony of this integration of avant-garde with mass culture.[63] Its existence is evidence that radical artists reordered their aesthetics and their social and political priorities to match the values of the surrounding patriotic culture.

We can see more clearly that futurist cultural iconoclasm and professional antagonism were part of a public art culture, not a core value held by individuals, as public space opened in wartime. When war came, David Burliuk wrote to Andrei Shemshurin and pleaded for a job, convinced that artistic life was at an end. "*All my plans* are destroyed," he worried, and his private proclamation of personal respectability and professional credentialing to Shemshurin represents his abandonment of the public unconventionality of the futurist milieu. "I have a diploma and can teach drawing . . . I beg you to help me get a position [*dolzhnost'*] in this area (or in any other). I am punctual, diligent, don't drink or smoke. . . . There will

be no Russian art, nobody feels like it."[64] Aleksandr Rodchenko described the artistic delights of his visit to a wartime exhibition that made great art available to all in the public. "There was a precious exhibition of old Western masters," he wrote to Varvara Stepanova. "There were the Italians, French, Flemish, and Dutch. . . . The latter are especially good. You would have liked it."[65] In truth, most in the avant-garde were never consistently against tradition, Russian culture, or the professional art world. Udaltsova expressed the ambition that all artists shared in February 1917: "I am still a dilettante, but I will be a Master."[66]

The political, cultural, and institutional distance between avant-garde culture and the wider public thus shrank during the war.[67] The participation of radical modernists in war mobilization shows that most were willing to join society to create a public outlet for their work. Ivan Kliun remembered how World War I disturbed previous practices and aligned the professional interests of the avant-garde with the goals of mobilization when it unexpectedly made his art available to the public during a war charity, which in turn helped attract the attention of a famous collector. "Life left its well-worn track," he wrote in his memoirs, "all the little matters of daily life were forgotten. Everything became mixed up, ripped from place and grabbed by one single goal, one idea—the idea of war. Artists organized a general exhibition for soldiers. . . . Twice at that exhibition I saw Sergei Ivanovich Shchukin arrive and stand a while in front of my paintings."[68] In 1914 the avant-garde began to enter a culture that they had once rejected and reviled, but their reorientation would bring few material benefits without institutional support from the art world, commercial media, or civil society. They could succeed if they changed style and tried to fit public tastes (chapter 3), but that would entail an abandonment of fundamental aesthetic principles. Non-objective art was one solution to this problem, a new aesthetic for a new era that would allow the avant-garde to contribute to Russia's cultural life yet maintain their professional distinctiveness in a new public environment.

From Destruction to Construction:
War and the Collapse of the Futurist Public, 1915–1916

In World War I the attempt of the avant-garde to build a separate public for their art foundered. Artists themselves were cut off from Western counterparts by travel restrictions and hostile borders, drafted into the army, or scattered across the country. Fans of futurism, generally younger than the audience for more established artists, were called up into military service in greater numbers than the public for other art milieus, and their absence deprived futurist exhibitions, readings, and lectures of an important part of the prewar audience. Those who remained, including artists, lost their fascination with the war's violence and felt dissatisfaction, confusion, and pessimism as the war dragged on. Rodchenko remembered that "very few" weekday visitors visited avant-garde exhibitions; the public that did come was different: more diverse and unpredictable (*sluchainaia*).[69] Olga Rozanova likewise complained about "poor" attendance at the exhibition 0.10 in 1915: "Just over two hundred attended the opening, the worst one I've ever had to endure."[70] The avant-garde public, weak and undefined in the prewar years, faced annihilation. "The war divided futurism as a unitary movement," remembered the poet Vadim Shershenevich. "There were few common enemies. We had to unite on the ground of mutual friends. Futurism ended. The futurists remained."[71]

The violence of the war delegitimized the futurist valorization of destruction and iconoclasm in the public eye. Several critics linked Italian futurism to the war and its horrors; Nikolai Berdiaev pointedly chose futurism as a metaphor for the militarism, materialism, and rationalized killing of modern life and Germanic culture.[72] The Great War, moreover, was so overwhelming that avant-garde threats to conventional culture appeared ludicrous in comparison. After hearing Vladimir Maiakovskii's antics at a wartime futurist show, for example, a "most elegantly dressed lady" shouted out: "So young and healthy.... What's he doing writing his foul poetry, he should be at the front!"[73] Nikolai Punin remembered that

the bourgeoisie "was already so shocked by the war, that futurist stalking the world."[74] The public began to overlook futurist exhibitions and events.[75] "If earlier some viewers got upset and others guffawed," wrote one writer, "then now you don't hear curses or laughter. Complete indifference."[76] Critics rejoiced at futurism's demise in the face of public apathy; the adjective they now used to describe it was "boring."[77] Tabloid writers penned witty columns about futurist artists who could no longer create scandals or attract crowds. One columnist joked that the only person who actually bought a painting at one futurist exhibition wanted to use it as a wall calendar.[78] Futurism, in short, became passé.

Such developments threatened to dissolve the new art culture that artists had tried to build before the war. Apathy and public boredom were a serious threat because radical artists needed an audience to meld art and life, and they thrived on controversy, showmanship, and public display to differentiate their work from other artists. Confrontation kept the audience interested, but shock aesthetics lost their effectiveness when the public refused to be shocked. Maria Burliuk remembered how the old strategies of public confrontation that had once worked to connect the avant-garde to the audience and assure a livelihood no longer functioned: "In October 1914 . . . Burliuk, Kamenskii, and Maiakovskii gave a lecture on the theme 'War and Art.' It was not successful and the futurists suffered a financial loss. For artists and poets difficult days had come."[79] Punin blamed the milieu's intellectual and professional malaise directly on the war: "We realized early on that the device of skewering the bourgeoisie, which the first participants in the Futurist movement had used so widely and with such stunning success, was harmful and inappropriate under the conditions of 1915–1916."[80] In 1915 Maiakovskii declared that futurism was "dead."[81] Malevich spat on it "with pride."[82]

Yet the avant-garde had to find an audience or face professional oblivion. They needed an institutional support system and stable public structure to protect them, and most art institutions remained closed to radical

art despite the avant-garde's participation in the new exhibitions and pa-triotic charities. Only one painting from a Jack of Diamonds artist sold at a charity exhibition where total sales reached eleven thousand rubles (it went for twenty-five), and just three pictures went at the Streetcar V exhibition in 1915.[83] Life in wartime was difficult, but it was very difficult for artists who could not sell paintings, and radical modernists felt resentment as professional success passed them by.[84] Their memoirs, diaries, and letters are littered with frustrations vented against the rich, laments on poverty, and complaints about other art groups, especially as the economy deteriorated late in the war. Times were so bad that Vladimir Maiakovskii shilled in David Burliuk's studio dressed as a "dandy" and speaking "in a loud voice about the worth" of each painting in front of a prospective buyer.[85]

Nadezhda Udaltsova put her faith in public institutions, not the private art market, to provide the institutional support for the art she wished to create. Udaltsova left a touching diary that documents the link between the avant-garde's poverty and their professional bitterness. Her economic and personal situation was desperate in the fall of 1916 with her art unsold. "What Golgotha awaits me?" she worried. "I can't earn more than 500 rubles a year from embroidery, but I need 2,400. Where will I get the other 1,900?" A month later she took in 230 rubles from painting but was still working only for bread in January 1917.[86] Professional frustration erupted in her writings as she raged against the thousands earned by the obscure Manevich while Malevich sold nothing: "One is a parasite in art, the other its living word."[87] She demanded protection from the market and looked to museums to supply that protection: "To sell my paintings to the rich is humiliating. Paintings should not be property; they should be for museums and collections." Punin, Tatlin's contact and advocate in the Russian Museum, was ecstatic when the museum purchased some early work in 1916: "They bought two Tatlins, truly an event for me, a milestone for my activity. In truth I could never have hoped for this."[88]

Radical modernists needed a new aesthetic to mobilize, rebuild, and regroup a public for their art, justify their claims to professional existence, and distinguish themselves from other groups as the avant-garde public destabilized and the broader public culture promised them acceptance in return for cooperation in the war effort. They turned from the demolition of culture to its construction, a radical departure from their prewar confrontational stance. In 1915 Maiakovskii openly declared the futurists' new constructive purpose, emphasizing that this new posture was a significant change from prewar destructive iconoclasm: "But once Futurism has died as the idea of select individuals, we do not need it anymore. We consider the first part of our program of destruction to be completed. So don't be surprised if today you see in our hands architectural sketches instead of clownish rattles, and if the voice of Futurism, which yesterday was still soft from sentimental reverie, today is forged in the copper of preaching."[89] Art at the First Futurist Exhibition Streetcar V in April 1915 contained the same cubist-inspired canvases as before the war. By September 1915 the avant-garde knew the old art was gone, but they did not know what would replace it.[90] War had demolished the futurist public and its iconoclastic aesthetic, and Russia became a hothouse of avant-garde creativity as the race to construct new ones was on.[91]

An important impulse in the search for a new art, whatever it was to be, was a professional struggle within the avant-garde milieu. In the spring of 1915, the stable membership of personalities that characterized the years between 1910 and 1914 broke down.[92] Tatlin and Malevich vied for leadership of the movement when links with international modernist culture were dissolved by the war, especially after Larionov and Goncharova left the country in 1915. Malevich's breakthrough *Black Square* came in mid-1915, and he made it public, with his new aesthetic philosophy, "suprematism," at the Last Futurist Exhibition 0.10 in December 1915. At the same time Tatlin began to abandon frame, canvas, and paint altogether to create three-dimensional "corner counter-reliefs" (*uglovye kontr-rel'efy*).[93] Both

Malevich and Tatlin used these innovations in form and philosophy of art to support, bolster, and mobilize an avant-garde culture that was losing institutional integrity.

Malevich, for his part, asserted that he was a leader not only of the Russian avant-garde but of world artistic culture. "Our genius," he boasted in 1918, "is to find new forms for our modern day."[94] In May 1915 the artist Mikhail Matiushin contacted him to help plan a new production of the 1913 opera *Victory over the Sun*. This correspondence apparently gave Malevich the idea that the shapes that he had used in the original 1913 stage design could be exhibited as art.[95] After unveiling the *Black Square* in 1915, Malevich applied his newly claimed professional power to seek allies for suprematism by discrediting artists who still were employing cubist style. "You know, everything they are doing is old-fashioned and unoriginal," he told Rodchenko as he tried to recruit the younger artist to suprematism. "That's already finished. A new art is coming, our Russian art. And I am making it, come with me, for you already have it intuitively. It's in the air!"[96] Malevich's angry response to a negative review by Alexandre Benois shows just how much he staked his professional legitimacy on the *Black Square* "in an art world marked by competition, stylistic eclecticism, and real social and economic disenfranchisement."[97] He argued in the unpublished letter that suprematists were serious artists participating in a common artistic endeavor to continue aesthetic progress, growth, and development in Russian culture, not charlatans, flimflam operators, or jokers masquerading as artists. "Is it a boor that is striving to leave yesterday behind and to enrich himself with a new, healthier form of art?" he asked. "Is it a boor that calls on the generation to grow fruits in its own garden and with its own hands?" The world, he suggested, was enriched by the work of "a technician of genius" every fifty years.[98] Malevich's criticism of other artists remained fierce, but suprematism, for him, was a great contribution to world art culture, an assertion of a new genius in art, and the action of an artist following in the footsteps of the great artists of the past.[99]

Nadezhda Udaltsova, like Malevich, sought to legitimize suprematism as a contribution to professional Russian art culture. In 1915 or early 1916 she argued in an unpublished article that the new art deserved a place in national culture. Prewar public hostility was replaced with open tolerance and respect for previous generations and artistic opponents alike: "We as artists pay tribute to the old times. We know they also struggled for a new ideal."[100] Suprematism should be recognized as a new art of the present, she argued, and she demanded that the avant-garde receive its rightful place in Russian art. Udaltsova chastised critics who did not accept Russian modernism as Russian and cast doubt upon their professional credentials and abilities. "Where is our Russian art?" she asked. "What does the Russian reader know about Russian art of recent years?"[101] For her, public nationalism and professional justice required the art world to accept avant-garde work as legitimate art in the national artistic canon. Suprematism was a constructive contribution to Russian art culture in 1915; it was not designed to replace, disrupt, or destroy.

Vladimir Tatlin also tried to construct an artistic following around his new counter-reliefs. As Nikolai Punin recalled it, Tatlin was an artistic genius whose "gifts, obviously, surpassed the gifts of all his contemporaries" and whose "every judgment, every expression of thought on art, was for us a breakthrough into the new culture."[102] The "influence" of this "truly great person" was "boundless," according to Punin, who emphasized Tatlin's role in leading the work of their circle as they met in Lev Bruni's apartment in Petrograd: "both under Tatlin's direction and without him, but in resolving tasks set *by him*, we sweated over the construction of spatial models, over various types of collections of materials of different properties, qualities, and forms." Tatlin's focus on form, material, and technique was to be the contribution of this mobilized group of avant-garde artists to the creation of a new, non-objective art. "From outside all this might have seemed to be just crazy," Punin continued, "but in reality it was the creative tension of people who thought that through their efforts the world could eventually be moved away from its ageless canons and 'enter a New

Renaissance.'"[103] Tatlin's work, according to Punin, was the foundation for the long-expected renovation in art.

Personal conflict arose from these attempts to produce a new aesthetic and claim leadership in the avant-garde.[104] Tatlin and Malevich protected counter-reliefs and suprematism as one would protect a new blockbuster commercial product, and their rivalry was sometimes bitter, sometimes comical. The competition, with its feelings of "envy and jealousy toward the successes of other artists," led Tatlin to "serious tribulations and strange acts."[105] Vera Pestel remembered that he kept the blinds down in the daytime because he feared Malevich might peek in the window from the street.[106] Malevich also kept suprematism tightly under wraps: "They all know the name, but no one knows the content. Let *it be a secret.*"[107] As Varvara Stepanova wrote, "You feel that he has discovered something, but he says nothing. Every effort is being made to find out what he's going to call his works."[108] Aleksei Kruchenykh joked that Malevich was so afraid someone would steal his ideas that he painted in complete darkness.[109]

The clash that erupted at the 0.10 exhibition shows that the two sides could barely share the same physical space when Malevich tried to "ruin" the exhibition for Tatlin.[110] According to Stepanova, the suprematists took "Draconian measures" to keep Tatlin from "exhibiting his reliefs alongside their works."[111] Both Malevich and Tatlin tried to keep their art secret as they set up the exhibition, a process that was rife with quarreling, intrigue, and insults. Tatlin became so fed up that he and his allies moved their work to a separate room, which they labeled the "Exhibition of Professional Painters." Liubov Popova, "to avenge Malevich," responded with a sign in her exhibition space: "Room of Professional Painters."[112] Olga Rozanova described in a letter to Kruchenykh how the suprematists saw Tatlin's group as professional rivals for public attention and sought to consolidate their cohesion as an art group in response: "I recently got a verbose letter from Kliunkov [Kliun]. Flattering and alarming. They are afraid that the group with Bruni, Tatlin and others will be significantly larger and have more success with the public than the Suprematists. He's

appealing to me. He says that the Suprematists should work closely and harmoniously."[113] No other episode could better show how the creation of non-objective art was part of a competition for professional leadership inside the avant-garde.

The development of non-objective abstraction offered the avant-garde a sense of purpose, a promise of institutional stability, and an aesthetic legitimacy when war seemed to overshadow all three. Suprematists and Tatlin's followers had no doubt that their art was different from all other art, and they used that difference to demonstrate their unique contributions to Russian culture and their authority as modernity's true creative geniuses. No longer did the avant-garde reject the past; they now argued that their historical destiny was to lead humanity to a glorious future. Malevich's assertion that suprematism was the "New Painterly Realism" rhetorically linked his new art to previous artistic traditions, while, at the same time, the neologism *suprematism* labeled his art as superior to the work of rival artists. Claims that non-objective art was a radical break with past art, including cubism, futurism, and prewar abstraction, helped the avant-garde to build and consolidate their professional identity and to create order through form in a disordered world. It may have worked; suprematism seems to have found at least some interest in the public by late 1916.[114] Pestel began to wonder whether her colleagues were capturing the atmosphere of the age. "Why does society tolerate us, why are they interested, why do the critics praise us, and look at us seriously as art innovators?" she wondered. "Is it because all are fools? Or are we subject to the spirit of the time, the blind force of fate, producing an art for its time?"[115]

A Counter to War: Non-Objective Art and Its Meaning in 1915

World War I did not cause the invention of non-objective art, but it shaped the public environment in which Tatlin and Malevich invented, explained, and justified it. No single interpretation can capture the essence of the complex environment that resulted in the development of non-objectivity in

Russia or in Europe.[116] The meaning of Malevich's suprematism and Tatlin's counter-reliefs, like all art, is not fixed; it changes with the historical context, the values of any given public culture, and the perceptions of the observer. Variations of the *Black Square* were set decorations in 1913, solutions to institutional and formal problems of the avant-garde life in 1915, and revolutionary art in 1918. The original re-imagination of art as an artifact in 1915, however, was closely linked to conditions inside an avant-garde milieu made unstable by World War I. Kandinsky, although peripheral to these groups, captured the irony in his usual impenetrable fashion in 1920: "What art was unable to gain from peace it gained from war. Until its appointed time, the envisaged aim conceals unforeseen consequences. The striving toward materialism gives birth to the non-material. The hostile becomes the friendly. The greatest minus turns out to be the biggest plus."[117] Contemporary statements by artists, critics, and journalists all linked the non-objective art of Tatlin and Malevich to the war, showing once again how the mobilization for World War I aligned the avant-garde with wider public culture.

These artists in Russia were perhaps the first to abandon the objective in art, a step that had tremendous significance in European and even world culture.[118] Art no longer lay in a representation of external objects, but in the form, artistic execution, and reality of the physical artifact. In 1915 Tatlin and Malevich openly argued that their works no longer represented anything beyond their own existence. "Now I am not interested in anything except form and surface," Tatlin told Iakov Tugendkhold in regard to his counter-reliefs.[119] The use of common materials like nails, wood, and glue and the shaping of space across the corner of the room tell us that Tatlin's counter-reliefs existed as non-objective expressions of physical plasticity and materiality, not representations of reality (figure 21).[120] Punin emphasized how work on counter-reliefs was a new process of creation: "We sawed, planed, cut, ground, stretched, and glued. We almost forgot about easel-painting. We spoke only of contrasts, of links, of ten-

sion, of the angle of a cut, of 'textures.'"[121] The writings of Malevich and his associates show that they, too, were grappling with problems of representation and the definition of art. "Before us sculpture was a means of reproducing objects," wrote Ivan Kliun. "There was no sculptural art, but there was the art of sculpture. Only we have become fully aware of the principle: Art as an end in itself. . . . Our sculpture is pure art, free from any surrogates; there is no content in it, only form."[122] Art historians can debate whether Russian non-objective art was as formally innovative as these artists claimed, for there are examples of extreme abstraction before the war, but at the very least, as Charlotte Douglas observes, Malevich "advanced a nonfigurative vocabulary of a severity unknown in the history of Western painting."[123]

What was truly radical about non-objective art in wartime Russia was not so much its form but the new definition of art that explained it. Non-objective art was radically new from an intellectual point-of-view, for although abstraction and non-objective art shared formal qualities, their intellectual bases were very different.[124] Prewar modern art, even if abstract, was always understood to represent something outside itself. Aesthetic modernists, for example, argued that their art expressed the inner reality of the artist's artistic vision or the eternal world of forms, while cubists claimed to represent real objects better than traditional painters, and futurists wanted to incorporate the texture of modern industry and urban life into art. Mikhail Larionov believed that art must relate to everyday "concrete" life, and he presented his highly abstract rayism as the depiction of light rays reflected from everyday objects.[125] Goncharova thus used her rayist technique to represent the light rays reflecting from a cat, an approach that leaves the cat's figure obscured but still discernible (figure 8). Even Kandinsky, the self-appointed high priest of abstraction, explicitly rejected "completely abstract forms" as "insufficient" for precise artistic practice in 1911; his compositions were "expressions" of various inner feelings that worked as a physical phenomenon on the eye much as

sound stimulated the ear (figure 19).[126] Non-objective artists, in contrast, presented their art as fundamentally different from abstraction. Rozanova asserted that non-objective art and all previous art were "not two different tendencies in one art, but two different arts."[127] For her, abstract art had more in common with the art of the Renaissance than with suprematism because "the artists of antiquity and of the Renaissance, the Impressionists, the Cubists, and even to some degree the Futurists are all united by the same thing: the object."[128] Tatlin's counter-reliefs, in the eyes of a contemporary, were not new words inside an artistic language; they were a completely new language.[129] From this perspective, Malevich's *Englishman in Moscow* (figure 9) is more like Repin's *Barge Haulers* (figure 3), since both represented something outside themselves, than paintings like the *Black Square* (figure 1), which are nothing but wood, canvas, and paint.

The war's material consequences shaped the physical existence of non-objective art in a direct sense. Already in 1914 one modernist predicted that art would turn to the material: "A new beauty is coming. The artist will make it real with paint, metal, stone, marble. The new creation will reflect modernity [*sovremennost'*] and profile it."[130] Material deprivation, the scarcity of high-quality paint, and inferior art supplies forced many artists to improvise and experiment with alternate media. Kandinsky switched to watercolor when he had no oils, canvas, or easel.[131] Kirill Zdanevich had no paint at the front, so he made a "trench album" from a Hebrew bible, photographs, playing cards, garbage, and other odds and ends.[132] Aleksandr Rodchenko was stuck in the provinces with a limited palette: "I paint in red and black because that's all there is."[133] Non-objective art was perfect for an environment of scarcity because geometric shapes in solid colors economized color and simplified execution, and the use of ordinary materials made access to paint and canvas unnecessary. Punin recalled that Lev Bruni's studio in 1916 was littered with ordinary stuff: "everywhere there lay 'materials': iron, tin, glass, cable, cardboard, leather, some putty, lacquers and varnishes; a lathe, saws, files, various pincers, drills, sand-

paper, and emery paper of different sorts and grades had appeared from who knows where."[134] Visual inspections and X-ray photography suggest that Malevich, for whatever reason, created his first *Black Square* by recycling a canvas that had originally contained a different image, a decision made physical in the painting's uneven cracks, shades, and shapes (figure 1). These artists, faced with wartime shortages and inconvenience, built the material of life into art. In some cases it was all they had.

Russia's non-objective artists, furthermore, presented their art to the public as the solution to the problem of war, the means to counter its dehumanizing violence. The realization that the war would be a long, drawn-out, and nasty conflict touched the avant-garde as it did all Russians. Futurist poets, for example, began "to replace their patriotic and artistic belligerence with pacifist longings for a world without war" once they realized that the real war involved "senseless suffering and destruction."[135] Rozanova's abstract illustrations for Aleksei Kruchenykh's books *War* (1915) and *Universal War* (1916) were images that, although they are difficult to interpret as antiwar pictures, imply the universality of war.[136] Malevich had concluded that the war was a supreme catastrophe by mid-1916: "The war has already passed a long time ago. Now there is horror, a nightmare has pierced through conscious [*bodryi*] reason. What is happening now is not like a war. It is a madness of the human brain."[137] Burliuk, a public patriot in 1914, was in despair in 1917 as he waited for word about his brother Vladimir (killed in action near Salonika): "Generally when people go to war—it's bad. War is also bad. Oh, when will 'it' end?"[138] The avant-garde had volunteered their professional skills to address the war when it seemed a positive experience, and they matched the public face of war in a different way once attitudes shifted toward a more sober, "real" understanding of the war in 1915.

As an overwhelming public problem, World War I was the logical context that could clarify the purpose of Tatlin's counter-reliefs to the public. Although the artist himself wrote no theoretical tracts, aesthetic com-

mentaries, or much at all to explain counter-reliefs, his public advocate Sergei Isakov presented them as a solution to the problem of war. For Isakov, Tatlin's work was designed not to reflect reality but to give the artist power over reality, and the militarized language he invoked suggests that the reality this art opposed was the destructive and violent war. Counter-reliefs, according to Isakov, were "the way out of the frustrating dead-end of modernity." That dead end was "the tyranny of the machine," which "in modern life" played a "colossal role" and governed destinies. Through counter-reliefs the artist was the "master of the material world," holding out hope that "the whole of humanity" might cast off the "yoke" of the machine, a task that the war made absolutely necessary: "Was it not the growth of industry, the hypertrophy of technology that rejected the greatest commandment of humanity 'Thou shall not kill' and forced the whole of humanity to plunge into streams of fraternal blood? The phrase 'From Kant to Krupp' sounds smart. But it is short-sighted. Remove militarism, get rid of the cannon."[139] Punin later remembered that the artists around Tatlin used nonpainterly materials to find a better way to save reality from violent destruction. "We weren't searching for a new method," he wrote, "we were looking for a means to seize reality, devices, by means of which it would be possible to grasp reality with an iron grip, without tearing it up or being torn up by it, by its convulsions and moans, its agony, and put it on canvas."[140] In the context of wartime Russia, counter-reliefs gave artists the power to counter the reality of war and the culture that enabled it by creating a new physical reality that contained no violence.

The suprematists around Malevich also emphasized how their art gave artists the power to restore a disintegrated world. Suprematists broke down painting to its most basic elements, but this destruction was a prelude to the creation of a new, elemental, and indestructible reality. As Ivan Puni and Kseniia Boguslavskaia put it in 1915, "An object (a world) freed from meaning disintegrates into real elements—the foundation of art. The correlation of elements discovered and revealed in a picture is a new reality,

the departure point of the new painting."[141] Malevich argued in his book-let *From Cubism and Futurism to Suprematism* (several editions in 1915 and 1916) that all existing human art culture, whether primitive, academic, or futurist, was based on a "utilitarian reason" that drew the artist away from pure creation by insisting that art had to imitate nature. Cubists, he suggested, had "destroyed objects together with their meaning, essence, and purpose."[142] The futurists, too, had violated the "cohesion of things" with their desire to transmit an impression of movement, and "in this breakup and violation of cohesion lay the latent meaning that had been concealed by the naturalistic purpose."[143] Only the suprematist, who alone painted with pure intuition, could exercise the power of creation without destruction: "*Objects have vanished like smoke; to attain the new artistic culture*, art advances toward creation as an end in itself and toward domination over the forms of nature."[144] Suprematism promised a new art culture that did not exist to destroy but to make the world whole. "Our world of art has become new, nonobjective, pure," Malevich declared, where "forms will live, like all living forms of nature. These forms announce that man has attained his equilibrium."[145] He made sure to distance the *Black Square* from the war when he wrote to Alexandre Benois that suprematism, though destructive of art conventions, was "not like the killing of man's living source (war)."[146]

The *Black Square*, as the most indestructible element of nature, restored order to a chaotic reality that in 1915 meant the world war. Suprematist paintings consolidated and stabilized color and style into geometric forms not to subvert vision, as the avant-garde had done before the war, but to restructure, reorder, and restore it. As John Milner has shown, Malevich and his colleagues used meticulous geometry to construct their suprematist paintings, a practice that extended to the arrangement of paintings at the exhibition itself.[147] The *Black Square*'s icon-like quality brought further order to a world disrupted, and its placement in the "icon corner" of the exhibition room served to make this relationship clear. Icons de-

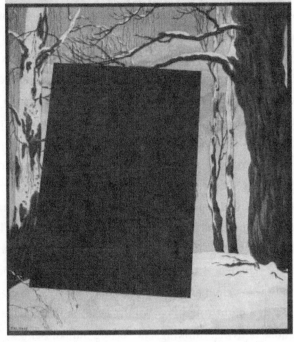

23. G. I. Narbut. Cover (censored) for the magazine *Lukomor'e*, no. 6 (1915).

picted life through symbolic representation, not reflections of external reality, and they provided consolation, healing, and redemption for the sorrows of life, a need that was great in wartime Russia.[148] Vera Pestel felt the icon's qualities in suprematist paintings as they drew her away from the outside world. "How tranquil it was to look at various squares, to think of nothing, to want nothing," she wrote in 1916. "It was good to sit in that room and not to think of any subjects."[149] Whether Malevich intended it or not, his *Black Square* negated the war; its clear colors and lines were an alternate reality on paint and canvas, a reality where the war's chaos and destruction did not exist. Like the censor's squares that shielded viewers from unacceptable wartime realities on the covers of popular journals (figure 23), the form of the *Black Square* removed mass violence from nature and brought order to chaos.

Tatlin and Malevich strengthened their avant-garde credentials when they redefined art and reordered physical reality through form, but they did not convince important professional gatekeepers to accept their achievements. Established critics refused to recognize the avant-garde's self-proclaimed reinvention of art, and they, as participants in a mobilized culture, also linked non-objective art to the war, if only to identify it as a threat to the profession. Aleksandr Rostislavov alone among prominent critics indicated that suprematism deserved discussion as an artistic development.[150] But even he refused to praise the avant-garde in public. Rozanova noted the disjunction between the critic's personal views and public behavior as she fulminated at the help that "the fool" refused to give her: "Rostislavov is in ecstasy over my works and has told me that most likely not even I know my own true worth, etc. Now if he would only write that in *Rech* [*Discourse*]—vulgar man."[151] To Benois, the *Black Square* represented only modernity's negative side: war, dehumanization, and the end of art. Suprematism, for him, was "a sign of the times," part of the same philosophy that "blows away millions of living, thinking, and feeling human beings." It meant mass culture, Americanization, and the loss of art's privileged place in society, phenomena that were leading everything to "ruin" (*gibel'*).[152] Iakov Tugendkhold, for his part, wrote a lengthy article criticizing Tatlin's approach as an artistic cul-de-sac that reaffirmed the era's soulless materialism. "The futurist *worship* of those sides of modernity [*sovremennost'*] that our cultural consciousness strives to overcome," he argued, disqualified the avant-garde from serious consideration as artists.[153]

Only in wartime did avant-garde artists in Russia suggest that art could represent nothing outside itself. Malevich and Tatlin used this new view of art to help them assert professional control over an avant-garde space that had lost its prewar raison d'être, aesthetic justification, and audience, and the war was such a public presence that they could use it to prove that non-objective art was not a destructive force but a constructive solution worthy of public respect. Their re-imagination of art thus resolved a para-

dox of modern aesthetics: how to capture reality in art without imitating, falsifying, and destroying that reality. Tatlin's counter-reliefs became the foundation of later constructivism, while the Bolsheviks, wittingly and unwittingly, gave the results of wartime innovation worldwide exposure and influence during the 1920s. Kandinsky, though not a suprematist, brought a style deeply influenced by Malevich when he fled Russia for the Bauhaus in 1921.[154] Today the *Black Square* remains the subject of myriad books, press articles, and international art exhibitions. It has become an emblem of modern Russia, one formed and shaped by the encounter of its creator with the First World War.

5. The Revolver and the Brush

The Political Mobilization of Russian Artists

through War and Revolution, 1916–1917

The appearance of avant-garde art in the public culture of early Bolshevik Russia was a striking aspect of the revolutionary experience. In 1914 the avant-garde was a small minority with little influence in the Imperial Russian art world, and they were not a part of pre-revolutionary leftist political culture. With a few exceptions, the political left preferred the tastes of the nineteenth-century intelligentsia over aesthetic modernism, which they believed appealed to an elite group of snobbish intellectuals and rich collectors, and no political party, whether revolutionary, liberal, or conservative, recognized radical modernism as "their" art.[1] Yet after 1917 prominent avant-garde artists volunteered to help the Bolshevik regime build a revolutionary culture, important modernists joined Soviet administrative institutions, and official policy and practice recognized modernism as legitimate art. The emergence of a politically engaged avant-garde, however, was not new to the Soviet experience: it was a continuation, redirection, and intensification of attitudes and behavior that had begun in the mobilization for war. World War I was the avant-garde's "first public test [*ispytaniem na obshchestvennost'*]," but it did not reveal them to be political revolutionaries, as the Left Front of Arts (Levyi Front Iskusstv) artists proclaimed in 1923.[2] The war instead created conditions for them to engage liberal political culture, a political orientation that changed when the public environment shifted in 1917.

Extensive debate exists about the politics of modern artists, in particular the avant-garde, in European and Russian culture. Some art historians identify leftist or anarchist sympathies among artists like Picasso, Courbet, Manet, Seurat, and the surrealists.[3] Others hold that the collectivist, romantic, or nationalist tendencies within avant-garde aesthetics lent their art a neoconservative, nationalist, or fascist valence.[4] Russian modernism, for its part, has been described as apolitical, revolutionary, or totalitarian, interpretations that are patterned by the desire to confront, and explain, the proximity of the avant-garde to the Soviet regime.[5] Yet if we put the October Revolution out of view for a moment, we can see that the avant-garde scandalized society but did not make their art beholden to a political party or support a specific political ideology before the Bolsheviks came to power. Many accepted the Bolsheviks after 1917 out of sympathy for the revolution, but others denied that the avant-garde had a revolutionary political agenda.[6] Some seem uninterested in the details. Marc Chagall, who participated alongside his colleagues in early Soviet art institutions, admitted that his knowledge of Marxism was confined to "knowing that Marx was a Jew and that he had a long white beard."[7]

The contradictory views of the politics of Russian modernism, like the multiple explanations about the war's impact on art form, are more easily reconciled if we look at the total public arena in which artists were active. Individual artists had political views, but their public engagement with politics depended more on their need to assert or defend professional interests in the public sphere. Some, such as Larionov, understood their public activity in more overtly political, if non-party, terms, but what mattered most for most artists, including many in the avant-garde, was the ability to find a public that could support their professional life.[8] In 1914, modern artists joined a mobilized culture of war, adopted many of the jingoistic, nationalist, and patriotic tropes that filled the mass media, and participated in war-related institutions, activities that represented public, if not personal, support for the war effort, the tsarist regime, and the status

quo. Likewise, liberals and modernists had an ambivalent relationship.[9] But when a wartime convergence between avant-garde and society took place in politics, as in other areas of the public sphere, prominent modernists entered a liberal political environment and presented their art to the public in those terms. The avant-garde, even if they did challenge surrounding society, did not seek to be part of a revolutionary public culture until after the Bolsheviks came to power in October 1917.

Rampaging Red Banners?
Modern Art and Political Radicalism before 1914

Years ago Camilla Gray located the Russian avant-garde within the socio-critical tradition of the nineteenth-century intelligentsia, and later critics have emphasized the radical politics of the avant-garde or the links between their art and Stalinist aesthetics.[10] Katerina Clark, for example, has observed that Russian intellectuals were on a "quest to find the quintessential revolutionary culture" between the 1910s and 1930s.[11] Common to these notions is the assumption that modernists opposed the political, social, and economic order and actively sought to subvert it. Aleksei Kruchenykh made the pre-revolutionary avant-garde's link to radical politics clear in the 1920s: "Our specific socio-political orientation, organically linked with revolutionary aims in art, was never presented blatantly by us, but it did determine the content of our artistic output."[12] Yet there is little or no evidence that avant-garde artists participated in organized political activity before the war, and their public activity shows that they remained focused on professional and aesthetic interests even in 1917.[13] How do we reconcile the apparent revolutionary politics of the prewar avant-garde with their lack of linkage to political parties or political culture? The prewar avant-garde seemed to be revolutionaries but did not act like revolutionaries because there was a disjunction between the politicized rhetoric of modernism in the public culture and the professional orientation of artists' public engagement. This disjunction closed

between 1914 and 1917 when political mobilization became vital to their professional goals.

Avant-garde painters were possibly the most politically leftist individuals in the art world, but their politics did not align with organized political action, and certainly not with Bolshevism.[14] Conservative, liberal, and radical political beliefs could be found among all kinds of artists in Imperial Russia, including some in the same milieu, group, or family. Apollonarii Vasnetsov, for example, held "revolutionary views," but his brother Viktor was "unshakably conservative," and both tended to be members in the same art groups.[15] As a cohort, the avant-garde differed little in their personal politics from non-artist peers who held liberal, socialist, or anarchist views, and few, if any, were mobilized to support a political cause. When Nikolai Punin developed an idea about the "socialist character of futurism" in 1916, he admitted that his conception had nothing to do with "art for every worker." Nor was it related to any party or program; for him, futurism was socialist in its expression of "the entirety [*sovokupnost'*] of aesthetic sensations, which socialism develops."[16] Leftist political views, moreover, did not translate to support for Bolshevism: Mensheviks, Social Revolutionaries, and anarchists were among the Bolsheviks' most bitter opponents before and after 1917. Political anarchism, with its celebration of individual freedom and hostility toward bureaucracy, probably fit best the political sensibilities of avant-garde artists.[17] Olga Rozanova, for example, argued in 1913 that art should be free from all constraints: "We declare war on all the jailers of the Free Art of Painting who put it in the chains of the commonplace: of politics, literature, and the horror of psychological effects."[18] Malevich and Udaltsova never did overcome their anarchistic and individualistic suspicion of the Bolshevik state.[19]

The experience of revolution in 1905 shows how much politics and art milieu were not aligned. The year 1905 marked a new level of artistic engagement with politics through direct action and the representation of the revolution in art, but aesthetic orientation did not determine this engagement. Valentin Serov, in a spectacular public act, resigned from the

Academy of Arts to protest Bloody Sunday, while some young artists and art students went to the barricades. The police threatened Itinerant and Salon exhibitions with closure when they planned to exhibit "events," but paintings that depicted the revolution nonetheless appeared at their annual exhibitions.[20] Evgenii Lansere, one of the more politically oriented aesthetic modernists, remembered the atmosphere of 1905 as a time of great hope for change in his milieu: "Our circle was in complete sympathy with the general mood which seized liberal society after the defeat in Manchuria, after 9 January [Bloody Sunday] and after Russia's internal disturbances.... We sympathized with any opposition to the government."[21] Yet artists made little effort to mobilize outside the bounds of the art world: they did not engage the public through charities or other direct social work, nor did they form revolutionary political organizations or professional unions (despite proposing one). Lansere, Somov, and Dobuzhinskii, in fact, linked their professional interests to the social and political fate of all Russia when they argued that art could only be free in a society that was free.[22] The experience of revolution in 1905 shows that artists believed that the best way to participate in politics was to depict the revolution in art (as discussed in chapter 1), not to engage in organized civic activism or political agitation.

Individual reactions to 1905 in the art world were neither homogeneous nor universally sympathetic to the revolution. Those artists who opposed the regime were not experienced in political agitation or well organized for political action. Igor Grabar recalled that several of his associates in the Union of Russian Artists planned a "social democratic" journal, but the group appeared to have no Social Democrats. "I don't remember who," he remembered, "but there were some 'populists' and 'Toilers' [Trudoviki] and maybe also Socialist Revolutionaries on the veranda of the dacha where we sat."[23] Many became disturbed, afraid, or confused when revolutionary activity and the government's response turned violent and chaotic. Alexandre Benois did not greet the revolution with enthusiasm, and in 1906 one critic noted unease among modernists: "The new culture, which is

coming to us under the canopy of rampaging red banners, so loud and so tragic, has greatly frightened many artists and aesthetes."[24] Kazimir Malevich later asserted that he took up a revolver, went to the barricades, and participated in a shootout ("it was a real war"), but only after another art student had convinced him to stop painting.[25] In March 1905 the young Punin was just confused: "I don't have any strong convictions yet. I am not aligned with one political side or the other; nor do I have anything of my own to suggest."[26]

In the 1910s critics did speak of the avant-garde in political terms when they used labels like *extreme left* artists, *revolutionaries*, or *rebels* to describe them, a practice that, as Jane Sharp argues, forged an association between radical politics and avant-garde art in public rhetoric that would emerge more fully after 1917.[27] But political language was a product of professional conflict and competition in the art world, and it had existed before the avant-garde came on the scene. Such political discourse served to describe the professional challenge that new groups posed in relation to older milieus and to measure the degree of their aesthetic challenge along a political and chronological spectrum. In the culture of the pre-revolutionary Russian art world, "right" artists followed older art styles and institutions from the Academy to the Itinerants, while the World of Art, with its rejection of the aesthetic conventions of nineteenth-century art, formed the "left" of art. The "moderates" of the Union of Russian Artists, with nationally oriented, modernist-tinged paintings, were often placed in the center. Such political metaphors were not essentialized to any specific group except in the most general sense; they varied with the relative position of the critic toward the artists: conservative critics considered the impressionism of the Union of Russian Artists a "left" and "modernist" art, while more liberal or modernist critics judged the Union a "moderate" or even "conservative" aesthetic.

In Imperial Russia, as elsewhere, art critics and artists used a language of identity and difference to distinguish art groups from each other in the

art world.[28] The most common metaphors were linked to generational conflict; they included images of struggle between *old* and *new* or *old* and *young*, a practice that went back at least to the 1860s. Other terms served to distinguish the avant-garde from the World of Art and the Union of Russian Artists, including *vanguard* (military), *extreme* (qualitative), *new* or *latest* (temporal), or *futurist* (style). Not only were these tropes as common or more common than political metaphors, but most had already been used by critics to describe the previous generation of aesthetic modernists. When art critics wrote of "left" and "right" in art, they were using a language of metaphor and analogy to describe the position of artistic milieus in relation to others inside the art world, not referring to personal political views or specific political parties. This language of differentiation in Imperial Russian art criticism simplified, explained, and communicated the contours of the art world to the public.

The function of the language of political radicalism in Russian art criticism was to define the avant-garde as a threat to the art establishment. For hostile critics, radical modernism threatened the profession because naive or abstract art required, in their view, little artistic skill or specialized training, qualities that separated art as a profession from traditional crafts and modern mass culture.[29] Alexandre Benois thus used radical political metaphors to identify the work of the avant-garde with radical revolution, but he also railed against the Americanism of the avant-garde, that is, their extreme individualism, emphasis on popular or commercial culture, and rejection of the formal techniques, media, and sublime artistic inspiration that set art off from mass production. Moreover, he equated the arrival of the avant-garde to the end of the Roman Empire, when, in his mind, artists sought to escape a decadent civilization through the embrace of unorthodox beliefs. For Benois, cubism was a barbarian art that heralded the rise of a new artistic culture, a new Byzantium in Russia.[30] That he could identify the avant-garde as left-wing, American, or barbarian shows that he was not concerned with the avant-garde's actual politi-

cal stance. Benois was instead identifying their threat to the conventional practice of art and to the power of the art establishment (and himself) to regulate the profession. He dropped such language in a 1916 review after he noticed more acceptable behavior, suggesting that a professional future might lie in store for those radical artists who decided to engage the public as artists, not pranksters: "The artisan-like, market-oriented, or simply stupid charlatan stuff are completely absent from this exhibition or are so small that they remain hidden and negligible. It is difficult to say who of these young people will be able 'to be successful' and who will find demand in society. But that there are candidates for such good fortune I do not doubt and I am ready to support a few."[31]

Any political radicalism that existed in the prewar avant-garde was itself shaped by conditions inside the art profession. Tsarist security services were vigilant against political revolutionaries, and they responded to perceived threats with repression and exile. When radical artists drew the attention of local censors and police officials, however, they came under suspicion for testing the boundaries of the art profession or broader public culture. Students at the Moscow School of Painting, for example, attracted police surveillance and could even be arrested for criticism and demonstrations directed against school administrators, and during the Revolution of 1905 young artists occupied school buildings, backed striking workers and victims of political terror, and protested the school's administrative decisions.[32] In 1910 Mikhail Larionov led a demonstration of students against conservative policies in the school and was expelled in response.[33] Local police also monitored Vladimir Tatlin from 1909 to 1911 after he became engaged as an art student in "revolutionary agitation" against the administration of the Penza School of Art in 1905 and 1906.[34] That authorities did not exile or imprison radical artists is a sign that such actions were not considered a threat to the political system. The avant-garde's pattern of organized political activity against institutions was instead a challenge to an art establishment that held power over their aesthetic and professional aspirations.

The avant-garde's political position was therefore ambiguous and undetermined in public culture before the war. They remained aesthetic radicals, and sometimes political radicals, but their public activity, like that of other artists, remained focused on achieving professional goals: to create the art they wanted, have that art accepted, and become recognized as legitimate artists, a stance that, ironically, encouraged them to be part of the system, not against it. Tatlin, like others, may have held leftist views, but he sought success within the Imperial Russian art world. Malevich made clear in his autobiography that the difference between political revolution and aesthetic radicalism lay in the character of public action: "I said then that if I become a revolutionary (that was in 1905), I will fight not with a brush but with a revolver, and I will paint whatever I feel."[35] The choice of the futurists before the Revolution of 1917, he suggested, was to choose expression in art over the reflection of a specific ideology. Avant-garde art was therefore not recognized as nationalist, Bolshevik, or anarchist in Imperial Russian political culture, although it did seem threatening to many who felt insecure about prevailing social and political conditions. If anything, modern art was associated with liberalism, for it was critics in liberal journals and newspapers who took modernism most seriously. So it should be no surprise that prominent avant-garde artists decided to side with liberal politicians and aesthetic modernist rivals to protect their professional interests when the culture of war reached into the Tretiakov Gallery. Modern art was not revolutionary art during World War I; it was liberal art.

Invading Autocracy: Liberal Politics, Modern Artists, and the Tretiakov Gallery in 1916

Avant-garde art was not part of a well-defined political discourse until the First World War, when it became linked to the liberal politics of the Moscow city council in the Tretiakov Gallery affair of 1916. By the early twentieth century the Tretiakov was the most important collection of national

art in the empire.[36] As such it defined Russian art for the viewing public and was vital to artists' commercial success, public reputation, and claims to art-historical significance.[37] Modern art could become a recognized part of Russian culture if intellectually, legally, and physically it was included in Russia's national museum. But was modern art Russian? Did it deserve a place in Russia's national gallery? In early 1916 prominent modernists adopted a politicized language to mobilize uncertain deputies in the Moscow city council (duma) to support reform in the Tretiakov. If the city decided to back the changes, modern art would have institutional legitimacy in the world of politics and in the world of art. The 1916 debate over the Tretiakov Gallery was about more than a museum. It was about liberal politics, modern art, and national culture in a time of war.

The appointment of a new director in 1913 brought renewed controversy to the Tretiakov Gallery, which had been the focus of city and artistic intrigue since Pavel Tretiakov donated it to the city of Moscow in the 1890s. After some public disagreement the city chose an art professional, Igor Grabar, an artist, critic, and art historian with links to the World of Art, who hoped to modernize the gallery, that is, to systematize, reorder, and historicize the collection. In Grabar's view, Pavel Tretiakov's well-meaning but amateur arrangement needed a new professional look, didactic presentation, and scientific mission that would include art from all eras of Russian history, not just the Itinerants and the other artists contained in Tretiakov's original collection. City politicians and artists briefly debated the wisdom of Grabar's proposed changes, but the duma seemed to resolve the problem when it voted by a narrow margin to allow him to conduct the modernization. Grabar proceeded over the next few years to replace Tretiakov's cluttered presentation with a simplified one that emphasized important paintings. He was given the formal power to define the contents of Russia's national museum, and, implicitly, the power to shape the canon of Russian art history, at least as it was represented in the Tretiakov.

Modern art was a core issue in the rhetoric of anti-Grabar activists after the Tretiakov Gallery issue exploded into the newspapers with a vengeance in January 1916. Contemporaries saw two sides in the Tretiakov debate: traditionalist or conservative artists who opposed Grabar, and modernist or liberal artists who supported him. Supporters of the anti-Grabar movement generally came from a variety of aesthetically conservative art groups or held conservative political and cultural beliefs. Many were established artists who clung to an idea of a museum of Russian art that conserved the art of their teachers, themselves, and their students, and they wanted to protect the preeminence of the Itinerants and other Russian masters from the growing acceptance of contemporary modern art in public life. Viktor Vasnetsov, the genre painter Vladimir Makovskii, and the conservative press were especially prone to criticize radical avant-garde art in their articles against Grabar, even though the director seems to have had no intention to purchase such art for the museum. These and other anti-Grabar activists took their objections to the newspapers in early 1916 after a noisy public resignation by Tretiakov board member S. A. Shcherbatov, just as the museum was being prepared for its final presentation to the public after several years of reorganization. Antimodernism, nationalism, and xenophobia became tools that allowed these campaigners to delegitimize modern art and disqualify it from Russia's museum, tools provided by the wartime discourse of patriotism, violence, and fear.[38]

Pro-Grabar discourse was different because it was linked to the political configuration inside and around the Moscow city duma, not to the anti-Grabar complaints and criticisms published in a variety of daily newspapers. Artists, critics, and intellectuals who supported Grabar's reforms turned the dispute from a discussion of aesthetics and national culture to one of party politics and the political role of art in society. They had a more focused discussion because they were concerned with the immediate and practical politics of lobbying the Moscow city duma. Grabar's advocates thus addressed their arguments primarily to the duma and liberal politi-

cians, not to the broad public, and their articles appeared only in a short two-week period in late January and early February 1916. Indeed, modern artists could at first ignore conservative challenges in the public because they had the votes to survive a challenge in the duma, where their political supporters, the left-liberals, had a narrow majority.

Real trouble for the advocates of Igor Grabar started when Evgenii N. Trubetskoi criticized the Tretiakov changes in a January 1916 newspaper commentary entitled "Invading Autocracy in the Tretiakov Gallery."[39] Trubetskoi was a Right Cadet, religious philosopher, and State Duma deputy who had participated in earlier liberal controversies about culture and nationalism. His motives for participation in this controversy are obscure. Possibly he agreed with city duma moderates who considered Grabar's management style and acquisition decisions to be an abuse of P. M. Tretiakov's original instructions to the city. Grabar had indeed sometimes made decisions on purchases, policies, and finances without consulting the Tretiakov board. Trubetskoi may, however, have chosen this political language for tactical reasons to keep modern art out of the gallery, for he was at that time writing and lecturing on the need to combat cosmopolitanism in the intelligentsia as a way to mobilize the country in wartime.[40] He believed that traditional Russian culture, especially the icon, could provide the consolation, healing, and redemption that Russian people (and indeed all humanity) needed in a world of chaos, violence, and materialism. For him, a return to traditional values would mobilize Russia for victory. "The icon," he wrote, "heralds the end of the war."[41]

Trubetskoi tried to mobilize liberal deputies against the museum reforms by casting the problem in classic terms of Russian political liberalism: the struggle against autocracy. In his article, modern art and the aesthetic character of the collection were not mentioned; instead, the Cadet politician pleaded with the left-liberal majority in the city duma to choose between "invading autocracy and the elements of public self-government in the Tretiakov Gallery." Grabar, according to Trubetskoi, had ignored the

public aspects of the museum's administration that were fixed in the gallery charter by the duma and the executors for the estate of deceased Tretiakov. He was an enlightened despot "not subject to any law or rule" who had refused to consult the museum board about acquisitions and other museum business. Trubetskoi was thus using the language of liberal politics to protect the gallery, unlike conservative artists, critics, and journalists who addressed the broader public in terms of aesthetics, moral justice, and nationalism. Such political language could justify a vote against Grabar in the name of anti-autocratic liberal values for those liberal deputies who might not accept nationalist or antimodernist arguments.

This article changed the public rhetoric of the museum controversy because it was an obvious attempt to sway liberal politicians against museum reforms. Trubetskoi had some success. His public intervention surprised and shocked Grabar, who called it a "slap in the face" from an unexpected direction.[42] Within a week, as Alexandre Benois remarked, a curious alliance between the reactionary Black Hundreds, "old-time" deputies (*starodumtsy*), and liberals was forming.[43] If Trubetskoi's arguments convinced wobbling deputies to vote against museum reform, Grabar's modernization program would stop and the national museum would be closed to modern art. Pro-Grabar activists had to gather support in the city council before a vote could take place. Mstislav Dobuzhinskii suggested to Benois on January 28 that they needed to defend Grabar with pressure on the politicians: "Our duty is to act collectively in public in his defense. After the declaration of the group of artists was brought to the duma with the clear purpose to act on the duma, we have to *do exactly the same*."[44] Major World of Art figures began to draw up declarations and petitions to support the museum director. Benois's intimation that dark political forces stood behind the anti-Grabar movement may itself have been a subtle attempt to scare or shame left-liberal doubters and to mobilize modern artists to support Grabar.

The most comprehensive public statement of pro-Grabar sympathies was the "Declaration of Artists and Art Specialists" of February 4, 1916. Some forty artists, academics, critics, and collectors signed this letter, which was reproduced in several daily newspapers in Moscow. Many were linked to the World of Art and Union of Russian Artists, but Vladimir Tatlin, Liubov Popova, Aristarkh Lentulov, Georgii Iakulov, and Ilia Mashkov also signed for the avant-garde. These pro-Grabar artists and critics argued that the Tretiakov should not represent a particular era or collector. "Old art and new," they asserted, "have equal rights to be in the gallery, for they are only various phases of our art history. The more complete the gallery represents them, the better."[45] This position reflected the cosmopolitan sensibilities and professional interests of modern artists, for a Tretiakov museum open to modern art meant prestige and income as well as a more realistic (from their point of view) representation of Russian art history. For the first time, the avant-garde and World of Art took a common public stance on a political and professional issue, in effect creating a broad coalition of modernists. Modern artists, bitterly divided between aesthetic modernists and avant-garde in the public culture of the art world, united to support their interests in the different milieu of left-liberal politics.

The artists who signed the "Declaration" defined the Tretiakov controversy largely as a political issue, not an aesthetic or moral one. They rhetorically linked their political and artistic opponents with autocracy and political conservatism: "The demand of the right-wing deputies [*pravodumtsev*] and a group of artists to annul the gallery reform work is a demand of artist-reactionaries, and the struggle of progressive [*peredovykh*] duma members and the gallery board in defense of the renovation of the gallery is a struggle for artistic progress."[46] In this way modern art stood for progress, while opposition to it represented reaction. There was no middle course under these terms and no intention to allow one. Grabar's supporters wanted to give a stark choice to a specific narrow audience, a set

of wavering duma deputies: either you support us progressives or you are with those reactionaries. The newspaper editor who pegged a disclaimer to one pro-Grabar declaration showed that the real danger was wobbly liberals, not conservatives, reactionaries, or Black Hundreds: "In fact the matter is about several left-wing deputies [*levodumtsy*] who are against Grabar's reform."[47] Plans to make a vote on the Tretiakov subject to party discipline in the duma show that Grabar's supporters took seriously the possibility that they might lose.[48]

The intended audience received the message. Sergei Kotliarevskii, a prominent Right Cadet, wrote a letter to the liberal Moscow daily *Russian News* on February 5, the day after the "Declaration." His letter shows that dissatisfaction with Grabar's policies ran deep inside a powerful wing of the liberal movement. He turned the tables on the modernists of the "Declaration" who had painted Grabar's opponents as reactionaries. "If it is necessary to speak of reaction in art," he wrote, "then everything is reactionary that limits freedom and independence, reactionary because of the introduction of political standards."[49] For Kotliarevskii, to argue over the location of paintings on the walls of the Tretiakov was to divide the country's political forces at the very time when those forces should concentrate on practical political and social work. His call for artists to put aside their squabbling represented liberal hopes to mobilize the country for victory in the war. But Grabar's supporters understood this argument to suggest that they should cease public lobbying and accept the old gallery. They worked immediately to quash liberal doubts about modern art.

The liberal art critic Abram Efros responded the next day with a reaffirmation of the importance of politics in culture. Efros made Grabar's reforms palatable to doubting liberals using the classic language of liberal social utilitarianism, the mirror image of Trubetskoi's rhetorical approach (which had used the language of liberal anti-autocratic politics against Grabar). For Efros, the form of an art gallery was always linked to politics "because modern museum improvement [*obnovlenie*] . . . runs not

only under the banner of aesthetics but also the democratization of national art collections." Museums were no longer private collections for the pleasure of occasional guests, but public institutions that served a broad audience. Efros reminded his readers that public authorities had the obligation to permit public galleries to fulfill vital didactic and other social functions. "To stifle or ignore this role of the public [*obshchestvennost'*] in art," he concluded, "would be a dangerous misconception."[50] Modern art strengthened Russian culture not because it was beautiful or Russian but because it furthered the general education and cultural development of the Russian people. In this sense Russian art was broadly defined to include all art produced in Russia, and modern art, even radical art, had an important role to play in modern Russian culture.

The attempts to make modern art foreign and exclude it from the Russian national museum failed. In early 1916 city duma deputies put off a vote on the museum and created a commission to determine the legal powers of the director and the duma. Modern artists and their supporters ceased their lobbying in the press. Anti-Grabar articles continued for several months, but Mikhail Nesterov sensed the end was near in April 1916. "The war with Grabar is not over," he wrote, "but chances are great that all our agitation [*volneniia*] will be in vain."[51] In the end, the commission refused to recommend the removal of Grabar or the reversal of museum reforms, and in May 1916 the duma ratified its recommendations. The politicians reserved for themselves the right to approve new acquisitions from any artist not represented in Tretiakov's original collection. This political control over art was apparently acceptable, for Grabar remembered the outcome as a "great victory."[52]

Modern artists had mobilized themselves publicly to achieve the professional goal of attaining the recognition necessary to gain a place in Russia's national gallery. The resolution of the Tretiakov debate implicitly recognized the mission of the museum to represent a broad definition of Russian art, not conserve the collection of P. M. Tretiakov. Since Gra-

bar was allowed to continue his work, the gallery would include different types of Russian art, not just the Itinerants or any other formally recognized school of Russian painting, and the institutionalization of modern art in Russian culture continued. Important representatives of the radical avant-garde had entered a public debate on the side of other modern artists for the first time, and modern art was allowed to enter Russia's art-historical canon, at least as it was represented in the Tretiakov Gallery. They had joined a public debate to serve their interests, and the tone of the debate was not only filled with war language and militarized speech but was also deeply embedded in liberal politics. In 1916 the avant-garde's public politics reflected the liberal politics of a Moscow city duma that supported their professional interests.

Evil Happenings: Mobilization for Revolution and the Crisis of the Public in 1917

Revolution in 1917 brought important changes to the public culture that sustained Russian artists, and in response they shifted their mobilization in civil society from the culture of war to the revolution of the profession. In late 1916 and early 1917 the public sphere began to destabilize under the economic and political strains of war. In the broader economy, food shortages became more common, and inflation accelerated (see table 7 in the appendix). A visual expression of economic dissolution and disarray was the crisis in the publishing industry. The number of photographs in the *Flame* dropped suddenly from over 85 percent of all images in August 1916 (a level roughly steady since the first months of the war) to around 45 percent in December as it became more difficult to produce photographs. Public opinion toward the war, and the future, began to shift as the economic position of the middle and working classes declined in 1916.[53] Defeatism and disillusionment grew among the populace, and political tensions increased in the State Duma. Maurice Paléologue saw anxiety and downheartedness on New Year's Day 1917: "No one takes any more inter-

est in the war, no one believes in victory any longer; the public anticipates and is resigned to the most evil happenings."[54]

World War I was the mobilization event that had first united artists in public action and patriotic culture, and as such it patterned their response to events in February 1917. Artists, like the rest of society, welcomed the end of the old regime in late February and early March 1917. Public mobilization, patriotism, and enthusiasm revived after months of discouragement and pessimism. Learning from their experience in 1914, critics and artists alike were optimistic that revolution would not hinder artistic life. They set up exhibitions, auctions, and charity institutions after February 1917 as they had after August 1914. Public engagement for the war continued when organizers exhibited Finnish modern art and donated proceeds to the war effort, and several artists produced war posters to rally popular support for the continuation of the war.[55] But more often public mobilization was transferred from the war to the revolution. In April the large interparty charity exhibition Artists of Moscow for Victims of Political Repression echoed 1914's Artists of Moscow for Victims of War in spirit and form. Artists from all aesthetic styles proclaimed their revolutionary sympathies and credentials at meetings and gatherings as they had proclaimed their patriotism in 1914. The institutions and attitudes that artists had earlier mobilized for total war now were used to support a new democratic Russia.

Public mobilization in the art world did not change with the February Revolution; what changed was the goal of those who mobilized as engagement with war shifted to engagement with revolution. Artists, illustrators, and publicists resurrected the visual culture of the war to reflect the revolution as patriotic agitation and enthusiastic propaganda revived. The revolution, like the war in 1914, suddenly appeared in postcards, posters, and *lubki*, and the agitprop trains and traveling exhibitions of the Provisional Government continued a tradition of wartime trophy tours. Battle painters and illustrators transferred the culture of war to the revolu-

tion when they sketched illustrations of street battles and revolutionary activity; the forces of the old regime replaced the Germans as the enemy in revolutionary iconography, but the heroes remained ordinary Russian people. Maiakovskii even re-created the look of Today's Lubok with revolutionary prints that echoed his wartime work, but with a stunning change: Nicholas II now appeared as the enemy of the people instead of the people's leader against the enemy.[56] Such artistic engagement with contemporary events had no more success among critics than before; several complained that artists could not depict the reality of revolution, much as they had decried the attempts of realists to reproduce war.[57]

One difference between 1914 and 1917, however, was that political restrictions and social conventions broke down in 1917 as the state and traditional art institutions fell into deeper disarray, which in turn opened public space for individuals and groups to mobilize more completely. The heightened institution-building of the war years broke open as freedom in February gave artists the ability to form institutions outside the traditional art world and to organize their profession without state interference.[58] The number of art groups spiked sharply in Moscow and Petrograd as over one hundred groups existed throughout the country in 1917, a number never seen before in Russian history (see graph 2 in the appendix). Twenty-eight new groups appeared in 1917, more than twice as many as in 1909 and three times more than in 1914. Artists used such institutions to protect their interests in a time of political instability, economic disruption, and institutional confusion. A national Union of Artists, for example, emerged as an umbrella organization to unite the many local professional unions that popped up to represent the economic interests of artists and the art world.

Modernists found it easier to enter public institutions as the traditions of the group-based art world that had begun to weaken during the war years collapsed. The academic milieu and its aesthetic supporters were discredited, newly formed unions, advocacy groups, and special commis-

sions took organizational power away from the major art groups, and new public tasks needed to be undertaken, such as the protection of monuments from revolutionary vandalism. In March, Maxim Gorky and other cultural notables, including several members from the World of Art, set up a commission for the preservation of museums, art, and cultural heritage.[59] This commission, the Union of Artists, and other professional organizations were in essence the institutional realization of the informal unity that had covered the art world after 1914. Radical modernists could now join the general public mobilization to support their art and their place in an art world suffused with professional instability, a development that would have been unimaginable before 1914. "Left" artists thus entered the Moscow art union as a recognized faction next to "right" and "center" artists. Modern artists who had supported the war, Imperial Russia, and the war effort now worked for the revolution, for Russia's cultural heritage, and for themselves.

Professional tensions remained high despite this rapprochement. The future boundaries of the art world were uncertain, and artists struggled to have a hand in shaping that future. In March, prominent artists and critics in the World of Art and the Union of Russian Artists moved to take over the institutions of the old Imperial art system as Alexandre Benois and his colleagues began negotiations with the Provisional Government to convert the Imperial Ministry of the Court into a Ministry of Arts. These modern artists believed that they were best able to protect art treasures and administer art policy in the aftermath of revolution, and they wanted to institutionalize the link between art and politics with themselves as the leaders. Others, including the avant-garde and aesthetic conservatives, interpreted these proposals as an unacceptable conflation of art and politics which excluded them. Olga Rozanova seemed surprised to find herself in the midst of intense, acrimonious institution-building in April 1917: "I am: a member of the Trade Union Club, a member of the cooperative, a delegate from Supremus [a planned suprematist journal], and the secre-

tary of the journal by the same name. . . . as soon as I get home from work I have to go to one meeting or another and from 7 to 1 in the morning listen to people talking nonsense. This whole time the only intelligent things I heard were from David Burliuk and Mayakovsky. Some artists really are awful. . . . They go on sputtering away as before. . . . these wretches have reduced everything to a bureaucracy."[60] The struggle for the art world thus increased in 1917 as mobilization in civil society increased.

Most artists' plans were moot by the summer as the public sphere contracted and the art world shrank. The Provisional Government failed to solve Russia's manifold problems, and the country sank into social revolution, economic collapse, and political chaos. This disorder diverted attention away from art and the unsolved problems of the art world as society became preoccupied with political and economic questions.[61] The art season of 1917–18 began earlier than usual and continued after the Bolshevik takeover in October 1917, but attendance was down (sales held up; see tables 1–4 in the appendix).[62] Abram Efros noted in early 1918 that "the center of artistic life has shifted from creation to protection," and he saw that "depression and dejection reigned in the exhibition halls."[63] After October several influential newspapers were banned, and news and reviews of the art world were put out of reach to the public. The Hermitage was closed and prepared for evacuation as the Germans approached, and other museums experienced deep financial and administrative problems. During the Civil War (1918–21) professional life vanished, institutions dissolved, artists fled abroad or to the countryside, and the money economy disappeared. The number of art groups dropped sharply in 1918, 1919, and 1920 (see graph 2 in the appendix), painters stopped painting, and established groups like the Union of Russian Artists did not exhibit (see graph 3). Civil society, the art world, and the mass commercial culture lay in tatters. In 1919 Udaltsova wrote in her diary of how the inadequacies of life impeded artistic practice: "How cold and hungry life is in all senses. . . . There is no personal life, there is no creation."[64] Public support for professional art activity had collapsed.

In 1917 the language of war and the habits of mobilization that avant-garde artists gained after 1914 continued. The Last Futurist Exhibition 0.10 truly was the last; during the 1916–17 and 1917–18 art seasons, suprematists presented their work at the Jack of Diamonds and intergroup exhibitions but spent much of the revolutionary year organizing committees, unions, and lectures alongside artists from the other art milieus. This public work meant that the previously iconoclastic avant-garde worked, ironically, to protect Russian art. Kazimir Malevich was mobilized enough to join a commission attached to the Moscow Soviet to promote art education among the people and to chair a committee for the creation of a People's Academy of Art.[65] The suprematists were now a part of the art world, but public instability made work difficult for them as for other artists. In December 1917 Malevich was trying to hold the milieu together with a language of militant politics and merciless warfare. Udaltsova described how he tried to force her to come to his views during a disagreement:

> Malevich went a little crazy [*nemnogo spiatil*]. We had a conversation.
> —I want to introduce party discipline [he said].
> —Well, with yours that is easier to do than with mine. We have a group.
> —Then it is total war [*voina besposhchadnaia*].
> —That's ludicrous, Kazimir Severinovich, I speak of how we should work together to come to some agreement, and you [speak of] war.[66]

Ivan Kliun remembered World War I, not the revolution, as the spark that changed the structure of the avant-garde world: "The war of 1914 mixed everything up, and futurism dispersed, but the revolution completely finished it."[67] Radical art in the new Russia would have to seek a different public expression.

Constructing a Soviet Art Public:
Avant-Garde Artists and the Bolsheviks

The key characteristic of the immediate post-revolutionary art world was the massive disorder caused by a collapsing civic society, economic chaos, and uncertain public culture. Professional artists no longer had traditional bases for support as the art world contracted, and the October Revolution threatened to change the fundamental structure of the art world. The art milieu that was weakest in the pre-revolutionary public, the one that had an unsteady public position, fewest connections to mainstream life, and least material power, was now in a better position than before to build its new art culture.[68] The most vulnerable of artists, the avant-garde, joined other disgruntled professionals, quasi-professional groups, and paraprofessionals of all types who proved to be "a major source of recruitment into professional occupations during the early Soviet period."[69] When the avant-garde tried to mobilize a public for revolutionary art, their politics and professional goals merged in a new, more public fashion. As Paul Wood has put it, the Bolshevik Revolution gave "these artistic developments a political focus and in so doing further transformed them. The result was a specific conjunction, a union even, of the formal and the political: an avant-garde practically transformed by a wider social revolution."[70] A specific form of revolutionary politics, Bolshevism, had come to define the public space devoted to art in Russia, a situation that did not exist prior to October 1917.

Bolshevik leaders had not needed an art policy before October, and they had no consistent, extensive, or unified attitude toward the arts when they came to power.[71] Most expected that a socialist art would emerge to eclipse old aesthetic values and wanted art to mobilize the masses and bring the revolution to the people, but they were not sure what defined proletarian or socialist art, and they did not have experience in art administration. Civil society had all but disappeared, and the country's new rulers relied on the

state to keep art affairs going, a policy amenable to Bolshevik political instincts. They moved quickly to nationalize existing private art collections and institutions and to set up new state institutions. izo Narkompros, the Department of Fine Arts of the People's Commissariat of Enlightenment (Ministry of Education), became the first official state department in Russian history designed to administer art policy and artistic affairs; it organized art exhibitions open to all forms of art, ran art education, and produced art publications. By 1919 juries at state exhibitions were abolished, entrance was made free, and izo Narkompros was given "rather large sums" to acquire paintings.[72] The art scene in the early years of the revolutionary regime was thus in a state of flux, a condition that the government addressed with state control of institutions but aesthetic toleration for any artists who did not engage in counter-revolutionary activity.

The Bolshevik takeover and the collapse of the Imperial Russian public provided an opportunity for avant-garde artists to build a new public for a new world. Anatolii Lunacharskii, the first People's Commissar of Enlightenment, played a crucial role in developing early Bolshevik cultural policies, and he advocated a policy of broad coalition because he knew that the revolutionary state needed allies in its early uncertain days.[73] Lunacharskii tolerated radical modernism, but he was not a partisan of the avant-garde inside the art administration, and he mistrusted expressions of institutional independence, an issue that caused friction between his ministry and the artists who worked for it. Government support for the avant-garde was, in part, a practical arrangement that came from the need to protect the art world from total collapse. Avant-garde art had material advantages; it was cheaper than easel painting and had wider application in architecture, theater, posters, and public festivals. Some argued, moreover, that avant-garde styles would be an effective visual language to reach peasants and common folk, and the new art promised to improve industrial production through efficient design. Finally, many avant-garde artists volunteered to work for the new revolutionary government. One rea-

son why they could so easily take the professional field for themselves was that artists from other milieus had the means to escape to the countryside or abroad; many Itinerants simply went into hiding.[74] The identification of such art groups with the old establishment also served to discredit them in the early revolutionary days.

The Bolshevik Revolution allowed artists to give a new political meaning to avant-garde art that was created in war. "Into this chaos," Aleksandr Rodchenko wrote, "came suprematism extolling the square as the very source of all creative expression. and [*sic*] then came communism and extolled work as the true source of man's heartbeat."[75] The collapse of the pre-revolutionary art public and the uncertainty in the new government's policies created an opportunity for the avant-garde to create a new radicalized art culture. Utopian dreams seemed realizable after the old restrictions on public expression collapsed, and many different groups presented ideas for shaping the values of the new revolutionary culture.[76] Constructivists, suprematists, production artists, and other "left" painters took the non-objective art created during the war and removed its links to the art world. Many hoped to remake life through art, which in the era of the proletarian revolution meant fusing technology and art to produce objects that would be aesthetic and functional.[77] The avant-garde continued to exhibit their art, discuss it in journals, and teach it in art schools, but they also brought art into factories, workshops, and design schools, and their art merged with the material world as artists built it into dishware, books, clothing, furniture, and other objects of daily life. VKHUTEMAS (Higher State Art and Technical Workshop) thus became an important school of design that combined art education and a guildlike atmosphere in a curriculum designed to create the "artist-constructors" who could help construct a new socialist culture.[78] For them, socialism would be realized when the differences between art and artifact, between creation and labor, were broken down.

Avant-garde participation in early Soviet artistic life represented a victory for a milieu that had been oppressed in professional and material terms before the revolution. Tatlin did not hesitate to take advantage of the situation. His desire to lead an organization of professional unity at the beginning of World War I was realized after 1917 when he became a functionary in IZO Narkompros in 1920.[79] To Vera Pestel, Tatlin himself seemed surprised that someone would appoint him to an important position within the art world: "A miracle happened. Lunacharskii came for me in a car and now I am here." He intended to use his new power to help avant-garde colleagues: "Bring your paintings, we will buy everything. I have money now, like a prostitute, and a fur hat." Pestel remembered how the avant-garde rejoiced in their professional victory in the war against their aesthetic rivals. "The government bought us, gave us commissions," she wrote. "It was happy and exciting. They thought the world of us. We defeated the World of Art, the Association, the 'Blue Rose' and other aesthetic groups. We didn't even talk about the Itinerants. They had already left the front of art a long time ago."[80] Artists like Tatlin had finally come into their own, protected by public institutions, after years on the margins of Russian art culture.

Material desperation and professional ambition were powerful incentives for radical artists to participate in the construction of this new art world. Udaltsova described her desperate situation in May 1918 after the art world had collapsed and removed any chance for her to live as an independent artist. Her existence as an artist depended on the policies, even whims, of the government: "How sick I am of everything—the councils, the schools, the boards. I want to work, live, and love. But to work, you need money, to live, you need money, and to love you need free time. . . . But the board [of IZO Narkompros] probably will not approve, and money will disappear. Hunger is advancing; to survive you have to earn 1,000 rubles a month, although the school, I think, will keep me."[81] Pestel described the material advantages that cooperation with the new govern-

ment brought: "Until then Tatlin walked around year around in an old gray cloth overcoat, without gloves, in the same coarse felt hat.... Now he has a studio, was dressed in a fur coat, ... on his head was a fur hat with earflaps and fur boots. Dressed like that he sat in his office in IZO."[82] Kliment Redko recognized who buttered the bread: "Artists knew in practice that there would be constant work for them only from the Bolshevik government."[83] Even some who cooperated for a time eventually put their professional life over political principles; artists like Kandinsky, Chagall, Boguslavskaia, Kliun, and Gabo eventually emigrated to pursue opportunities abroad rather than face the uncertain and difficult conditions for art in the early Soviet Union.[84]

In fact, the art world in the immediate revolutionary period was never exclusively controlled, or even dominated, by the avant-garde. Bits of the old, battered art public survived as the avant-garde, conventional artists, and the Bolsheviks struggled to create a new one. Grabar continued his work in the Tretiakov Gallery, and Benois directed the Russian Museum and worked closely with the revolutionary government to protect historical works of art. A partial re-inflation of the traditional art world occurred when the New Economic Policy (NEP) in the early 1920s allowed for a measure of private economic activity after the Civil War ended.[85] The art market revived, pluralism reappeared, and old institutions of the pre-revolutionary art world resurfaced. In 1922, for example, one large charity exhibition raised money for famine victims.[86] The Itinerants and Union of Russian Artists exhibited until 1923 (see graph 3 in the appendix), while new groups formed, including the Union of Realist Artists (Ob"edinenie khudozhnikov-realistov) (1927–32).

This recovery of the old art life was only partial, for the economic situation and the role of the government were different in the 1920s compared to the Imperial period. Mikhail Nesterov noted how dissimilar public space seemed in 1920: "Moscow has changed greatly in two years, there is no trade and everything that accompanies it: advertising, stores, markets,

and the rest do not exist."[87] For him, the success of the avant-garde was all too visible on the walls of the Tretiakov, an outcome that he had fought fiercely in 1916, and the illegitimacy of the new state was demonstrated by the confusion of its art culture: "the Tretiakov Gallery has been expanded with a new room of extreme trends. . . . A lot of monuments have been put up. Alas, very bad ones!" Nesterov had been one of Imperial Russia's most successful artists, but he found it difficult to restore his position in face of the material hardship. "I am slowly returning to work . . . but working is hard: there is no paint." In 1921 he wrote that art prices were high in Moscow but that he was not rushing to sell paintings due to tremendous inflation.[88] The next year he did show two paintings at the Union of Russian Artists exhibition, which was visited by "a lot of people" and had "good work" from old and new artists.[89] Yet the exhibition remained a shadow of its former self with some five thousand visitors, a number that would have been seen as a failure before 1917 (see graph 3). The art world under NEP was not its imperial counterpart; it contained a heightened role of the state, a mishmash of ideas and institutions, a new, politicized Soviet public culture, and an unstable economic environment.

The power to define revolutionary art resided in public culture, and artists struggled to shape that culture to support their art in this early Soviet period. Radical artists were keen to remove other artists from art institutions or prevent them from public activity, and strife and infighting within the avant-garde itself was common.[90] Malevich, for example, wrote to El Lissitzky in 1924 that "in spite of all the high-up avant-gardes of the reactionaries . . . I am conducting attacks against their positions," including "that idiot Tatlin."[91] Disagreements continued in an environment where the proper role of art in a revolutionary world was not settled, and new artistic groups emerged to challenge the avant-garde's professional status. Some spurned constructivism in the hopes of developing a "viable and socially relevant Modernism" similar to the New Objectivity (Neue Sachlichkeit) that appeared in Europe.[92] Others rejected radical

modernism altogether. The Association of Artists of Revolutionary Russia (Assotsiatsiia khudozhnikov revoliutsionnoi Rossii) (1922–32) appealed to younger artists who wanted to apply the style of the Itinerants to contemporary political events, and soon it became one the country's important art groups.[93] "Only now," the association declared in 1924, "is it becoming clear that the artist of today must be both a master of the brush and a revolutionary fighting for the better future of mankind."[94] To distinguish itself as the only group of artists devoted to revolutionary culture, the Society of Easel Painters (Obshchestvo stankovistov) (1925–32) rejected Itinerant realism, non-objectivity, postimpressionism, and any trends of the old art world that did not represent revolutionary modernity (*sovremennost'*).[95] Soviet artists needed to be artist-revolutionaries because such language promised professional success in the new Bolshevik public environment.

The avant-garde was forced to uphold its revolutionary nature as it came under attack from other groups. Aleksandr Rodchenko defended them from antimodernist criticism when he argued in his memoirs that extreme poverty and isolation had led radical artists to oppose the capitalist order and its art world during the war:

> Those who write that left art was a perversion of the bourgeoisie or its mirror are not right. In 1916 I took part in a futuristic exhibition called The Store. In those days I walked around winter and summer in a ragged autumn coat and cap. I lived in a room behind the oven in a kitchen partitioned with plywood. I went without food. But I despised the bourgeoisie, despised their favorite art: The Union of Russian Artists, the aesthetes of the World of Art. I was close to the unprotected Malevich, Tatlin, and others. We were rebels against accepted canons, tastes, and values. We did not work for the taste of the bourgeoisie. We disturbed their tastes. They did not understand us and did not buy.[96]

The Left Front of Arts argued in 1923 that the futurists alone had turned against the war and seen the coming revolution. Yet to their opponents, the war experience proved the opposite. In 1915 the famous realist writer Leonid Andreev had already used the cooperation of the futurists with society and their convergence with the establishment to undermine their claims of opposition and concern for the people. He, too, saw the war as a test, but a test they had failed with their frivolous and superficial art: "They live and breathe only for the petit bourgeois philistine [*meshchaninom*] and serve only him, and their dreams—that is the love of the philistine, who is always generous to those who can entertain him."[97] The avant-garde's rivals knew what Rodchenko tried to obscure: many radical artists had cooperated with the established order in World War I and had aspired to join its culture before the Bolsheviks came to power.

Soviet public culture eventually proved hostile to the avant-garde and intolerant toward institutions outside state control. The position of radical modernists in the early Bolshevik art world was never secure. In 1922 Lunacharskii suggested that nonrepresentational methods were "powerless to give psychological expression to the new content of the revolution," but Malevich refused to concede to anyone outside the artist the ability to determine the form of art: "the true artist will never agree to limit himself to the object of practical realism and its content."[98] The Stalinists settled the uncertainty of the post-revolutionary era when an authoritarian state and totalizing public discourse replaced civil society to become the context where public art was produced.[99] This new art world was different from its Imperial and NEP predecessors because control over art was taken away from independent artists, organizations, and buyers, that is, from the professionals and art consumers who determined the boundaries of the public for art in civil society. The socialist realist artists of the Stalin era did not serve an independent art public; they addressed a public that consisted of the party and party-controlled institutions. This official public was much more effective at mobilizing culture, for all work

that did not meet party standards had to remain in the intimate sphere. Avant-garde artists could still create art that was not acceptable in Stalinist public culture, but they had to work in secret.[100]

The link between avant-garde and Bolshevik revolutionaries was not forged in late Imperial Russia but in the early revolutionary period, and even then it was tenuous. Little suggests that the pre-revolutionary avant-garde differed much from the rest of the intelligentsia or educated society in their political attitudes; their art became overtly revolutionary in a public sense only after 1917, when they experienced widespread personal and professional distress, faced the collapse of the art world, and encountered tolerant but uncertain Bolshevik policies. What mattered most for the politicization of art was the specific character of the surrounding public culture that enabled professional art activity. Individual political attitudes did not lead artists to support Bolshevism before 1917, nor did antipathy or indifference prevent cooperation after 1917, and avant-garde artists took the side of national patriots in 1914, liberal politicians in 1916, and Bolshevik revolutionaries in 1917 to protect and boost their position within the art world. They were already on the way out by the 1920s, redefined by other artists, critics, and political authorities as bourgeois formalists to deny their legitimacy as acceptable artists.[101] In 1921 Malevich was livid because he felt excluded from plans to stage a Soviet art exhibition abroad, and his professional powerlessness and dependence on state power were plain in the sarcasm he directed at IZO director David Shterenberg: "You David Petrovich are in charge. . . . This is why I am writing to you, because you have power, I have ideas without power, and this is why you must do as I ask in this note. Thank you for the food parcel, my wife has begun to spit blood."[102] Individual modernists could continue to work in Stalinist public culture if they produced acceptable work, but they, together with the rest of the independent art world, were abolished as free professionals with the introduction of Stalinist cultural policies in the 1930s.

Conclusion

In 1915 Kazimir Malevich was supremely confident that Europe's artistic tradition lay in ruins. His striking *Black Square* (figure 1) was to be the absolute, indestructible zero point for the construction of a new human culture, a culture designed to replace the old, corrupt, and dying art of European civilization. But Malevich could not have imagined that he and the *Black Square* would help shape a revolutionary Bolshevik culture in the early 1920s, find an echo in abstract expressionism in the 1950s, or grace the Guggenheim in the 1990s. For Malevich was unsure that he would live out the year 1916, let alone become an icon of modern twentieth-century life, when the battlefields of the eastern front loomed before him like a bloody canvas. "It doesn't depress me that I am going to war, that I am going to fertilize a square arshin of earth," he wrote while awaiting conscription in 1916. "Worse is that I can foresee no quick end or peace, nor the years it will take to see again that life that existed on the fields of art before the war."[1] Malevich did survive, but the First World War had already transformed the art world he knew. That world was soon to be destroyed in the revolution and Civil War.

World War I changed the parameters of public life in Russia, if only for a few years, and we should not underestimate the importance of those changes. A mobilized and militarized culture of war expanded across civil society, and public structures, priorities, and expressions were altered as war suddenly became a problem that was shared by more people at once than was any previous event in history. This mass mobilization of the pub-

lic did not mean that all individuals were mobilized, but it did mean that public engagement and expression became focused on the war and its effects. Individuals experienced similar problems as the war's effects rippled through the public sphere, and an unprecedented social and cultural mobilization increased social communication between different groups, aligned diverse interests, and disrupted prewar norms and institutions. Public culture became more fluid as people sought to bring order to the chaos and uncertainty that such disruptions brought; they had to find new ways to sustain themselves as familiar social roles, cultural assumptions, and financial support destabilized. Mobilization was much more pervasive, and much more complex, than the traditional Russian myth of the war experience, with its focus on social fragmentation, failed patriotism, and weak civil society, would have us believe.

The experience of the art world shows that Russian civil society expanded during the war years. War and art had seemed to be two separate activities before the war, but the lines between the art world and the broader public weakened after 1914, and artists participated in great social events on a scale that would have been unthinkable in the previous decade. Artists were not only capable of self-mobilization, but they continued to innovate in the public sphere even as the war ground on and revolution came upon them. They produced militarized culture on a new scale, created new institutions in charity events and intergroup exhibitions, and found new audiences as refugees and the nouveaux riches joined the art market. After 1914 a different art world emerged in Imperial Russia, one based more on individual painters and with a more active and diverse public for art, but this art world remained based in civil society and needed a stable economic, political, and social environment to operate. World War I thus enabled and enlivened civil society, but, ironically, the economic, social, and political problems that it brought hindered the ability of individuals to self-mobilize in 1917.

The Great War had a great impact on the public place, internal culture, and visual practice of Russian modernism. Wartime mobilization enabled radical modernists to enter public culture and the mainstream art world for the first time in their careers, and many artists, whether in the aesthetic modernist or avant-garde movement, reduced their public isolation as they sought to protect their artistic milieu and align it with the culture, politics, and institutions of broader society. The emotional impact of the war, the desire to tell stories about it, and the tilt toward conservative taste in the market led aesthetic modernists to adopt narrative and more figurative art, while public patriotism, professional ambitions, and material needs turned the avant-garde from public iconoclasm and aesthetic destruction toward public engagement and aesthetic construction. The changes in public culture brought on by wartime mobilization gave painters in both modernist milieus opportunities to participate in areas from which they had been excluded or self-excluded, and they became allies to protect the place of modern art in Russian culture during the Tretiakov Gallery debate. Avant-garde public mobilization, political engagement, and integration into mainstream culture began in the mobilization for World War I. These shifted toward revolution only as the public culture changed in 1917.

A key moment in the history of Russian modernism came when public space opened and the avant-garde dropped their challenge to the public in World War I. It is unclear whether they were ever aesthetic revolutionaries in the sense that they sought to destroy the existing art world and replace it with a new one, but their public utterances and behavior did pose a challenge to established society, culture, and politics before the war. In 1914 individual aspirations and ambitions entered the public culture for all to see as avant-garde artists produced patriotic culture, self-mobilized in war charities, participated in liberal politics, and created non-objective art. "We must present the artistic guild with a vigorous call to unite," declared Vladimir Tatlin in 1914, and he offered up the avant-garde for col-

laboration: "I believe that precisely those who have been rejected, who are blamed above all for partisanship and irreconcilability, will be the first to stretch out their hands in reconciliation."[2] In their relationship to prevailing public power, the avant-garde were, ironically, less revolutionary when they participated in early Soviet art culture than when they painted their faces in 1913. It was in the mobilization for World War I that Russia's radical modernists changed their art culture to accept established authority, a stance they maintained when they cooperated with the Bolshevik state.

A close look at the war experience makes clear that artists in Imperial Russia, including the supposedly apolitical aesthetic modernists and allegedly revolutionary avant-garde, were part of a professional culture in a pluralist public sphere. Even during the revolution and early Soviet period, professional values often trumped political activity. Olga Rozanova, for example, put her occupational identity above all else as she intensified her public engagement in July 1917: "Speaking generally, I want to be an artist first and only then all the rest . . . I want as soon as possible to paint pictures and write articles, and I am absolutely convinced that this is what I must do!"[3] Kandinsky admitted after he returned to Germany in 1922 that his contributions to early Soviet culture had not reflected his personal interests: "I did a great deal of work, but for the 'public Good'— my [own] work was always left behind; I stole the time for it from the public Good."[4] As a part of public culture, avant-garde art was not inherently totalitarian, communist, fascist, nationalist, anarchist, or liberal; its political meaning shifted with political, social, and cultural changes in professional life. To see the art of the pre-revolutionary avant-garde as the inevitable art of the revolution is to read back into history what did not exist at the time. It is to accept the terms of a Soviet public culture in which all artists had a professional interest in emphasizing their revolutionary credentials over the bourgeois nature of their opponents.

The revolution, of course, cannot be removed from Russian history, but the case of Russian artists in World War I reminds us that Russia has an-

other history, one that can contribute to our understanding of the war, artistic politics, and modern aesthetics. The war experience shows that, in many ways, we can view the entire period from 1914 to 1921 as a process of mobilization, one interrupted by a change in political context.[5] Perhaps we should imagine not what would have been different without the war but what would have been different without the revolution or with a different revolution. Modernism in the arts would probably have had a more central place in later twentieth-century Russian culture; it is easy to imagine the avant-garde, in other conditions and with a different history, achieving public success in a constitutional monarchy, democratic republic, or conservative nationalist order, as many Russian émigré artists did in the interwar period. A failed revolution, on the other hand, might have deflated and discredited the avant-garde, as in Germany, where expressionism as an art philosophy to remake modern life failed in the German Revolution.[6] We will never know, for the Bolshevik Revolution wiped out all alternatives, and the Soviet experience renders impossible any attempt to recover other histories. In this sense, the significance of the war for Russian history after 1917 can never be known in a way that makes it comparable to the experience of people in Britain, France, or Germany.

We can, however, judge World War I's significance for Russian history before 1917, and there is one artifact that can always confirm its importance: the *Black Square*, now hanging in the Tretiakov Gallery. Its existence testifies to the influential effects of the war on Russian and world culture. Pablo Picasso, Wassily Kandinsky, František Kupka, Mikhail Larionov, and other artists all developed abstraction to various degrees before 1914, but they never gave up the object in art. Nor was the year 1917 a landmark for formal innovation.[7] The great break to non-objectivity came with suprematism in 1915, and it was in war that the Imperial Russian avant-garde created visual forms that revolutionized how we adorn and view the world.[8] It may not be a coincidence that the artists who redefined abstraction as non-objectivity, and art as artifact, did so after experiencing wartime dis-

location in their personal lives, radical shifts in public culture, and sudden isolation from the international modernist public centered in Paris: Tatlin and Malevich in Russia, the Dadaists in Switzerland, and the De Stijl artists in Holland. Russia's non-objective artists were largely forgotten after the 1930s and little recognized in modern art history until the 1960s, but their influence is still seen in the design of modern buildings and contemporary abstract art. Malevich, whom almost no one took seriously in 1915, was a spectacularly successful artist from this point of view. His elemental creation can never be destroyed even if the physical work should become lost, just as Tatlin's vanished corner counter-relief (figure 21) can be re-created as a site of memory for the creativity of artists in Russia during the Great War.

A non-objective art that countered the disorder of war found little space in Bolshevik public culture. The Soviet Union had a different public orientation, one that tried to bring the Bolshevik Revolution to a population who did not understand it and to organize violence against internal enemies. The Bolshevik language of revolution contained within it the tropes of military mobilization, complete with metaphors of disaster and patriotic violence.[9] "The hurricane of October had swept aside all the obstacles in the way of the new art," wrote Aleksei Kruchenykh, and the mission of poets and artists was to mobilize, "to set the marching pace for the soldiers of the revolution, arm the mass millions with a warlike song, to organise and raise the spirits in joy."[10] But the need to address the new political and representational tasks of the 1920s led some in the avant-garde to abandon the idea of non-objectivity even if they kept its form intact. Nikolai Kolli's *Red Wedge* (figure 24), for example, represents visually how the prerevolutionary culture of war was integrated into Soviet "militarized socialism."[11] Kolli's 1918 revolutionary monument was stylistically akin to the *Black Square* in its geometry and use of color, but the artist used this simple visual language to create a narrative of revolutionary violence in which the red power of proletarian force splits white counter-revolutionary resis-

24. N. Kolli. *Red Wedge*. 1918. Pencil, watercolor, and India ink on paper, 33 × 20.5 cm. Shchusev State Museum of Architecture, Moscow.

tance.[12] Shapes and colors represent political forces in the real world, and the words "Krasnov's bands" are carved into the white block to ensure that the audience understands this meaning.[13] The *Red Wedge* thus ceased to be non-objective when made part of the mobilized public culture of Bolshevism. With a black square at its foundation, though, it remains the face of world war reinterpreted through revolution and civil war.

Appendix

Graph 1. Number of art groups in Russia, 1863–1932

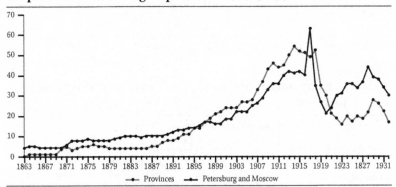

Source: Compiled from information in D. Ia. Severiukhin and O. L. Leikind, *Zolotoi vek: Khudozhestvennykh ob"edinenii v Rossii i sssr (1820–1932)* (St. Petersburg: Izdatel'stvo Chernysheva, 1992). All figures are approximate; "provinces" includes all places outside Petersburg and Moscow.

Graph 2. Number of art groups in Russia, 1900–1924

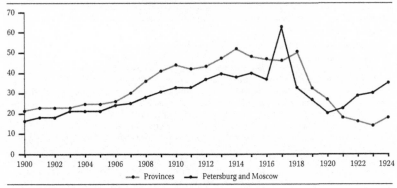

Source: Compiled from information in D. Ia. Severiukhin and O. L. Leikind, *Zolotoi vek: Khudozhestvennykh ob"edinenii v Rossii i sssr (1820–1932)* (St. Petersburg: Izdatel'stvo Chernysheva, 1992). All figures are approximate; "provinces" includes all places outside Petersburg and Moscow.

Graph 3. Visitors to annual Union of Russian Artists exhibitions, 1905–1923

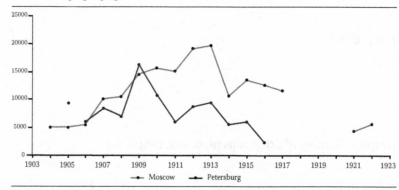

— Moscow — Petersburg

Source: V. P. Lapshin, *Soiuz russkikh khudozhnikov* (Leningrad: Khudozhnik RSFSR, 1974), 215–47.

Table 1. Regular annual exhibition sales, Petersburg/Petrograd, 1911–1918

In thousands of rubles, rounded to the nearest thousand.

	1911–12	1912–13	1913–14	1914–15	1915–16	1916–17	1917–18
World of Art[1]		25	10	20	35	100	
Itinerants[2]	27	42[3]	49[4]	38	40	100[5]	135
Union of Russian Artists[6]	22	28 (26)	46	25 (23)	28	50	
Spring Salon[7]	34	24	35	48	70		
Avant-garde		2[8]					

Note: Data are approximate; variations may stem from unspecified inclusion of ancillary exhibitions, pre-event sales, or inaccurate reporting.

1. *Apollon*, March 1913, 44; *Khudozhestvenno-pedagogicheskii zhurnal* 13, no. 1 (1914): 12; *Rech'*, April 3, 1915, 5, March 29, 1916, 5, March 31, 1917, 5.

2. *Rech'*, April 3, 1912, 4, April 6, 1915, 3, April 5, 1916, 5; *Apollon*, October–December 1917, 88.

3. Includes one painting by Repin which sold for 15,000 rubles. *Rech'*, April 9, 1913, 4.

4. Includes one painting by Repin which sold for 16,000 rubles and one painting by Bogdanov-Bel'skii which sold for 5,000 rubles. *Khudozhestvenno-pedagogicheskii zhurnal* 13, no. 8 (1914): 123.

5. Approximate total from the first few weeks. *Rech'*, February 21, 1917, 5.

6. Figures are from Rossiiskii Gosudarstvennyi Arkhiv Literatury i Iskusstva, f. 2066, op. 1, ed. khr. 169, 170. Newspaper reports that differ from the archival source are given in parentheses. See *Rech'*, April 3, 1912, 4; *Apollon*, April 1913, 44; *Rech'*, March 30, 1915, 3, March 29, 1916, 5.

7. *Rech'*, March 23, 1912, 4, April 9, 1913, 4; *Khudozhestvenno-pedagogicheskii zhurnal* 13, no. 7 (1914): 108; *Rech'*, March 31, 1915, 5; *Iskusstvo i zhizn'* 14, no. 5 (1915): 137; *Apollon*, April–May 1915, 90; *Vechernee vremia*, April 4, 1916, 4.

8. Natalia Goncharova. *Apollon*, May 1914, 44.

Table 2. Visitors at regular annual exhibitions, Petersburg/ Petrograd, 1911–1918

In thousands, rounded to the nearest thousand.

	1911–12	1912–13	1913–14	1914–15	1915–16	1916–17	1917–18
World of Art			14	10	12	9	6[1]
Itinerants	17	16	17	13	16		
Union of Russian Artists	7	10	10	7	7	3	
	(12)	(13)	(12)		(11)		
Spring Salon	20	15	19	21			

Note: Data are approximate; variations may stem from unspecified inclusion of ancillary exhibitions, pre-event sales, or inaccurate reporting. Unless otherwise noted, sources are the same as those found in table 1.

1. First two weeks. *Apollon*, October–December 1917, 87.

Table 3. Regular annual exhibition sales, Moscow, 1911–1918

In thousands of rubles, rounded to the nearest thousand.

	1911–12	1912–13	1913–14	1914–15	1915–16	1916–17	1917–18
World of Art[1]			10		20	60	
Itinerants[2]	18	12	10	15	22	60	
Union of Russian Artists[3]	40	32	47	36	56	58	66
	(10)			(40)		(90)	
Avant-garde				2[4]		7[5]	

Note: Data are approximate; variations may stem from unspecified inclusion of ancillary exhibitions, pre-event sales, or inaccurate reporting.

1. *Khudozhestvenno-pedagogicheskii zhurnal* 13, no. 4 (1914): 60; *Russkie vedomosti*, January 31, 1916, 5; *Ranee utro*, February 3, 1917, 2.

2. *Rech'*, April 3, 1912, 4, April 9, 1913, 4; *Khudozhestvenno-pedagogicheskii zhurnal* 13, no. 4 (1914): 60; *Rech'*, January 30, 1915, 5, February 5, 1916, 5; *Ranee utro*, January 11, 1916, 2, January 11, 1917, n.p.

3. Figures are from Rossiiskii Gosudarstvennyi Arkhiv Literatury i Iskusstva, f. 2066, op. 1, ed. khr. 169–70. Newspaper reports that differ from the archival source are given in parentheses. See *Rech'*, April 3, 1912, 4, April 9, 1913, 4; *Khudozhestvenno-pedagogicheskii zhurnal* 13, no. 4 (1914): 60; *Iskusstvo i zhizn'* 14, no. 2 (1915); *Russkie vedomosti*, January 8, 1916, 5; *Ranee utro*, January 11, 1916, 2; *Rech'*, March 29, 1916, 5; *Russkie vedomosti*, January 9, 1917, 5; *Ranee utro*, January 9, 1917, 2; *Utro Rossii*, January 10, 1917, 4.

4. "1915" exhibition. *Ranee utro*, April 27, 1915, 2.

5. Jack of Diamonds. V. P. Lapshin, *Khudozhestvennaia zhizn' Moskvy i Petrograda v 1917 godu* (Moscow: Sovetskii khudozhnik, 1983), 60.

Table 4. Visitors at regular annual exhibitions, Moscow, 1911–1918

In thousands, rounded to the nearest thousand.

	1911–12	1912–13	1913–14	1914–15	1915–16	1916–17	1917–18
World of Art			9	10	15	12	
Itinerants	16	9	10	6	7	7	
Union of Russian Artists	15	19	19 (23)	11	13 (15)	12 (15)	12
Avant-garde						3	

Note: Data are approximate; variations may stem from unspecified inclusion of ancillary exhibitions, pre-event sales, or inaccurate reporting. Sources are the same as table 3.

Table 5. Regular annual exhibition sales, Petersburg/Petrograd, 1914–1917

Indexed, 1914–15 art season = **100**

	1913–14	1914–15	1915–16	1916–17
World of Art	50	100	175	500
Itinerants	129	100	105	263
Union of Russian Artists	184	100	112	200
Spring Salon	73	100	145	

Note: Data are approximate; variations may stem from unspecified inclusion of ancillary exhibitions, pre-event sales, or inaccurate reporting. Sources are the same as table 1.

Table 6. Regular annual exhibition sales, Moscow, 1914–1917

Indexed, 1914–15 art season = **100**

	1913–14	1914–15	1915–16	1916–17
World of Art[1]	74		150	444
Itinerants	67	100	146	400
Union of Russian Artists	131	100	155	161

Note: Data are approximate; variations may stem from unspecified inclusion of ancillary exhibitions, pre-event sales, or inaccurate reporting. Sources are the same as table 1.

1. 1915–16 = 150. There is a missing exhibition, but to complete the table, growth approximately in line with other groups in 1915–16 is assumed.

Table 7. Inflation, selected items

Indexed, January 1915 = 100

	7/1914	1/1915	1/1916	7/1916	1/1917	3/1917
Ruble[1]	54	100	186	219	300	388
Cost of living[2]	78	100	138	156		
Cover price of the *Flame*[3]	88	100	167	200	200	250

Note: Data are approximate.

1. Modified from *Russkoe slovo*, "Rubl' v opasnosti!" May 25, 1917, 1; Michael Florinsky, *The End of the Russian Empire* (New York: Collier, 1961), 47.

2. Florinsky, *End of the Russian Empire*, 120.

3. Cover price in kopecks: February 1914 = 5, January 1915 = 6, March 1916 = 10, November 1916 = 12, April 1917 = 15.

Notes

Introduction

1. Pierre Nora, "General Introduction: Between Memory and History," in *Realms of Memory: Rethinking the French Past*, vol. 1, *Conflicts and Divisions*, ed. Pierre Nora and Lawrence D. Kritzman (New York: Columbia University Press, 1996), 7–8; Etienne François and Hagen Schulze, eds., *Deutsche Erinnerungsorte*, vol. 1 (Munich: Beck, 2001), 17–18.

2. Peter Holquist, *Making War, Forging Revolution: Russia's Continuum of Crisis, 1914–1921* (Cambridge: Harvard University Press, 2002), 1–2; Frederick C. Corney, "Rethinking a Great Event: The October Revolution as Memory Project," in *States of Memory: Continuities, Conflicts, and Transformations in National Retrospection*, ed. Jeffrey K. Olick (Durham: Duke University Press, 2003), 18–19.

3. Deniel Orlovski [Daniel Orlovsky], "Velikaia voina i rossiiskaia pamiat'," in *Rossiia i pervaia mirovaia voina*, ed. N. N. Smirnov et al. (St. Petersburg: Dmitrii Bulanin, 1999), 49; Hubertus Jahn, *Patriotic Culture in Russia during World War I* (Ithaca: Cornell University Press, 1995), 1. For the important exceptions to this lack of memory, see my article "Oh, That! Myth, Memory, and the First World War in the Russian Emigration and the Soviet Union," *Slavic Review* 62 (2003): 69–86.

4. N. N. Alevras, "Pervaia mirovaia voina v soznanii rossiiskikh istorikov-sovremennikov," in *Chelovek i voina: Voina kak iavlenie kul'tury*, ed. I. V. Narskii and O. Iu. Nikonova (Moscow: AIRO-XX, 2001), 282; Iu. A. Pisarev and V. L. Mal'kov, eds., *Pervaia mirovaia voina: Diskussionnye problemy istorii* (Moscow: Nauka, 1994), 4; A. P. Liferov, "Rossiia i pervaia mirovaia voina: Aktual'nost' problemy," in *Rossiia v pervoi mirovoi voine: Tezisy mezhvuzovskoi nauchnoi konferentsii, 4–5 oktiabria 1994 goda* (Riazan': RGPU, 1994), 3; P. V. Mul'tatuli, *Zabytaia voina: Rossiia i Germaniia v pervoi mirovoi voine, 1914–1918* (St. Petersburg: Borei Art, 1998), 8.

5. Jay Winter, "Catastrophe and Culture: Recent Trends in the Historiography of the First World War," *Journal of Modern History* 64 (1992): 525–26.

6. See John Horne, ed., *State, Society, and Mobilization in Europe during the First World War* (Cambridge: Cambridge University Press, 2002), xiv; Jay Winter, *Remembering War: The Great War between Memory and History in the Twentieth Century* (New Haven: Yale University Press 2006), 81.

7. Stéphane Audoin-Rouzeau and Annette Becker, *14–18: Understanding the Great War*, trans. Catherine Temerson (New York: Hill and Wang, 2002), 11; quote taken from http://www.historial.org/us/home_b.htm (accessed February 17, 2007). The French and German versions of the museum's website omit the words "main protagonists."

8. There is a huge monograph literature on the war's social and cultural impact in the United Kingdom, France, Germany, and the United States, including several anthologies on the war and culture: Jean-Jacques Becker et al., eds., *Guerre et cultures, 1914–1918* (Paris: Armand Colin, 1994); Wolfgang Mommsen, ed., *Kultur und Krieg: Die Rolle der Intellektuellen, Künstler und Schriftsteller im Ersten Weltkrieg* (Munich: Oldenbourg, 1996); and Aviel Roshwald and Richard Stites, eds., *European Culture in the Great War: The Arts, Entertainment, and Propaganda, 1914–1918* (Cambridge: Cambridge University Press, 1999).

9. More than fifty nationalities are represented in Tim Cross's anthology of war poetry called *The Lost Voices of World War I* (London: Bloomsbury, 1988). Not one is Russian.

10. Hans Rogger, "Russia in 1914," *Journal of Contemporary History* 3 (1966): 229.

11. Richard Stites, "Days and Nights in Wartime Russia: Cultural Life, 1914–1917," in Roshwald and Stites, *European Culture*, 29–31.

12. Peter Gatrell, *A Whole Empire Walking: Refugees in Russia during World War I* (Bloomington: Indiana University Press, 1999), 3–4, 7; Eric Lohr, *Nationalizing the Russian Empire: The Campaign against Enemy Aliens during World War I* (Cambridge: Harvard University Press, 2003), 6–9.

13. Holquist, *Making War*, 2.

14. Laura Engelstein, "New Thinking about the Old Empire: Post-Soviet Reflections," *Russian Review* 60, no. 4 (2001): 487–88.

15. Peter Gatrell, *Russia's First World War: A Social and Economic History* (Harlow: Pearson Longman, 2005), 2.

16. Jürgen Habermas, *Strukturwandel der Öffentlichkeit: Untersuchungen zu einer Kategorie der bürgerlichen Gesellschaft* (Neuwied: Luchterhand, 1974), 32–35.

17. Gail W. Lapidus, "State and Society: Toward the Emergence of Civil Society in the Soviet Union," in *Inside Gorbachev's Russia*, ed. Seweryn Bialer (Boulder: Westview Press, 1989), 121, 131; Moshe Lewin, *The Gorbachev Phenomenon: A Historical Interpretation* (Berkeley: University of California Press, 1991), viii. For applications of the idea of civil society to Imperial Russia see Daniel R. Brower, *The Russian City between Tradition and Modernity, 1850–1900* (Berkeley: University of California Press, 1990), 94–95; Louise McReynolds, *The News under Russia's Old Regime: The Development of a Mass-Circulation Press* (Princeton: Princeton University Press, 1991), 3–4; Manfred Hagen, *Die Entfaltung politischer Öffentlichkeit in Rußland, 1906–1914* (Wiesbaden: Franz Steiner, 1982), 374–75.

18. Geoffrey Hosking, *Russia and the Russians: A History* (Cambridge MA: Belknap,

2003), 385, 400; Samuel D. Kassow, "Russia's Unrealized Civil Society," in *Between Tsar and People: Educated Society and the Quest for Public Identity in Late Imperial Russia*, ed. Edith W. Clowes, Samuel D. Kassow, and James L. West (Princeton: Princeton University Press, 1991), 370–71.

19. Thomas Earl Porter, "The Emergence of Civil Society in Late Imperial Russia: The Impact of the Russo-Japanese and First World Wars on Russian Social and Political Life, 1904–1917," *War and Society* 23, no. 1 (2005): 49, 59–60.

20. David Wartenweiler, *Civil Society and Academic Debate in Russia, 1905–1914* (Oxford: Clarendon Press, 1999), 3.

21. Jean L. Cohen and Andrew Arato, *Civil Society and Political Theory* (Cambridge: MIT Press, 1992), ix.

22. Joseph Bradley, "Subjects into Citizens: Societies, Civil Society, and Autocracy in Tsarist Russia," *American Historical Review* 107, no. 4 (2002): 1105–6; see also Murray Frame, *School for Citizens: Theatre and Civil Society in Imperial Russia* (New Haven: Yale University Press, 2006), 2–6.

23. Michael Warner, "Publics and Counterpublics," *Public Culture* 14, no. 1 (2002): 55–56, 59.

24. Thomas Bender, "Wholes and Parts: The Need for Synthesis in American History," *Journal of American History* 73, no. 1 (1986): 126.

25. Dzhon E. Boult [John E. Bowlt], "Khudozhestvennaia novatsiia i voennaia strategiia: Russkii avangard i Pervaia mirovaia voina," in *Avangard 1910–x-1920–x godov: Vzaimodeistvie iskusstv*, ed. G. F. Kovalenko (Moscow: Iskusstvoznanie, 1998), 25. The only major historical monograph on Russian culture and the war is Jahn's *Patriotic Culture*, which focuses on the commercial patriotic culture of the war's first year. For a general overview of the war and Russian culture see Stites, "Days and Nights," 8–31.

26. I use present-day nomenclature to reflect current academic practice and to remain as neutral as possible vis-à-vis historical subjects. These descriptors were sometimes used in Imperial Russia, but the precise language that described artists varied and was often contested: realists were known as *utilitarians* and aesthetic modernists as *aesthetes* or *decadents*. The use of *avant-garde* (*avangard*) in current art criticism is anachronistic. See D. V. Sarab'ianov, *Russkaia zhivopis': Probuzhdenie pamiati* (Moscow: Iskusstvoznanie, 1998), 264. Imperial Russian art critics did employ *vanguard* (*peredovoi*) to describe the artistic avant-garde, but *futurist* was more common in the war years. In this book I use *modern art* to cover all modernists, including aesthetic modernists and the avant-garde; in Imperial Russia, *sovremennoe iskusstvo* could mean *modern art* or *contemporary art* depending on the context.

27. Sidney Monas and Jennifer Greene Krupala, eds., *The Diaries of Nikolay Punin, 1904–1953*, trans. Jennifer Greene Krupala (Austin: University of Texas Press, 1999), 27.

28. *Les nouvelles littéraires*, June 14, 1924, 5.

29. See René Fülöp-Miller, *The Mind and Face of Bolshevism: An Examination of Cultural Life in Soviet Russia* (New York: Harper and Row, 1965), 96.

30. Monas and Krupala, *Diaries*, 31.

Chapter 1. The Wars against Tradition

1. Emphasis original. Anna Lawton and Herbert Eagle, eds. and trans., *Russian Futurism through Its Manifestoes, 1912–1928* (Ithaca: Cornell University Press, 1988), 51.

2. John E. Bowlt, ed. and trans., *Russian Art of the Avant-Garde: Theory and Criticism, 1902–1934* (New York: Viking, 1988), 105.

3. Viktor Shklovskii, *Zhili-byli* (Moscow: Sovetskii pisatel', 1966), 271–72.

4. Harley Balzer, "The Problem of Professions in Imperial Russia," in Clowes, Kassow, and West, *Between Tsar and People*, 183; Louise McReynolds, *Russia at Play: Leisure Activities at the End of the Tsarist Era* (Ithaca: Cornell University Press, 2003), 3; Elise Kimerling Wirtschafter, *Social Identity in Imperial Russia* (De Kalb: Northern Illinois University Press, 1997), 86–96, 171–73.

5. Jeffrey Brooks, "Readers and Reading at the End of the Tsarist Era," in *Literature and Society in Imperial Russia, 1800–1914*, ed. William Mills Todd III (Stanford: Stanford University Press, 1978), 149; Richard Stites, *Russian Popular Culture: Entertainment and Society since 1900* (Cambridge: Cambridge University Press, 1992), 28.

6. For a discussion, see McReynolds, *Russia at Play*, 5–9. On the public culture of the Russian monarchy see Richard S. Wortman, *Scenarios of Power: Myth and Ceremony in Russian Monarchy*, vol. 2, *From Alexander II to the Abdication of Nicholas II* (Princeton: Princeton University Press, 2000).

7. Magali Sarfatti Larson, *The Rise of Professionalism: A Sociological Analysis* (Berkeley: University of California Press, 1977), xii, xvi–xvii.

8. Vera L. Zolberg, *Constructing a Sociology of the Arts* (New York: Cambridge University Press, 1990), 21.

9. For an explanation of this terminology see the introduction, note 26.

10. Thomas Crow, *Painters and Public Life in Eighteenth-Century Paris* (New Haven: Yale University Press, 1985), 5.

11. *S.-Peterburgskie vedomosti*, January 3, 1908, 3. For similar sentiments see *Novoe vremia*, January 1, 1911, 17.

12. Camilla Gray, *The Russian Experiment in Art, 1863–1922* (New York: Abrams, 1962), 10; Alan Bird, *A History of Russian Painting* (Boston: Hall, 1987), 131.

13. G. Iu. Sternin, *Khudozhestvennaia zhizn' Rossii vtoroi poloviny XIX veka 70–80–e gody* (Moscow: Nauka, 1997), 10.

14. David Jackson, *The Wanderers and Critical Realism in Nineteenth-Century Russian Painting* (Manchester: Manchester University Press, 2006), 76–77.

15. S. Frederick Starr, "Russian Art and Society," in *Art and Culture in Nineteenth-*

Century Russia, ed. Theofanis George Stavrou (Bloomington: Indiana University Press, 1983), 99.

16. Elizabeth Valkenier, *Russian Realist Art. The State and Society: The Peredvizhniki and Their Tradition* (New York: Columbia University Press, 1989), 4. Only about three hundred painters were credentialed between 1894 and 1914. See V. R. Leikina-Svirskaia, *Russkaia intelligentsiia v 1900–1917 godakh* (Moscow: Mysl', 1981), 159–60.

17. Starr, "Russian Art," 91–92.

18. Richard Stites, *Serfdom, Society, and the Arts in Imperial Russia* (New Haven: Yale University Press, 2005), 30.

19. Stites, *Arts*, 288–89.

20. William Brumfield, *A History of Russian Architecture* (New York: Cambridge University Press, 2004), 348; Albert Schmidt, "Architecture in Nineteenth-Century Russia," in Stavrou, *Art and Culture*, 180, 183.

21. Dmitri V. Sarabianov, *Russian Art from Neoclassicism to the Avant-Garde, 1800–1917* (New York: Abrams, 1990), 26.

22. Valkenier, *Realist Art*, 57.

23. Bird, *Russian Painting*, 142.

24. Valkenier, *Realist Art*, 35.

25. Quoted in Valkenier, *Realist Art*, 39.

26. A. I. Tsomakion and L. K. Diterikhs, eds., *Ivanov, Fedotov, Perov, Kramskoi*, Zhizn' zamechatel'nykh liudei (St. Petersburg: Redaktor, 1995), 190–91.

27. Valkenier, *Realist Art*, 62–63.

28. Valkenier, *Realist Art*, 85.

29. Sarabianov, *Russian Art*, 157.

30. Valkenier, *Realist Art*, 85.

31. Valkenier, *Realist Art*, 36–37.

32. Elizabeth Kridl Valkenier, *Ilya Repin and the World of Russian Art* (New York: Columbia University Press, 1990), 83.

33. *Tovarishchestvo peredvizhnykh khudozhestvennykh vystavok: Pis'ma, dokumenty*, vol. 2 (Moscow: Iskusstvo, 1987), 631.

34. Elizabeth Valkenier, "The Intelligentsia and Art," in Stavrou, *Art and Culture*, 169.

35. Quoted in Valkenier, *Repin*, 137.

36. Grigory Sternin, "Public and Artist in Russia at the Turn of the Twentieth Century," in *Tekstura: Russian Essays on Visual Culture*, ed. Alla Efimova and Lev Manovich (Chicago: University of Chicago Press, 1993), 91.

37. Janet Kennedy, *The "Mir iskusstva" Group and Russian Art, 1898–1912* (New York: Garland, 1977), 1.

38. See Gerald Izenberg, *Modernism and Masculinity: Mann, Wedekind, Kandinsky through World War I* (Chicago: University of Chicago Press, 2000), 3.

39. See Irina Paperno and Joan Delaney Grossman, eds., *Creating Life: The Aesthetic Utopia of Russian Modernism* (Stanford: Stanford University Press, 1994), 2–4; Hilary Fink, *Bergson and Russian Modernism, 1900–1930* (Evanston: Northwestern University Press, 1999), xv.

40. Quoted in Gray, *Russian Experiment*, 37. For a description of the multifaceted character of the World of Art see Viacheslav Shestakov, *Iskusstvo i mir v "Mire iskusstva"* (Moscow: Slavianskii dialog, 1998), 3.

41. G. Iu. Sternin, *Khudozhestvennaia zhizn' Rossii na rubezhe xix–xx vekov* (Moscow: Iskusstvo, 1970), 8.

42. For a general description of modernism in the arts see Eugene Lunn, *Marxism and Modernism: An Historical Study of Lukács, Brecht, Benjamin, and Adorno* (Berkeley: University of California Press, 1982), 33–37. The theoretical literature on modernism is large. A compact outline of modern art and its history is Pam Meecham and Paul Wood's "Modernism and Modernity: An Introductory Survey," in *Investigating Modern Art*, ed. Liz Dawtrey et al. (London: Open University, 1996), 1–33.

43. Emphasis original. Bowlt, *Theory and Criticism*, 8.

44. See Ekaterina Bobrinskaia, *Russkii avangard: Istoki i metamorfozy* (Moscow: Piataia strana, 2003), 7. At the time, the word *decadent* was contested and contradictory. See John E. Bowlt, "Through the Glass Darkly: Images of Decadence in Early Twentieth-Century Russian Art," *Journal of Contemporary History* 17, no. 1 (1982): 93–94.

45. *Russkie vedomosti*, January 1, 1903, 50.

46. *Mir iskusstva* 1, no. 1 (1899): 12.

47. *Zolotoe runo* 11–12 (1909): 107.

48. Gray, *Russian Experiment*, 59.

49. Kennedy, *Mir iskusstva*, 5.

50. Bowlt, "Through the Glass Darkly," 100.

51. Sarabianov, *Russian Art*, 225.

52. Shestakov, *Iskusstvo i mir*, 4–5.

53. Grigori J. Sternin, *Das Kunstleben Rußlands zu Beginn des zwanzigsten Jahrhunderts* (Dresden: Verlag der Kunst, 1980), 18.

54. Gray, *Russian Experiment*, 39.

55. E. P. Gomberg-Verzhbinskaia, *Russkoe iskusstvo i revoliutsiia 1905 goda: Grafika, Zhivopis'* (Leningrad: Izdatel'stvo leningradskogo universiteta, 1960), 27, 140–41.

56. M. V. Dobuzhinskii, *Pis'ma* (St. Petersburg: Dmitrii Bulanin, 2001), 70–71.

57. Gomberg-Verzhbinskaia, *Russkoe iskusstvo*, 132.

58. *Zolotoe runo* 2 (1906): 83. Trans. Carol Adlam, available at http://hri.shef.ac.uk/rva/texts/benois/beno1/benois.html (accessed February 14, 2007).

59. Quoted in Sternin, *Kunstleben*, 109.

60. V. V. Vanslov, ed., *Russkaia progressivnaia kritika: Khrestomatiia* (Moscow: Izobrazitel'noe iskusstvo, 1977), 352–53, 355. Trans. Carol Adlam, available at http://hri.shef.ac.uk/rva/texts/stasov/stas17/stas17.html (accessed February 14, 2007).

61. Jeffrey Brooks, "Popular Philistinism and the Course of Russian Modernism," in *Literature and History: Theoretical Problems and Russian Case Studies*, ed. Gary Saul Morson (Stanford: Stanford University Press, 1986), 90; William Richardson, *Zolotoe Runo and Russian Modernism, 1905–1910* (Ann Arbor: Ardis, 1986), 32.

62. Renato Poggioli, *The Theory of the Avant-Garde* (Cambridge MA: Belknap, 1968), 30; Peter Bürger, *Theory of the Avant-Garde* (Minneapolis: University of Minnesota, 1984), 49; Stephen F. Eisenman, *Nineteenth Century Art: A Critical History* (London: Thames and Hudson, 1994), 220.

63. *Russkie vedomosti*, January 4, 1913, 4.

64. N. A. Gurianova, *Exploring Color: Olga Rozanova and the Early Russian Avant-Garde, 1910–1918*, trans. Charles Rougle (Amsterdam: G and B Arts International, 2000), 186.

65. Alexei Kruchenykh, *Our Arrival: From the History of Russian Futurism*, trans. Alan Myers (Moscow: RA, 1995), 87.

66. Kandinsky and Chagall spent much of their careers outside Russia, but their contacts with Russian art life increased after they returned to the country in 1914.

67. Bowlt, *Theory and Criticism*, 88–89.

68. Bürger, *Avant-Garde*, 22; Andreas Huyssen, *After the Great Divide: Modernism, Mass Culture, Postmodernism* (Bloomington: Indiana University Press, 1986), viii.

69. See Jane A. Sharp, "The Russian Avant-Garde and Its Audience: Moscow, 1913," *Modernism/Modernity* 6, no. 3 (1999): 102.

70. N. I. Khardzhiev, *Stat'i ob avangarde v dvukh tomakh*, vol. 1 (Moscow: RA, 1997), 140.

71. Sarab'ianov, *Russkaia zhivopis'*, 267, 284.

72. Gurianova, *Rozanova*, 195.

73. Sarabianov, *Russian Art*, 246.

74. Quoted in M. G. Nekliudova, *Traditsii i novatorstvo v russkom iskusstve kontsa XIX–nachala XX veka* (Moscow: Iskusstvo, 1991), 309.

75. On the link between these paintings and Russian icons see Margaret Betz, "The Icon and Russian Modernism," *Artforum* 25, no. 10 (1977): 40–41.

76. K. S. Petrov-Vodkin, *Pis'ma, Stat'i, Vystupleniia, Dokumenty*, ed. E. N. Selizarova (Moscow: Sovetskii khudozhnik, 1991), 158; *Apollon*, March 1915, 15, 17.

77. Jane A. Sharp, "The Critical Reception of the *0.10* Exhibition: Malevich and Benua," in *The Great Utopia: The Russian and Soviet Avant-Garde, 1915–1932* (New York: Guggenheim Museum, 1992), 40.

78. Sharp, "Russian Avant-Garde," 99–100.

79. Kruchenykh, *Our Arrival*, 57; Roman Jakobson, *My Futurist Years* (New York: Marsilio, 1997), 4.

80. These are very rough figures based on the participants named in D. Ia. Severiukhin and O. L. Leikind, *Zolotoi vek: Khudozhestvennykh ob"edinenii v Rossii i SSSR (1820–1932)* (St. Petersburg: Izdatel'stvo Chernysheva, 1992). I have not included painters whose sex I cannot determine based on their names.

81. V. P. Lapshin, *Soiuz russkikh khudozhnikov* (Leningrad: Khudozhnik RSFSR, 1974), 250–65.

82. Jane Ashton Sharp, *Russian Modernism between East and West: Natal'ia Goncharova and the Moscow Avant-Garde* (New York: Cambridge University Press, 2006), 116. She was quickly acquitted on the grounds that the images were shown at a private meeting.

83. Sharp, *Russian Modernism*, 2; Benedikt Livshits, *The One and a Half-Eyed Archer* (Newtonville MA: Oriental Research Partners, 1977), 45.

84. Members of the avant-garde were on average ten years younger and more likely to come from the provinces than their aesthetic modernist counterparts. See Robert C. Williams, *Artists in Revolution: Portraits of the Russian Avant-garde, 1905–1925* (Bloomington: Indiana University Press, 1977), 189–90.

85. On the instability of the Union of Youth group, see Jeremy Howard, *The Union of Youth: An Artists' Society of the Russian Avant-Garde* (Manchester: Manchester University Press, 1992), 1–2.

86. Gurianova, *Rozanova*, 124.

87. Sharp, *Russian Modernism*, 272; Jakobson, *Futurist Years*, 7.

88. Katerina Clark, *Petersburg, Crucible of Cultural Revolution* (Cambridge: Harvard University Press, 1995), 31.

89. *Apollon*, February 1913, 56.

90. *Khudozhestvenno-pedagogicheskii zhurnal* 13, no. 9 (1914): 139.

91. Larissa Alekseevna Zhadova, ed., *Tatlin*, trans. Paul Filotas et al. (New York: Rizzoli, 1988), 183.

92. *Novoe vremia*, January 1, 1913, 11, January 1, 1914, 13. The number of art groups shows a steady, predictable rise from 1900 to 1914 (see graph 2 in the appendix).

93. E. Pskovitinov, *Iskusstvo i voina* (Petrograd: Manasevich, 1914), 14.

Chapter 2. In the Storm

1. *Peterburgskii kur'er*, August 6, 1914, 3.

2. Dmitrii Merezhkovskii, *Nevoennyi dnevnik, 1914–1916* (Petrograd: Ogni, 1917), 141–42.

3. John Horne, "Introduction: Mobilizing for 'Total War,' 1914–1918," in Horne, *State, Society, and Mobilization*, 3.

4. Annette Becker, *La guerre et la foi: De la mort à la mémoire, 1914–1930* (Paris: Armand Colin, 1994), 9; Gail Braybon, introduction, in *Evidence, History, and the Great War: Historians and the Impact of 1914–1918*, ed. Braybon (Oxford: Berghahn, 2003), 2.

5. L. L. Farrar Jr., "Nationalism in Wartime: Critiquing the Conventional Wisdom," in *Authority, Identity, and the Social History of the Great War*, ed. Frans Coetzee and Marilyn Shevin-Coetzee (Providence: Berghahn, 1995), 134; George Robb, *British Culture and the First World War* (Houndmills: Palgrave, 2002), 124–25.

6. John F. Hutchinson, "The Patriot Game: Russia and the First World War," *Interna-*

tional History Review 8 (August 1986): 438–40. For examples see Bernard Pares, *My Russian Memoirs* (London: Jonathan Cape, 1931), 353; Wladimir Weidlé, *Russia: Absent and Present* (New York: Vintage, 1961), 113; Mikhail Florinsky, *Russia: A History and an Interpretation*, vol. 2 (New York: MacMillan, 1967), 1257. For a more recent restatement see Robert Thurston, "New Thoughts on the Old Regime and the Revolution of 1917 in Russia: A Review of Recent Western Literature," in *Modernization and Revolution: Dilemmas of Progress in Late Imperial Russia*, ed. Edward K. Judge and James Simms (Boulder: East European Monographs, 1992), 160. Most émigrés thought the war was the immediate cause of the revolution. See Jane Burbank, *Intelligentsia and Revolution: Russian Views of Bolshevism, 1917–1922* (New York: Oxford University Press, 1986), 244.

7. Thurston, "New Thoughts," 130. For examples see Gregory Freeze, "The Soslovie (Estate) Paradigm and Russian Social History," *American Historical Review* 91 (1986): 11–36; Hutchinson, "Patriot Game," 445; Joan Neuberger, *Hooliganism: Crime, Culture, and Power in St. Petersburg, 1900–1914* (Berkeley: University of California Press, 1993), 24.

8. Horne, "Introduction," 1–2.

9. Arthur Marwick, "Painting and Music during and after the Great War: The Art of Total War," in *Great War, Total War: Combat and Mobilization on the Western Front, 1914–1918*, ed. Roger Chickering and Stig Förster (Cambridge: Cambridge University Press, 2000), 504.

10. Stéphane Audoin-Rouzeau, *L'enfant de l'ennemi (1914–1918): Viol, avortement, infanticide pendant la Grande Guerre* (Paris: Aubier, 1995), 10.

11. M. V. Nesterov, *Pis'ma izbrannye* (Leningrad: Iskusstvo, 1988), 211.

12. Peter Paret, *Imagined Battles: Reflections of War in European Art* (Chapel Hill: University of North Carolina Press, 1997), 65.

13. Rosa Newmarch, *The Russian Arts* (New York: Dutton, 1916), 159. The only academic treatment of Russian battle painting appears to be V. V. Sadoven', *Russkie khudozhniki batalisty XVIII–XIX vekov* (Moscow: Iskusstvo, 1955). Popular histories include E. V. Kuznetsova, *Istoricheskii i batal'nyi zhanr* (Moscow: Prosveshchenie, 1982); Vladislav Artemov, *Voiny, srazheniia, polkovodtsy v proizvedeniiakh klassicheskoi zhivopisi* (Moscow: OLMA-Press, 2002).

14. McReynolds, *The News*, 85–86; Wortman, *Scenarios of Power*, 134–35.

15. For a description see I. I. Rostunov et al., *Russko-turetskaia voina, 1877–1878* (Moscow: Voenizdat, 1977), 17–19.

16. Valkenier, *Realist Art*, 71–72.

17. Aleksandr Benua, *Istoriia russkoi zhivopisi v XIX veke* (Moscow: Respublika, 1995), 283–84.

18. Quoted in Vahan D. Barooshian, *V. V. Vereshchagin: Artist at War* (Gainesville: University Press of Florida, 1993), 85.

19. Vasilii Vasil'evich Vereshchagin, *Izbrannye pis'ma* (Moscow: Izobrazitel'noe iskusstvo, 1981), 31.

20. Vereshchagin, *Pis'ma*, 30–31.

21. Quoted in Sarabianov, *Russian Art*, 148.

22. Quoted in Barooshian, *Vereshchagin*, 72–73.

23. Newmarch, *Russian Arts*, 164.

24. Newmarch, *Russian Arts*, 167–68.

25. *Vestnik Evropy* 39 (1904): part 2, 420.

26. Quoted in Maurice Paléologue, *Three Critical Years* (New York: Speller, 1957), 26.

27. Abraham Ascher, *The Revolution of 1905*, vol. 1, *Russia in Disarray* (Stanford: Stanford University Press, 1988), 47.

28. These figures come from a content analysis of *Ogonek*, sampled every two months in 1904–5 and 1914–16. I have made similar surveys of the daily newspaper *Novoe vremia* and the monthly illustrated satirical journal *Novyi Satirikon* for 1914–16.

29. Dietrich Geyer, *Russian Imperialism* (New York: Berg, 1987), 341.

30. Ascher, *Revolution*, 48.

31. Petrov-Vodkin, *Pis'ma*, 71.

32. Aleksandr Benua, *Moi vospominaniia*, vol. 2 (Moscow: Nauka, 1993), 397.

33. *Novoe vremia*, February 7, 1904, 13.

34. *Russkie vedomosti*, February 2, 1905, 3.

35. *Teatr i iskusstvo*, March 21, 1904, 249.

36. David Wells, "The Russo-Japanese War in Russian Literature," in *The Russo-Japanese War in Cultural Perspective, 1904–1905*, ed. David Wells and Sandra Wilson (Houndmills: Macmillan, 1999), 108–33.

37. *Novoe vremia*, February 19, 1906, 4.

38. *Novoe vremia*, March 2, 1905, 4.

39. *Novoe vremia*, February 18, 1906, 3; see also *S.-Peterburgskie vedomosti*, January 3, 1907, 3.

40. *Novoe vremia*, February 26, 1905, 13.

41. *Novoe vremia*, February 21, 1904, 4, April 7, 1904, 4; *Slovo*, December 23, 1904, 4.

42. *Novoe vremia*, March 7, 1905, 1.

43. *Russkie vedomosti*, March 31, 1904, 3; M. V. Nesterov, *Vospominaniia* (Moscow: Sovetskii khudozhnik, 1989), 293.

44. *Novoe vremia*, February 25, 1905, 2, February 9, 1906, 1, February 27, 1905, 1.

45. *Vestnik uchitelei risovaniia*, no. 11 (September 1904): 157.

46. *Mir iskusstva*, no. 10 (1904): 214.

47. *Russkie vedomosti*, November 12, 1914, 5.

48. A. F. Berezhnoi, *Russkaia legal'naia pechat' v gody pervoi mirovoi voiny* (Leningrad: LU, 1975), 15.

49. *Iskusstvo i zhizn'* 14, no. 4 (1915): 89.

50. W. Bruce Lincoln, *Passage through Armageddon: The Russians in War and Revolution, 1914–1918* (New York: Simon and Schuster, 1986), 188.

51. *Iskusstvo i zhizn'* 14, no. 2 (1915): 29–30.

52. *Zhenshchina i voina*, March 5, 1915, 1.

53. M. Taube, *La politique russe d'avant-guerre et la fin de l'empire des tsars (1904–1917)* (Paris: Ernest Leroux, 1928), 380–81.

54. Frank Golder, ed. and trans., *Documents of Russian History, 1914–1917* (New York: Century, 1927), 147.

55. *Vestnik fotografii* 9, no. 1 (1916): 4.

56. Kandaurov to Konstantin Bogaevskii, October 11, 1914, Rossiiskii Gosudarstvennyi Arkhiv Literatury i Iskusstva [hereafter RGALI], fond 700, opis' 1, edinitsa khraneniia 46 [f. 700, op. 1, ed. khr. 46].

57. William Gleason, "The All-Russian Union of Zemstvos and World War I," in *The Zemstvo in Russia: An Experiment in Local Self-Government*, ed. Terence Emmons and Wayne S. Vucinich (Cambridge: Cambridge University Press, 1982), 366, 369.

58. *Vechernie izvestiia*, January 14, 1915, 4.

59. V. V. Strakhov and N. A. Bulychev, "Sel'skokhoziaistvennye druzhiny rossiiskikh uchashchikhsia v gody mirovoi voiny (1914–1917 gg.)," in *Rossiia v pervoi mirovoi voine*, 157.

60. Dmitry M. Odinetz and Paul J. Novgorotsev, *Russian Schools and Universities in the World War* (New Haven: Yale University Press, 1929), 161.

61. Arthur Ruhl, *White Nights and Other Russian Impressions* (New York: Scribner, 1917), 214.

62. *Sovremennoe slovo*, January 8, 1915, 1.

63. *Novyi kolos*, October 2, 1915, 484.

64. Tikhon J. Polner, *Russian Local Government during the War and the Union of Zemstvos* (New Haven: Yale University Press, 1930), 101.

65. According to the number of times zemstvo informants mentioned conversations. See the *Statisticheskii ezhegodnik moskovskoi gubernii za 1915 god* (Moscow: S. P. Iakovlev, 1916), part 2, 118.

66. *Petrogradskii kur'er*, November 11, 1914, 7; *Vechernie izvestiia*, April 4, 1915, 3; *Vestnik Evropy* 51 (July 1916): 223, 225; *Novyi kolos*, April 1, 1916, 181; *Vestnik vospitaniia*, nos. 4–5 (April–May 1917): part 1, 136; *Novyi kolos*, September 25, 1915, 466; *Severnye zapiski*, nos. 4–5 (April–May 1916): 201–3.

67. S. S. Ginzburg, *Kinematografiia dorevoliutsionnoi Rossii* (Moscow: Iskusstvo, 1963), 191.

68. *Rech'*, November 21, 1914, 2.

69. Jahn, *Patriotic Culture*, 172.

70. Vladimir Denisov, *Voina i lubok* (Petrograd: Izdatel'stvo Novyi zhurnal dlia vsekh, 1916), 1. Such popular prints, called *lubki* (singular *lubok*) or *lubochnye kartinki*, were strongly associated with lowbrow culture by Russia's educated elites. The *lubok* in earlier times was a woodcut print with a satirical, folkloristic, or religious theme. In the early twentieth century, though, *lubochnye kartinki* were part of the mass commercial culture and differed in composition, content, and technical produc-

tion from previous *lubok* incarnations. Battle *lubki*, for example, were chromolithographs similar to prints produced in Germany and France. They served to illustrate and report on the war; many contained official or semiofficial texts that explained the action to viewers.

71. On masculine bravery see Karen Petrone, "Family, Masculinity, and Heroism in Russian War Posters of the First World War," in *Borderlines: Genders and Identities in War and Peace, 1870–1930*, ed. Billie Melman (London: Routledge, 1998), 102–3.

72. *Russkaia shkola* 26, no. 7 (1915): part 1, 95.

73. *Statisticheskii ezhegodnik moskovskoi gubernii*, 118.

74. These figures are in I. V. Vladislavlev, ed., *Bibliograficheskii ezhegodnik*, vol. 4, *Sistematicheskii ukazatel' literatury za 1914 god* (Moscow: Nauka, 1915), 191.

75. M. V. Muratov, *Knizhnoe delo v Rossii v XIX i XX vv.* (Moscow: Gosudarstvennoe sotsial'no-ekonomicheskoe izdatel'stvo, 1931), 194.

76. *Statistika proizvedenii pechati, vyshedshikh v Rossii v 1914 godu* (Petrograd: Tip. MVD, 1915), 8, 110–12; *Statistika proizvedenii pechati, vyshedshikh v Rossii v 1913 godu* (Petrograd: Tip. MVD, 1914), 8. Belletristic literature, in comparison, was just 2.5 percent of the market.

77. An ad writer claimed that almost ten people read every copy. *Ogonek*, October 26, 1914, n.p.

78. *Voina*, no. 16 (1914): n.p.

79. Tsentral'nyi Istoricheskii Arkhiv Moskvy, f. 31, op. 3, delo [d.] 2480 and d. 2485 (Moskovskii komitet po delam pechati).

80. *Statistika proizvedenii pechati, vyshedshikh v Rossii v 1914 godu*, 111–12.

81. Thomas Riha, "*Riech'*: A Portrait of a Russian Newspaper," *Slavic Review* 22 (1963): 669.

82. O. V. Tsekhnovitser, *Literatura i mirovaia voina, 1914–1918* (Moscow: Khudozhestvennaia literatura, 1938), 99.

83. *Argus*, no. 20 (August 1914): n.p.

84. Richard Washburn Child, *Potential Russia* (London: Unwin, 1916), 17.

85. Sergei Kudryashov, "The Russian Worker at War," in *Facing Armageddon: The First World War Experienced*, ed. Hugh Cecil and Peter Liddle (London: Leo Cooper, 1996), 546.

86. Paul Miliukov, *Political Memoirs, 1905–1917* (Ann Arbor: University of Michigan Press, 1967), 301–2.

87. *Nevskii al'manakh zhertvam voiny* (Petrograd: Obshchestvo russkikh pisatelei dlia pomoshchi zhertvam voiny, 1915), 62.

88. For examples see Alfred Knox, *With the Russian Army, 1914–1917* (London: Hutchinson, 1921), 549; Lincoln, *Passage through Armageddon*, 46; Miliukov, *Memoirs*, 300; Michael Florinsky, *The End of the Russian Empire* (New York: Collier, 1961), 228.

89. Nikolai Berdiaev, *Sud'ba Rossii* (Moscow: MGU, 1990), 8.

90. V. B. Stankevich, *Vospominaniia, 1914–1919* (Moscow: RGGU, 1994), 182.

91. Josh Sanborn calls the public mobilization of 1914 a "watershed moment" in his *Drafting the Russian Nation: Military Conscription, Total War, and Mass Politics, 1905–1925* (De Kalb: Northern Illinois University Press, 2003), 204. See also the extensive discussion between Sanborn, Scott Seregny, and Steve Smith in *Slavic Review* 59 (2000): 267–342; Stephen M. Norris, *A War of Images: Russian Popular Prints, Wartime Culture, and National Identity, 1812–1945* (De Kalb: Northern Illinois University Press, 2006), 136; and Melissa K. Stockdale, "United in Gratitude: Honoring Soldiers and Defining the Nation in Russia's Great War," *Kritika* 7, no. 3 (2006): 485.

92. See, for example, Denise Youngblood, in her review of *Patriotic Culture in Russia during World War I*, by Hubertus Jahn, in *American Historical Review* 102, no. 3 (1997): 853–54.

93. *Russkaia shkola*, no. 1 (1916): part 3, 44.

94. See my article "Flowers of Evil: Mass Media, Child Psychology, and the Struggle for Russia's Future during the First World War," in *Children and War*, ed. James Marten (New York: NYU Press, 2002), 38–49.

95. Stephen Graham, *Russia and the World* (London: Cassell, 1917), 102–3.

96. Nikolai Punin, "Kvartira No. 5," *Panorama iskusstv* 12 (1989): 180.

97. Ol'ga Leshkova to Mikhail Le-Dantiu, November 15, November 24, December 23, 1916, January 20, 1917, RGALI, f. 792, op. 3, ed. khr. 16.

98. A. A. Rylov, *Vospominaniia* (Leningrad: Khudozhnik RSFSR, 1960), 164.

99. Miliukov, *Memoirs*, 314.

100. Alexander Shlyapnikov, *On the Eve of 1917: Reminiscences from the Revolutionary Underground* (London: Allison and Busby, 1982), 24–25.

101. On the notion of "different wars" see Janet Watson, *Fighting Different Wars: Experience, Memory, and the First World War in Britain* (Cambridge: Cambridge University Press, 2004), 2–3.

102. Jahn, *Patriotic Culture*, 9.

103. N. P. Ledovskikh, "Russkaia tvorcheskaia intelligentsiia v gody pervoi mirovoi voiny," in *Rossiia v pervoi mirovoi voine*, 143.

104. Berdiaev, *Sud'ba Rossii*, 45.

105. M. M. Prishvin, *Dnevniki, 1914–1917* (Moscow: Moskovskii rabochii, 1991), 127.

106. Graham, *Russia and the World*, 19–20.

107. Kandaurov to Konstantin Bogaevskii, December 30, 1914, RGALI, f. 700, op. 1, ed. khr. 46, list [l.] 127.

108. *Novoe vremia*, July 24, 1916, 5.

109. *Petrogradskaia gazeta*, November 22, 1914, 2.

110. *Petrogradskaia gazeta*, December 15, 1914, 4.

111. *Petrogradskaia gazeta*, January 11, 1915, 3.

112. See Gaynor Kavanagh, *Museums and the First World War: A Social History* (London:

Leicester University Press, 1994), 36–38; Daniel Sherman, *Worthy Monuments: Art Museums and the Politics of Culture in Nineteenth-Century France* (Cambridge: Harvard University Press, 1989), 242.

113. *Starye gody*, October–December 1914, 130; *Apollon*, April–May 1915, 89, November 1914, 63, August–September 1916, 87.

114. *Starye gody*, October–December 1914, 130; *Apollon*, November 1914, 63, November 1914, 62–63.

115. *Starye gody*, October–December 1914, 119.

116. *Rech'*, April 8. 1916, 5.

117. *Apollon*, October–November 1915, 101.

118. Nesterov, *Pis'ma*, 260.

119. *Russkoe slovo*, December 28, 1914, 6.

120. Valentina Khodasevich, *Portrety slovami* (Moscow: Sovetskii pisatel', 1987), 96–97.

121. Tatiana Alexinsky, *With the Russian Wounded* (London: Unwin, 1916), 11.

122. Peter Kenez, "Russian Patriotic Films," in *Film and the First World War*, ed. Karel Dibbets and Bert Hogenkamp (Amsterdam: Amsterdam University Press, 1995), 39.

123. A. P. Ostroumova-Lebedeva, *Avtobiograficheskie zapiski*, vols. 1–2 (Moscow: Izobrazitel'noe iskusstvo, 1974), 522.

124. *Novoe vremia*, October 18, 1914, 4.

125. *Russkoe slovo*, December 7, 1914, 5.

126. *Petrogradskaia gazeta*, October 20, 1914, 5.

127. *Apollon*, February 1915, 58.

128. *Russkoe slovo*, January 18, 1915, 8.

129. *Iskusstvo i zhizn'* 13, no. 22 (1914): 299–300.

130. *Apollon*, October 1914, 67.

131. Florinsky, *End of the Russian Empire*, 46.

132. *Rech'*, October 24, 1914, 6.

133. *Petrogradskii listok*, March 15, 1916, 5.

134. *Iskry*, no. 37 (1914): 296.

135. *Petrogradskaia gazeta*, October 23, 1914, 3.

136. Stephen Graham, *Russia in 1916* (London: Cassell, 1917), 135.

137. *Petrogradskii listok*, December 20, 1915, 9.

138. *Apollon*, February 1915, 59; S. A. Ovsiannikova, "Khudozhestvennye muzei Peterburga i Moskvy," *Trudy nauchno-issledovatel'skogo instituta muzeevedeniia* 7 (1968): 187–88.

139. For examples see Irina Baburina, *Russkii plakat pervoi mirovoi voiny* (Moscow: Iskusstvo i kul'tura, 1992).

140. *Petrogradskaia gazeta*, January 7, 1915, 4.

141. Platon Beletskii, *Georgii Ivanovich Narbut* (Leningrad: Iskusstvo, 1985), 107.

142. For Narbut's image of Kriuchkov see postcard 250 in M. Chapkina, *Khudozhestvennaia otkrytka* (Moscow: Galart, 1993), 161.

143. *Apollon*, February 1915, 71–72; see also *Utro Rossii*, January 8, 1915, 4; *Petrogradskaia gazeta*, November 21, 1914, 3.

144. *Rech'*, September 11, 1914, 2; *Polveka dlia knigi* (Moscow: Sytin, 1916), 191.

145. Available in the collection of the National Library of Finland's Slavonic Library, Helsinki.

146. P. F. Belikov and V. P. Kniazeva, *Nikolai Konstantinovich Rerikh* (Samara: Agni, 1996), 100.

147. Kathryn Szczepanska, "Zwischen Patriotismus und Prophetie: Die russische Lyrik im Ersten Weltkrieg," in *Kriegserlebnis: Der Erste Weltkrieg in der literarischen Gestaltung und symbolischen Deutung der Nationen*, ed. Klaus Vondung (Göttingen: Vandenhoeck & Ruprecht, 1980), 355.

148. John Foster Fraser, *Russia of Today* (London: Cassell, 1916), 253.

149. *Russkie vedomosti*, December 2, 1914, 6.

150. *Russkie vedomosti*, December 15, 1914, 6.

Chapter 3. Love in the Time of Cholera

1. Pskovitinov, *Iskusstvo i voina*, 13.

2. Merezhkovskii, *Dnevnik*, 207.

3. Paul Fussell, *The Great War and Modern Memory* (New York: Oxford University Press, 1975), 35. For a discussion (and critique) of a direct link between modernism and the war, see Jay Winter, "Cultural Politics and the First World War: Recent Anglo/American Historiographical Trends," *Neue Politische Literatur* 39 (1994): 218–23.

4. Kenneth E. Silver, *Esprit de Corps: The Art of the Parisian Avant-Garde and the First World War, 1914–1925* (New Haven: Yale University Press, 1989), 396–97.

5. Jay Winter, *Sites of Memory, Sites of Mourning* (Cambridge: Cambridge University Press, 1995), 5.

6. Richard Cork, *A Bitter Truth: Avant-Garde Art and the Great War* (New Haven: Yale University Press, 1994), 9.

7. Livshits, *Archer*, 243.

8. *Petrogradskaia gazeta*, August 26, 1915, 2.

9. *Vestnik Evropy* 51 (June 1916): 176.

10. *Utro Rossii*, September 20, 1915, 3.

11. *Sinii zhurnal*, March 7, 1915, 8.

12. Quoted in Florinsky, *End of the Russian Empire*, 133.

13. Peter Kenez, *Cinema and Soviet Society, 1917–1953* (New York: Cambridge University Press, 1992), 19.

14. These figures are calculated from the information presented in A. S. Fedotov, "Pervaia mirovaia voina v russkikh literaturno-khudozhestvennykh al'manakhakh i

sbornikakh (1914–1916)," in *Russkaia kul'tura v usloviiakh inozemnykh nashestvii i voin X—nachalo XX v.*, vol. 2 (Moscow: Institut istorii SSSR AN SSSR, 1990), 261.

15. Fyodor Chaliapin, *Man and Mask: Forty Years in the Life of a Singer* (New York: Knopf, 1932), 214.

16. Jahn, *Patriotic Culture*, 176. The same occurred in Germany. See Jeffrey Verhey, *The Spirit of 1914: Militarism, Myth, and Mobilization in Germany* (Cambridge: Cambridge University Press, 2000), 125.

17. Constantin Stanislavsky, *My Life in Art* (Boston: Little, Brown, 1938), 548.

18. Vasilii Petrovich Komardenkov, *Dni minuvshie* (Moscow: Sovetskii khudozhnik, 1972), 41.

19. *Vestnik Evropy* 51 (January 1916): 414.

20. Farrar, "Nationalism in Wartime," 134.

21. *Rech'*, January 24, 1917, 5.

22. Carola Jüllig, "Die erste Kriegsspielzeit der Berliner Theater," in *Die letzten Tage der Menschheit: Bilder des ersten Weltkrieges*, ed. Rainer Rother (Berlin: Deutsches Historisches Museum, 1994), 133. The tendency was slower elsewhere in Germany.

23. Rainer Rother, "Anmerkungen zum deutschen Film," in Rother, *Die letzten Tage*, 200, 204.

24. Nicholas Hiley, "Der Erste Weltkrieg im britischen Film," in Rother, *Die letzten Tage*, 218.

25. Jean-Jacques Becker, *The Great War and the French People* (Leamington Spa: Berg, 1986), 248.

26. Florinsky, *End of the Russian Empire*, 129.

27. Polner, *Local Government*, 269.

28. Norman Stone, *The Eastern Front, 1914–1917* (London: Penguin, 1998), 208–9, 284.

29. Florinsky, *End of the Russian Empire*, 35.

30. Roland N. Stromberg, *Redemption by War: The Intellectuals and 1914* (Lawrence: Regents Press of Kansas, 1982), 153.

31. McReynolds, *The News*, 256.

32. *Statistika proizvedenii pechati, vyshedshikh v Rossii v 1915 godu* (Petrograd: Tip. MVD, 1916), 8, 96–98.

33. *Sel'skii vestnik*, June 3, 1915, 2–3.

34. *Vechernie izvestiia*, April 4, 1915, 3; *Russkaia shkola* 26, no. 1 (1915): 51; *Novyi kolos*, September 25, 1915, 473.

35. *Vestnik vospitaniia* 26, no. 8 (1915): I, 202.

36. Graham, *Russia in 1916*, 33.

37. Audoin-Rouzeau and Becker, *14–18*, 100.

38. Maurice Paléologue, *An Ambassador's Memoirs*, 3 vols. (London: Hutchinson, 1925), 1:337, 2:11–12, 317.

39. Graham, *Russia in 1916*, 90–91.

40. *Russkie vedomosti*, October 30, 1916, 6.

41. *Russkie vedomosti*, March 29, 1916, 7.

42. *Apollon*, October–November 1915, 121.

43. *Apollon*, August–September 1915, 95.

44. *Apollon*, August–September 1916, 89.

45. *Apollon*, October–November 1915, 121.

46. *Apollon*, January 1916, 35.

47. *Petrogradskaia gazeta*, August 26, 1915, 2.

48. *Petrogradskaia gazeta*, April 10, 1915, 2.

49. *Petrogradskaia gazeta*, December 7, 1915, 4.

50. V. P. Lapshin, *Khudozhestvennaia zhizn' Moskvy i Petrograda v 1917 godu* (Moscow: Sovetskii khudozhnik, 1983), 48; *Birzhevye vedomosti*, evening edition, February 24, 1916, 4.

51. *Rech'*, October 4, 1916, 5.

52. *Iskusstvo*, no. 2 (1916): 17.

53. Graham, *Russia in 1916*, 26–27, 127.

54. *Novoe vremia*, January 1, 1915, 14, January 6, 1916, 5.

55. *Petrogradskaia gazeta*, April 4, 1916, 3; Nesterov, *Pis'ma*, 270.

56. *Petrogradskaia gazeta*, November 24, 1916, 3.

57. *Vechernee vremia*, April 4, 1916, 4; Wassily Kandinsky to Gabriele Münter, May 15, 1916, Gabriele Münter-und Johannes Eichner-Stiftung archives, Munich.

58. *Russkie vedomosti*, January 9, 1917, 2.

59. *Birzhevye vedomosti*, evening edition, January 28, 1917, 5.

60. *Apollon*, January 1917, 56.

61. *Apollon*, October–November 1915, 100, April–May 1916, 70.

62. P. D. Ettinger, *Stat'i, iz perepiski, vospominaniia sovremennikov*, ed. A. A. Demskaia and N. Iu. Semenova (Moscow: Sovetskii khudozhnik, 1989), 146.

63. *Apollon*, August–September 1916, 85.

64. *Apollon*, January 1917, 60.

65. *Rech'*, February 26, 1916, 5.

66. *Apollon*, October–November 1915, 100–101; Ettinger, *Stat'i*, 143.

67. *Novoe vremia*, July 24, 1916, 5.

68. Irina Evstaf'eva, ed., *A. Sofronova: Zapiski nezavisimoi* (Moscow: RA, 2001), 84.

69. *Moskovskie vedomosti*, January 25, 1917, 2.

70. *Moskovskii listok*, October 8, 1916, 3.

71. *Russkie vedomosti*, November 19, 1916, 5.

72. Lapshin, *Khudozhestvennaia zhizn'*, 18.

73. Lapshin, *Khudozhestvennaia zhizn'*, 18.

74. Lapshin, *Khudozhestvennaia zhizn'*, 31.

75. *Petrogradskaia gazeta*, February 24, 1916, 2.

76. *Moskovskii listok*, January 5, 1917, 3.

77. *Novoe vremia*, May 10, 1916, 5.

78. *Apollon*, October 1916, 53.

79. *Petrogradskaia gazeta*, January 28, 1916, 3.

80. *Birzhevye vedomosti*, evening edition, February 19, 1917, 4.

81. *Apollon*, March 1915, 55.

82. *Apollon*, April 1915, 88; *Novoe vremia*, December 6, 1916, 7.

83. *Den'*, February 26, 1916, 4; *Argus*, no. 2 (1917): 72.

84. *Golos Moskvy*, December 30, 1914, 5.

85. *Golos Moskvy*, March 25, 1915, 5.

86. Otdel Rukopisei Rossiiskoi Gosudarstvennoi Biblioteki [hereafter OR RGB], f. 680, k. 1, ed. khr. 2, stranitsa [st.] 10.

87. *Birzhevye vedomosti*, morning edition, September 26, 1916, 4.

88. *Moskovskie vedomosti*, February 1, 1917, 2; *Vechernee vremia*, January 16, 1916, 3.

89. *Apollon*, April–May 1915, 90.

90. *Birzhevye vedomosti*, evening edition, November 5, 1916, 5.

91. *Birzhevye vedomosti*, evening edition, September 25, 1916, 5. Sales figures are in *Rech'*, October 25, 1916, 5.

92. John E. Bowlt, "The Moscow Art Market," in Clowes, Kassow, and West, *Between Tsar and People*, 128.

93. *Petrogradskaia gazeta*, October 27, 1914, 4.

94. Burliuk to Shemshurin, August 21, 1915, in OR RGB, f. 339, k. 2, ed. khr. 8.

95. *Petrogradskaia gazeta*, November 29, 1916, 3.

96. *Apollon*, February–March 1917, 80.

97. Konstantin Somov, *Pis'ma, dnevniki, suzhdeniia sovremennikov*, ed. Iu. N. Podkopaeva and A. N. Sveshnikova (Moscow: Iskusstvo, 1979), 155, 157.

98. *Utro Rossii*, December 10, 1916, 5.

99. Winter, *Sites of Memory*, 5.

100. Sonia E. Howe, *Real Russians* (London: Sampson Low, Marston, 1917), 198.

101. Aleksandr Kamensky, *Chagall: The Russian Years, 1907–1922* (New York: Rizzoli, 1989), 153, 156–57.

102. Fannina W. Halle, "Marc Chagall," *Das Kunstblatt* (1922): 514–15.

103. *Russkie vedomosti*, March 29, 1915, 6.

104. Marc Chagall, *My Life*, trans. Elisabeth Abbott (New York: Orion, 1960), 134, 133.

105. Jelena Hahl-Koch, *Kandinsky* (New York: Rizzoli, 1993), 244; Vivian Endicott Barnett, "Fairy Tales and Abstraction: Stylistic Conflicts in Kandinsky's Art, 1915–1921," in *New Perspectives on Kandinsky*, ed. Bengt Lärkner and Anders Rosdahl (Malmö: Sydsvenska Dagbladet, 1990), 99.

106. Barnett, "Fairy Tales," 101.

107. Clark V. Poling, *Kandinsky: Russian and Bauhaus Years, 1915–1933* (New York: Guggenheim Museum, 1983), 15.

108. Kandinsky to Gabriele Münter, May 31, 1915, Gabriele Münter-und Johannes Eichner-Stiftung archives.

109. Barnett, "Fairy Tales," 103.

110. Hahl-Koch, *Kandinsky*, 244.

111. *Petrogradskii listok*, February 21, 1917, 2.

112. *Petrogradskii listok*, February 23, 1917, 2.

113. *Apollon*, March 1915, 17.

114. *Novoe vremia*, February 24, 1917, 2.

115. *Birzhevye vedomosti*, evening edition, October 23, 1916, 3.

116. *Birzhevye vedomosti*, evening edition, February 29, 1916, 4; *Birzhevye vedomosti*, evening edition, October 23, 1916, 3–4; *Petrogradskii listok*, February 21, 1917, 2.

117. Somov, *Pis'ma*, 156.

118. *Petrogradskii listok*, October 23, 1916, 3, February 21, 1917, 2.

119. Iu. Markin, *Pavel Filonov* (Moscow: Izobrazitel'noe iskusstvo, 1995), 26–27.

120. *Novoe vremia*, January 4, 1916, 4.

121. *Novoe vremia*, March 12, 1915, 5.

122. *Rech'*, November 14, 1914, 5.

123. *Petrogradskii listok*, December 11, 1916, 4.

124. *Novoe vremia*, March 12, 1915, 5.

125. *Iskusstvo i zhizn'* 15, no. 10 (1916): 20.

126. Jost Hermand, "Heroic Delusions: German Artists in the Service of Imperialism," in *1914/1939: German Reflections of the Two World Wars*, ed. Reinhold Grimm and Jost Hermand (Madison: University of Wisconsin Press, 1992), 98; Thomas Noll, "Zur Ikonographie des Krieges," in Rother, *Die letzten Tage*, 270; Helmut Börsch-Supan, "Reaktion der Kunstzeitschriften auf den Ersten Weltkrieg," in Mommsen, *Kultur und Krieg*, 207.

127. Angela Weight, "Kriegsgenrekunst," in Rother, *Die letzten Tage*, 283.

128. *Ogonek*, February 15, March 1, November 15, 1915; *Novoe vremia*, November 8, 1915, 6.

129. *Petrogradskaia gazeta*, February 25, 1916, 3.

130. *Moskovskie vedomosti*, December 23, 1915, 2.

131. *Rech'*, April 29, 1915, 2.

132. *Novoe vremia*, December 21, 1914, 8.

133. Rylov, *Vospominaniia*, 167, 170.

134. *Novoe vremia*, May 19, 1915, 5.

135. *Petrogradskaia gazeta*, September 15, 1915, 4.

136. *Lukomor'e*, January 17, 1915, 15.

137. *Rech'*, February 14, 1915, 3.

138. *Novoe vremia*, January 4, 1916, 4.

139. *Nov'*, December 16, 1914, 9.

140. Iakov Tugendkhol'd, *Problemy voiny v mirovom iskusstve* (Moscow: Sytin, 1916), 161.

141. *Rech'*, October 14, 1916, 2.

142. *Polveka dlia knigi*, 191.

143. *Vremia*, March 18, 1916, 3.

144. *Lukomor'e*, March 21, 1915, 25.

145. Emphasis original. Iakov Tugendkhol'd, "V zheleznom tupike," *Severnye zapiski*, nos. 7–8 (July–August 1915): 102.

146. B. A. Kapralov, ed., *Boris Mikhailovich Kustodiev* (Moscow: Izobrazitel'noe iskusstvo, 1979), 150.

147. O. I. Podobedova, *Evgenii Evgen'evich Lansere, 1875–1946* (Moscow: Sovetskii khudozhnik, 1961), 155.

148. Travel diary of Evgenii Lansere, RGALI, f. 1982, op. 1, ed. khr. 66.

149. Podobedova, *Lansere*, 156.

150. *Rech'*, April 29, 1915, 2.

151. *Otechestvo*, no. 13 (1915): 10.

152. *Novoe vremia*, February 22, 1916, 5.

153. *Birzhevye vedomosti*, morning edition, December 14, 1914, 3.

154. *Novoe vremia*, March 27, 1916, 6.

155. *Novoe vremia*, August 29, 1915, 14.

156. *Petrogradskaia gazeta*, September 29, 1916, 2.

157. *Ogonek*, January 3, 1916, n.p.; *Petrogradskaia gazeta*, December 4, 1915, 2.

158. *Birzhevye vedomosti*, evening edition, December 5, 1915, 5.

159. *Novyi zhurnal dlia vsekh*, January 1916, 38.

Chapter 4. Masters of the Material World

1. Charlotte Douglas, "Tatlin und Malewitsch: Geschichte und Theorie, 1914–1915," in *Tatlin: Leben, Werk, Wirkung*, ed. Jürgen Harten (Cologne: Dumont, 1993), 210.

2. Jean-Claude Marcadé, "Malevich, Painting, and Writing: On the Development of a Suprematist Philosophy," in *Kazimir Malevich: Suprematism*, ed. Matthew Drutt (New York: Guggenheim Museum, 2003), 38. For a good summary of extensive Malevich scholarship as of the early 1980s, see W. Sherwin Simmons, *Kasimir Malevich's Black Square and the Genesis of Suprematism, 1907–1915* (New York: Garland, 1981), 3–6.

3. Sharp, "Russian Avant-Garde," 98–104.

4. Sharp, "Russian Avant-Garde," 108.

5. Bowlt, *Theory and Criticism*, 80.

6. Biographical writings of Andrei Shemshurin, OR RGB, f. 339, op. 6, ed. khr. 11; LEF, no. 1 (1923): 152.

7. Zhadova, *Tatlin*, 182.

8. Zhadova, *Tatlin*, 335.

9. A. A. Osmerkin, *Razmyshleniia ob iskusstve, pis'ma, kritika, vospominaniia sovremennikov*, ed. A. Iu. Nikich (Moscow: Sovetskii khudozhnik, 1981), 63.

10. Katherine S. Dreier, *Burliuk* (New York: Color and Rhyme, 1944), 78.

11. G. Iu. Sternin, *Khudozhestvennaia zhizn' Rossii 1900–1910-kh godov* (Moscow: Iskusstvo, 1988), 6–7.

12. Livshits, *Archer*, 85.

13. Albert Gleizes devised an alternative Celtic genealogy for cubism to counter the Latin nationalism that contemporaries used to attack it. See Mark Antliff, "Cubism, Celtism, and the Body Politic," *Art Bulletin* 74 (December 1992): 668.

14. *Apollon*, January–February 1914, 75.

15. Sharp, *Russian Modernism*, 1.

16. Bowlt, *Theory and Criticism*, 90.

17. Robert Jensen, *Marketing Modernism in Fin-de-Siècle Europe* (Princeton: Princeton University Press, 1994), 10. On the importance of the market for modernism see Michael Fitzgerald, *Making Modernism: Picasso and the Creation of the Market* (New York: Farrar, Straus and Giroux, 1995), 4.

18. Leonid Pasternak, *The Memoirs of Leonid Pasternak*, trans. Jennifer Bradshaw (London: Quartet, 1982), 57.

19. Khardzhiev, *Stat'i*, 130–31.

20. Memoir of Maria Petrova-Vodkina, RGALI, f. 2010, op. 2, ed. khr. 56, reel 1, st. 78–79.

21. On popular hostility to modernism see Brooks, "Popular Philistinism," 90–91; Neuberger, *Hooliganism*, 152–54.

22. For a discussion of avant-garde military service see Boult, "Khudozhestvennaia novatsiia," 28–29.

23. Kliment Red'ko, *Dnevniki, vospominaniia, stat'i* (Moscow: Sovetskii khudozhnik, 1974), 40.

24. Biographical writings of Andrei Shemshurin, OR RGB, f. 339, op. 6, ed. khr. 11.

25. *Petrogradskaia gazeta*, October 27, 1914, 4.

26. See *Novoe vremia*, May 16, 1915, 13, November 10, 1915, 6, November 15, 1916, 5, February 1, 1917, 6; *Rech'*, November 17, 1915, 5, June 14, 1916, 5.

27. *Utro Rossii*, January 25, 1915, 5; *Ranee utro*, January 22, 1915, 4.

28. Charlotte Douglas, ed., *Collected Works of Velimir Khlebnikov*, vol. 1, *Letters and Theoretical Writings* (Cambridge: Harvard University Press, 1987), 109.

29. V. V. Kamenskii, *Put' entuziasta* (Perm': Permskoe knizhnoe izdatel'stvo, 1968), 180–81.

30. Emphasis original. Lawton and Eagle, *Manifestoes*, 97.

31. Emphasis original. Lawton and Eagle, *Manifestoes*, 98.

32. *Moskovskii listok*, November 6, 1916, 4. See also *Birzhevye vedomosti*, morning edition, November 9, 1915, 4; *Petrogradskaia gazeta*, March 5, 1915, 2, November 8, 1915, 3.

33. *Rech'*, March 11, 1916, 5.

34. N. Udal'tsova, *Zhizn' russkoi kubistki* (Moscow: RA, 1994), 11–12.

35. Lawton and Eagle, *Manifestoes*, 96.
36. Vladimir Markov, *Russian Futurism: A History* (Berkeley: University of California Press, 1968), 277.
37. *Nov'*, November 21, 1914, 7; *Apollon*, March 1915, 62.
38. *Golos Moskvy*, January 30, 1915, 5; *Apollon*, December 1915, 54.
39. *Rech'*, April 16, 1915, 5.
40. See the handbill in *Olga Rozanova, 1886–1918* (Helsinki: Helsingin Kaupungin Taidemuseo, 1992), 16.
41. See the handbill in Kazimir Malevich, *Zhivopis', Teoriia*, ed. D. Sarab'ianov and A. Shatskikh (Moscow: Iskusstvo, 1993), 388.
42. *Golos Moskvy*, March 24, 1915, 2.
43. Zhadova, *Tatlin*, 184.
44. *Apollon*, February 1915, 71.
45. *Ranee utro*, December 7, 1914, 6.
46. *Russkie vedomosti*, December 7, 1914, 6.
47. Emphasis original. Lawton and Eagle, *Manifestoes*, 101.
48. N. Gur'ianova, "Voina i avangard," *Russian Literature* 32 (1992): 69.
49. Tugendkhol'd, "V zheleznom tupike," 104.
50. See the reproductions in Gerald Janecek, *The Look of Russian Literature: Avant-Garde Experiments, 1900–1930* (Princeton: Princeton University Press, 1984), 100.
51. Nikoletta Misler [Nicoletta Misler], "Apokalipsis i russkoe krest'ianstvo: Mirovaia voina v primitivistskoi zhivopisi Natalii Goncharovoi," in *N. Goncharova, M. Larionov: Issledovaniia i publikatsii*, ed. G. F. Kovalenko (Moscow: Nauka, 2001), 38.
52. Gur'ianova, "Voina i avangard," 66.
53. Evelyn Cobley, *Representing War: Form and Ideology in First World War Narratives* (Toronto: University of Toronto Press, 1993), 199.
54. John Milner, *Kazimir Malevich and the Art of Geometry* (New Haven: Yale University Press, 1996), 114.
55. For an extensive discussion of this image and its links to World War I, see Christina Lodder, "The Transrational in Painting: Kazimir Malevich, Alogism and *Zaum*," in her *Constructive Strands in Russian Art, 1914–1937* (London: Pindar, 2005), 52–57.
56. *Iskry*, June 22, 1914, 2.
57. Larissa Alekseevna Zhadova, *Malevich: Suprematism and Revolution in Russian Art, 1910–1930* (New York: Thames and Hudson, 1982), 30.
58. Douglas, "Tatlin und Malewitsch," 214.
59. *Rech'*, November 22, 1914, 4.
60. See Petrone, "Family," 105–6.
61. Sue Malvern, "Art and War: Truth or Fiction?" *Art History* 19, no. 2 (1996): 308.
62. *Ogonek*, October 5, 1914, n.p.; see also *Novyi zhurnal dlia vsekh*, December 1915, 32.
63. V. B. Mirimanov, *Russkii avangard i esteticheskaia revoliutsiia XX veka: Drugaia paradigma vechnosti* (Moscow: RGGU, 1995), 24.

64. Emphasis original. Burliuk to Shemshurin, letter postmarked July 27, 1914, in OR RGB, f. 339, k. 2, ed. khr. 8.

65. A. M. Rodchenko, *Stat'i, vospominaniia, avtobiograficheskie zapiski, pis'ma*, ed. V. A. Rodchenko (Moscow: Sovetskii khudozhnik, 1982), 114.

66. Udal'tsova, *Zhizn'*, 35.

67. A. V. Krusanov, *Russkii avangard, 1907–1932*, vol. 1 (St. Petersburg: Novoe literaturnoe obozrenie, 1996), 253.

68. I. V. Kliun, *Moi put' v iskusstve* (Moscow: RA, 1999), 87.

69. Rodchenko, *Stat'i*, 83.

70. John Bowlt and Matthew Drutt, eds., *Amazons of the Avant-Garde* (New York: Guggenheim Museum, 2000), 327.

71. V. N. Terekhina and A. P. Zimenkov, eds., *Russkii futurizm* (Moscow: Nasledie, 1999), 428.

72. Nikolai Berdiaev, *Krizis iskusstva* (Moscow: Leman and Sakharov, 1918), 22–23.

73. Kruchenykh, *Our Arrival*, 58.

74. Punin, "Kvartira No. 5," 182.

75. *Ranee utro*, March 24, 1915, 2.

76. *Petrogradskaia gazeta*, March 4, 1915, 2.

77. *Ogonek*, January 3, 1916, n.p.; *Apollon*, March 1916, 62; *Lukomor'e*, April 30, 1916, 25.

78. *Birzhevye vedomosti*, evening edition, December 5, 1915, 3–4.

79. Terekhina and Zimenkov, *Russkii futurizm*, 340.

80. Monas and Krupala, *Diaries*, 27.

81. Lawton and Eagle, *Manifestoes*, 100.

82. Bowlt, *Theory and Criticism*, 125.

83. *Ranee utro*, January 19, 1915, 2; *Birzhevye vedomosti*, morning edition, March 6, 1915, 5.

84. A newspaper rumor that a Russian collector purchased a painterly relief for three thousand rubles was surely false. See Douglas, "Tatlin und Malewitsch," 212. No collector would have paid such an astronomical sum, many times the usual price for avant-garde art, and there is no other mention in the press or memoir literature that such a sale took place.

85. Terekhina and Zimenkov, *Russkii futurizm*, 340.

86. Udal'tsova, *Zhizn'*, 29–30, 32.

87. Udal'tsova, *Zhizn'*, 32.

88. N. Punin, *O Tatline* (Moscow: RA, 1994), 13.

89. Lawton and Eagle, *Manifestoes*, 101–2.

90. K. S. Malevich, "Pis'ma k M. V. Matiushinu," *Ezhegodnik rukopisnogo otdela pushkinskogo doma na 1974 god* (Leningrad: Nauka, 1976), 187.

91. John Milner, *Vladimir Tatlin and the Russian Avant-Garde* (New Haven: Yale University Press, 1983), 99; V. Rakitin, "The Artisan and the Prophet: Marginal Notes on Two Artistic Careers," in *Great Utopia*, 26.

92. Krusanov, *Russkii avangard*, 257.
93. The dating for the counter-reliefs is uncertain, but in an exhibition brochure Tatlin claimed he created them in 1915. See Zhadova, *Tatlin*, figure 125.
94. Kazimir Malevich, *Sobranie sochinenii v piati tomakh*, vol. 1, ed. A. S. Shatskikh (Moscow: Gileia, 1995), 87.
95. Malevich, "Pis'ma," 180–81.
96. Rodchenko, *Stat'i*, 84.
97. Sharp, "Critical Reception," 49.
98. Kazimir Malevich, *Essays on Art, 1915–1928*, vol. 1, ed. Troels Andersen, trans. Xenia Glowacki-Prus and Arnold McMillin (Copenhagen: Borgen, 1968), 44.
99. Sharp, "Critical Reception," 44.
100. Udal'tsova, *Zhizn'*, 26.
101. Udal'tsova, *Zhizn'*, 27.
102. Monas and Krupala, *Diaries*, 29.
103. Emphasis mine. Monas and Krupala, *Diaries*, 30.
104. Charlotte Douglas suggests that Malevich may have patterned some of his ideas about early suprematism, especially his sudden focus on the material of art, after gaining knowledge of Tatlin's ideas from Udal'tsova, Isakov, and Popova. See Douglas, "Tatlin und Malewitsch," 214.
105. Khodasevich, *Portrety slovami*, 106.
106. Memoirs and writings of Vera Pestel', OR RGB, f. 680, k. 1, ed. khr. 2, st. 12.
107. Emphasis original. Malevich, "Pis'ma," 189.
108. Bowlt and Drutt, *Amazons*, 335.
109. Jakobson, *Futurist Years*, 24.
110. Bowlt and Drutt, *Amazons*, 335.
111. Bowlt and Drutt, *Amazons*, 335.
112. Bowlt and Drutt, *Amazons*, 336–37.
113. Gurianova, *Rozanova*, 165.
114. *Apollon*, January 1917, 70.
115. Memoirs and writings of Vera Pestel', OR RGB, f. 680, k. 1, ed. khr. 2, st. 10.
116. Bowlt, "Khudozhestvennaia novatsiia," 34.
117. Kenneth C. Lindsay and Peter Vergo, eds., *Kandinsky: Complete Writings on Art*, vol. 1, *1901–1921* (Boston: G. K. Hall, 1982), 446.
118. Mirimanov, *Russkii avangard*, 25; Jeannot Simmen, *Kasimir Malewitsch: Das Schwarze Quadrat* (Frankfurt am Main: Fischer, 1998), 6.
119. Tugendkhol'd, "V zheleznom tupike," 110.
120. A. Strigalev, "From Painting to the Construction of Matter," in Zhadova, *Tatlin*, 19.
121. Emphasis mine. Monas and Krupala, *Diaries*, 29–30.
122. Bowlt, *Theory and Criticism*, 114.
123. Charlotte Douglas, *Kazimir Malevich* (New York: Abrams, 1994), 22.
124. Evgenii Kovtun, "The Third Path to Non-Objectivity," in *Great Utopia*, 321.

125. Bowlt, *Theory and Criticism*, 100–101; Anthony Parton, *Mikhail Larionov and the Russian Avant-Garde* (Princeton: Princeton University Press, 1993), xxiii.

126. Wassily Kandinsky, *Über das Geistige in der Kunst* (Bern: Benteli, 1965), 71, 142.

127. Bowlt and Drutt, *Amazons*, 326.

128. Bowlt and Drutt, *Amazons*, 328–29.

129. Konstantin Umanskij, *Die Neue Kunst in Russland, 1914–1919* (Potsdam: Kiepenheuer, 1920), 19.

130. Pskovitinov, *Iskusstvo i voina*, 12.

131. Barnett, "Fairy Tales," 100.

132. Ol'ga Leshkova to Mikhail Le-Dantiu, December 2, 1916, in RGALI, f. 792, op. 3, ed. khr. 16.

133. Rodchenko, *Stat'i*, 114.

134. Monas and Krupala, *Diaries*, 28.

135. Katherine Hodgson, "Myth-making in Russian War Poetry," in *The Violent Muse: Violence and the Artistic Imagination in Europe, 1910–1939*, ed. Jana Howlett and Rod Mengham (Manchester: Manchester University Press, 1994), 65–66.

136. Cork, *Bitter Truth*, 123.

137. Malevich, "Pis'ma," 195.

138. Burliuk to Andrei Shemshurin, mid-1917, in OR RGB, f. 339, k. 2, ed. khr. 8. Udaltsova also expressed longings for peace about the same time. See Udal'tsova, *Zhizn'*, 37.

139. Zhadova, *Tatlin*, 333–35.

140. Monas and Krupala, *Diaries*, 26.

141. Bowlt, *Theory and Criticism*, 112.

142. Bowlt, *Theory and Criticism*, 132.

143. Bowlt, *Theory and Criticism*, 127.

144. Emphasis original. Bowlt, *Theory and Criticism*, 119.

145. Bowlt, *Theory and Criticism*, 133.

146. Andersen, *Malevich*, 46.

147. Milner, *Malevich*, 120–61.

148. Evgenii Trubetskoi, *Umozrenie v kraskakh* (Newtonville MA: Oriental Research Partners, 1976), 42–43.

149. Memoirs and writings of Vera Pestel', OR RGB, f. 680, k. 1, ed. khr. 2, st. 4.

150. *Rech'*, December 25, 1915, 5.

151. Bowlt and Drutt, *Amazons*, 326–27.

152. *Rech'*, January 9, 1916, 3.

153. Emphasis original. Tugendkhol'd, "V zheleznom tupike," 107.

154. Barnett, "Fairy Tales," 108.

Chapter 5. The Revolver and the Brush

1. Krusanov, *Russkii avangard*, 296.

2. *LEF*, no. 1 (1923): 4.

3. See James Rubin, *Realism and Social Vision in Courbet and Proudhon* (Princeton: Princeton University Press, 1980), 3–4; Patricia Leighten, *Re-Ordering the Universe: Picasso and Anarchism, 1897–1914* (Princeton: Princeton University Press, 1989), xv; Stephen E. Eisenman, "Seeing Seurat Politically," *Art Institute of Chicago Museum Studies* 14, no. 2 (1989): 211; Philip Nord, "Manet and Radical Politics," *Journal of Interdisciplinary History* 19 (Winter 1989): 447; Joan Ungersma Halperin, *Félix Fénéon: Aesthete and Anarchist in Fin-de-Siècle Paris* (New Haven: Yale University Press, 1988), xiv; Helena Lewis, *The Politics of Surrealism* (New York: Paragon House, 1988), x; Gertje R. Utley, *Picasso: The Communist Years* (New Haven: Yale University Press, 2000), 216–18.

4. See Mark Antliff, *Inventing Bergson: Cultural Politics and the Parisian Avant-Garde* (Princeton: Princeton University Press, 1993), 15; Jill Lloyd, *German Expressionism: Primitivism and Modernity* (New Haven: Yale University Press, 1991), viii; Andrew Hewitt, *Fascist Modernism: Aesthetics, Politics, and the Avant-Garde* (Stanford: Stanford University Press, 1993), 4; Modris Eksteins, *Rites of Spring: The Great War and the Birth of the Modern Age* (New York: Bantam Press, 1989), xvi.

5. Paul Wood, "The Politics of the Avant-Garde," in *Great Utopia*, 2.

6. Martin Hammer and Christina Lodder, *Constructing Modernity: The Art and Career of Naum Gabo* (New Haven: Yale University Press, 2000), 56; Livshits, *Archer*, 33; P. P. Konchalovskii, *Konchalovskii: Khudozhestvennoe nasledie* (Moscow: Iskusstvo, 1964), 22–23.

7. Chagall, *My Life*, 138.

8. Sharp, "Russian Avant-Garde," 98–104.

9. Brooks, "Readers and Reading," 106–9.

10. Gray, *Russian Experiment*, 6. On the links between avant-garde and Stalinist aesthetics see A. I. Morozov, *Konets utopii: Iz istorii iskusstva v sssr 1930–x godov* (Moscow: Galart, 1995), 10–11; Vladislav Todorov, *Red Square, Black Square: Organon for Revolutionary Imagination* (Albany: State University of New York Press, 1995), 12–14; Boris Groys, *The Total Art of Stalinism: Avant-garde, Aesthetic Dictatorship, and Beyond* (Princeton: Princeton University Press, 1992), 7–8; Igor Golomshtok, *Totalitarian Art in the Soviet Union, the Third Reich, Fascist Italy, and the People's Republic of China* (New York: Icon Editions, 1990), xiv. For a compact discussion of the different interpretations of the politics of the Russian avant-garde, see Wood, "Politics," 2–8.

11. Clark, *Petersburg*, 24.

12. Kruchenykh, *Our Arrival*, 50.

13. Irina Gutkin, *The Cultural Origins of the Socialist Realist Aesthetic, 1890–1934* (Evanston: Northwestern University Press, 1999), 29; John E. Bowlt, "Art in Exile: The Russian Avant-Garde and the Emigration," *Art Journal* 41, no. 3 (1981): 216.

14. Strigalev, "From Painting," 22; Krusanov, *Russkii avangard*, 295.

15. Vsevolod Vasnetsov, *Stranitsy proshlogo: Vospominaniia o khudozhnikakh brat'iakh Vasnetsovykh* (Leningrad: Khudozhnik rsfsr, 1976), 103.

16. Punin, *O Tatline*, 13.
17. Gurianova, *Rozanova*, 125. On the general link between avant-garde and anarchism see Yule F. Heibel, "'They Danced on Volcanoes': Kandinsky's Breakthrough to Abstraction, the German Avant-Garde and the Eve of the First World War," *Art History* 12, no. 3 (1989): 352.
18. *Olga Rozanova, 1886–1918*, 17.
19. Hubertus Gassner, "The Constructivists: Modernism on the Way to Modernization," in *Great Utopia*, 302–5.
20. Sternin, *Kunstleben*, 126.
21. Quoted in John Bowlt, *Silver Age: Russian Art of the Early Twentieth Century and the "World of Art" Group* (Newtonville MA: Oriental Research Partners, 1982), 111.
22. Sternin, *Kunstleben*, 85.
23. Igor' Grabar', *Moia zhizn'* (Moscow: Respublika, 2001), 210.
24. Sternin, *Kunstleben*, 107; *Zolotoe runo* 5 (1906): 56.
25. Kazimir Malevich, "Chapters from an Artist's Autobiography," trans. Alan Upchurch, *October* 34 (Autumn 1985): 40–41.
26. Monas and Krupala, *Diaries*, 7–8.
27. Sharp, "Critical Reception," 40.
28. See Malcolm Gee, "The Nature of Twentieth-Century Art Criticism," in *Art Criticism since 1900*, ed. Gee (Manchester: Manchester University Press, 1993), 13.
29. *Rech'*, December 25, 1915, 5, January 9, 1916, 3, March 21, 1915, 5.
30. *Rech'*, November 23, 1912, 2.
31. *Rech'*, December 2, 1916, 2.
32. N. Dmitrieva, *Moskovskoe uchilishche zhivopisi, vaianiia, zodchestva* (Moscow: Iskusstvo, 1951), 152–54.
33. Parton, *Larionov*, 32.
34. Strigalev, "From Painting," 22, 41.
35. Khardzhiev, *Stat'i*, 138.
36. Ia. V. Bruk, ed., *Gosudarstvennaia tret'iakovskaia galereia: Ocherki istorii, 1856–1917* (Leningrad: Khudozhnik RSFSR, 1981), 187.
37. Bruk, *Gosudarstvennaia tret'iakovskaia galereia*, 6; O. I. Podobedova, *Igor' Emmanuilovich Grabar'* (Moscow: Sovetskii khudozhnik, 1964), 159.
38. For more details see my article "Making Modern Art Russian: Artists, Politics, and the Tret'iakov Gallery during the First World War," *Journal of the History of Collections* 14, no. 2 (2002): 271–81.
39. *Russkoe slovo*, January 23, 1916, 6.
40. Evgenii Trubetskoi, "Voina i mirovaia zadacha Rossii," *Russkaia mysl'* 35 (December 1914): part 2, 94.
41. Trubetskoi, *Umozrenie v kraskakh*, 55.
42. I. E. Grabar', *Pis'ma, 1891–1917* (Moscow: Nauka, 1974), 316.
43. *Rech'*, January 30, 1916, 3.

44. Emphasis original. Dobuzhinskii, *Pis'ma*, 139.

45. *Russkie vedomosti*, February 4, 1916, 6.

46. *Russkie vedomosti*, February 4, 1916, 6.

47. *Utro Rossii*, February 4, 1916, 6.

48. *Vechernie izvestiia*, March 8, 1916, 5.

49. *Russkie vedomosti*, February 5, 1916, 4–5.

50. *Russkie vedomosti*, February 6, 1916, 5.

51. Nesterov, *Pis'ma*, 268.

52. Grabar', *Zhizn'*, 261.

53. Florinsky, *End of the Russian Empire*, 121–22, 153–55.

54. Paléologue, *Memoirs*, 3:133.

55. Lapshin, *Khudozhestvennaia zhizn'*, 108–10.

56. See Lapshin, *Khudozhestvennaia zhizn'*, 96.

57. *Petrogradskaia gazeta*, April 5, 1917, 6; *Petrogradskii listok* April 9, 1917, 2.

58. For details see Lapshin, *Khudozhestvennaia zhizn'*, 85–100.

59. Lapshin, *Khudozhestvennaia zhizn'*, 73–76; Bowlt, *Silver Age*, 128.

60. Gurianova, *Rozanova*, 170.

61. *Moskovskie vedomosti*, April 21, 1917, 2.

62. Lapshin, *Khudozhestvennaia zhizn'*, 252, 256.

63. *Russkie vedomosti*, January 21, 1918, 2.

64. Udal'tsova, *Zhizn'*, 50.

65. Lapshin, *Khudozhestvennaia zhizn'*, 128, 132.

66. Udal'tsova, *Zhizn'*, 40.

67. Kliun, *Moi put'*, 82.

68. Ia. A. Tugendkhol'd, *Iskusstvo oktiabr'skoi epokhi* (Leningrad: Academia, 1930), 19.

69. Kendall E. Bailes, "Reflections on Russian Professions," in *Russia's Missing Middle Class: The Professions in Russian History*, ed. Harley D. Balzer (Armonk NY: M. E. Sharpe, 1996), 51.

70. Wood, "Politics," 9.

71. James Von Geldern, *Bolshevik Festivals, 1917–1920* (Berkeley: University of California Press, 1993), 22.

72. *Moskva*, no. 2 (1919): 16.

73. M. P. Lazarev, *David Shterenberg* (Moscow: Galaktika, 1992), 151.

74. Brandon Taylor, *Art and Literature under the Bolsheviks*, vol. 1, *The Crisis of Renewal, 1917–1924* (London: Pluto, 1991), 161.

75. Bowlt, *Theory and Criticism*, 153.

76. Richard Stites, *Revolutionary Dreams: Utopian Vision and Experimental Life in the Russian Revolution* (New York: Oxford University Press, 1989), 3.

77. Christina Lodder, *Russian Constructivism* (New Haven: Yale University Press, 1983). 75–76.

78. Lodder, *Constructivism*, 109.

79. Wood, "Politics," 9.

80. Memoirs and writings of Vera Pestel', OR RGB, f. 680, k. 1, ed. khr. 2, st. 21.

81. Udal'tsova, *Zhizn'*, 45.

82. Memoirs and writings of Vera Pestel', OR RGB, f. 680, k. 1, ed. khr. 2, st. 20.

83. Red'ko, *Dnevniki*, 50.

84. Bowlt, "Art in Exile," 215.

85. Wood, "Politics," 10.

86. Taylor, *Art and Literature*, 163.

87. Nesterov, *Pis'ma*, 273.

88. Nesterov, *Pis'ma*, 274.

89. Nesterov, *Pis'ma*, 279.

90. Hammer and Lodder, *Gabo*, 98–99.

91. *Pis'ma Kazimira Malevicha El' Lisitskomu i Nikolaiu Puninu* (Moscow: Pinakoteka, 2000), 6.

92. Charlotte Douglas, "Terms of Transition: The *First Discussional Exhibition* and the Society of Easel Painters," in *Great Utopia*, 451.

93. Brandon Taylor, "On AKhRR," in *Art of the Soviets: Painting, Sculpture, and Architecture in a One-Party State, 1917–1992*, ed. Matthew Cullerne Bown and Brandon Taylor (Manchester: Manchester University Press, 1993), 51.

94. Bowlt, *Theory and Criticism*, 270.

95. Lazarev, *Shterenberg*, 175.

96. A. N. Lavrent'ev, *Rakursy Rodchenko* (Moscow: Iskusstvo, 1992), 18.

97. *Birzhevye vedomosti*, evening edition, May 4, 1915, 5.

98. Bowlt, *Theory and Criticism*, 194; Kazimir Malevich, *Sobranie sochinenii v piati tomakh*, vol. 3, ed. A. S. Shatskikh (Moscow: Gileia, 2000), 107.

99. Jeffrey Brooks, "Socialist Realism in *Pravda*: Read All about It!" *Slavic Review* 53 (1994): 973–75, 991.

100. Vassily Rakitin, "The Avant-Garde and Art of the Stalinist Era," in *Culture of the Stalin Period*, ed. Hans Günther (New York: St. Martin's Press, 1990), 187.

101. Sharp, "Russian Avant-Garde," 110.

102. Drutt, *Malevich*, 242–43.

Conclusion

1. Malevich, "Pis'ma," 194. A square arshin is about 5.4 square feet.

2. Zhadova, *Tatlin*, 184.

3. Quoted in Gurianova, *Rozanova*, 5.

4. Jelena Hahl-Koch, ed., *Arnold Schoenberg, Wassily Kandinsky: Letters, Pictures, and Documents*, trans. John Crawford (London: Faber and Faber, 1984), 73.

5. Holquist, *Making War*, 2.

6. Joan Weinstein, *The End of Expressionism: Art and the November Revolution in Germany, 1918–1919* (Chicago: University of Chicago Press, 1990), 3–4.

7. A. C. Wright, "Some Aspects of Twentieth-Century Russian Painting," *Canadian Slavonic Papers* 11, no. 4 (1969): 407.

8. Mirimanov, *Russkii avangard*, 26.

9. Much of the easel painting in the early exhibitions of the Association of Artists of Revolutionary Russia depicted military subject matter. See Taylor, *Art and Literature*, 163–65.

10. Kruchenykh, *Our Arrival*, 91–92.

11. See Mark von Hagen, *Soldiers in the Proletarian Dictatorship: The Red Army and the Soviet Socialist State, 1917–1930* (Ithaca: Cornell University Press, 1990), 7.

12. Christina Lodder, "Monuments to the Masses: Embodying the Collective," in Lodder, *Constructive Strands*, 193–94. The same could be said of the famous poster by El Lissitzky, *Beat the Whites with the Red Wedge* (1920), which was probably modeled on Kolli's monument.

13. General Krasnov was a White general who called for German intervention to defeat the Bolsheviks during the Civil War.

Selected Bibliography

There is a vast literature in Russian history, World War I studies, and art history for the material covered in this book. To economize, a short bibliography with some primary and secondary sources on Russian visual culture and World War I is here given. Please refer to citations in the text for more on the First World War, Russian art history, or individual artists.

Apollon, 1914–17. Art journal with running column "Iskusstvo i voina" and extensive news of the art world.

Baburina, Irina. *Russkii plakat pervoi mirovoi voiny*. Moscow: Iskusstvo i kul'tura, 1992.

Benua, Aleksandr [Alexandre Benois]. "Iskusstvo i voina." *Rech'*, September 18, 1914, 1.

———. "Khudozhestvennye pis'ma." *Rech'*, April 29, 1915, 2.

———. "Kniga o batal'nom iskusstve." *Rech'*, October 14, 1916, 2.

———. "Otvet baronu N. N. Vrangeliu." *Rech'*, September 21, 1914, 2–3.

———. "Posledniaia futuristskaia vystavka." *Rech'*, January 9, 1916, 3.

Berdiaev, Nikolai. "Futurizm na voine." *Birzhevye vedomosti*, morning edition, October 26, 1914, 3–4.

———. *Krizis iskusstva*. Moscow: G. A. Leman and S. I. Sakharov, 1918.

Boult, Dzhon E. [John E. Bowlt]. "Khudozhestvennaia novatsiia i voennaia strategiia: Russkii avangard i Pervaia mirovaia voina." In *Avangard 1910–x–1920–x godov: Vzaimodeistvie iskusstv*, ed. G. F. Kovalenko, 25–35. Moscow: Iskusstvoznanie, 1998.

Cork, Richard. *A Bitter Truth: Avant-Garde Art and the Great War.* New Haven: Yale University Press, 1994.

Denisov, Vladimir. "Voina i lubok." *Novyi zhurnal dlia vsekh,* December 1915, 42–46.

———. *Voina i lubok.* Petrograd: Novyi zhurnal dlia vsekh, 1916.

Efros, Abram. "Voina i iskusstvo." *Prozhektor,* no. 30 (1929): 26–27.

Fedotov, A. S. "Pervaia mirovaia voina v russkikh literaturno-khudozhest-vennykh al'manakhakh i sbornikakh (1914–1916)." In *Russkaia kul'tura v usloviiakh inozemnykh nashestvii i voin X—nachalo XX v.,* ed. A. N. Kopylov, 2:259–94. Moscow: Institut istorii SSSR AN SSSR, 1990.

Galaktionov, I. D. *Lubok: Russkie narodnye kartinki.* Petrograd: Ministerstvo finansov, 1915.

Gnedich, P. "Khu-ki na voine." *Petrogradskaia gazeta,* August 19, 1914, 4.

Grishchenko, A. *Voprosy Zhivopisi.* Vol. 4, *"Krizis iskusstva" i sovremennaia zhivopis': Po povodu lektsii N. Berdiaeva.* Moscow: Gorodskaia tipografiia, 1917.

Gross, V. *Voina v iskusstve.* Leningrad: Krasnaia gazeta, 1930.

Gur'ianova, Nina. "Voina i avangard." *Russian Literature* 32 (1992): 65–76.

Isakov, Sergei. "Voina i iskusstvo." *Novyi zhurnal dlia vsekh,* November 1914, 50–53.

Ivanov, A. I. *Pervaia mirovaia voina v russkoi literature 1914–1918 gg.* Tambov: TGU, 2005.

Jahn, Hubertus. *Patriotic Culture in Russia during World War I.* Ithaca: Cornell University Press, 1995.

Kovtun, E. F. "Izdatel'stvo 'Segodniashnii lubok.'" *Stranitsy istorii otechestvennogo iskusstva,* ed. E. N. Petrova, 2:82–85. St. Petersburg: Gosudarstvennyi russkii muzeii, 1993.

Krasnopol'skii, Otton. *Abstraktivizm v iskusstve novatorov (postimpressionizm i neoromantizm).* Moscow: Obshchestvennaia pol'za, 1917.

Kravchenko, N. "Vystavka kartin i etiudov I. A. Vladimirova." *Novoe vremia,* August 29, 1915, 13–14.

Lapshin, V. P. *Khudozhestvennaia zhizn' Moskvy i Petrograda v 1917 godu.* Moscow: Sovetskii khudozhnik, 1983.

Lebedeva, I. V. "Russkii voennyi lubok perioda pervoi mirovoi voiny." In *Istoriia, istoriografiia, bibliotechnoe delo: Materialy konferentsii spetsialistov Gosudarstvennoi publichnoi istoricheskoi biblioteki,* ed. L. L. Batova, 37–48. Moscow: GPIBR, 1994.

Ledovskikh, N. P. "Russkaia tvorcheskaia intelligentsiia v gody pervoi mirovoi voiny." In *Rossiia v pervoi mirovoi voine: Tezisy mezhvuzovskoi nauchnoi konferentsii, 4–5 oktiabria 1994 goda,* ed. Iu. V. Fulin, 143–53. Riazan': RGPU, 1994.

"Literaturnyi subbotnik. Voina i tvorchestvo." *Utro Rossii,* December 10, 1916, 5.

Liubosh, S. "Voina i pechat'." *Rech',* November 22, 1914, 3–4.

Magula, Gerasim. "Voina i khudozhniki." *Lukomor'e,* January 17, 1915, 15–16.

Misler, Nikoletta [Nicoletta Misler]. "Apokalipsis i russkoe krest'ianstvo: Mirovaia voina v primitivistskoi zhivopisi Natalii Goncharovoi." In *N. Goncharova. M. Larionov: Issledovaniia i publikatsii,* ed. G. F. Kovalenko, 31–42. Moscow: Nauka, 2001.

Nakatov, I. "Mobilizatsiia iskusstva." *Zhurnal zhurnalov,* September 16, 1915, 12–13.

Norris, Stephen. *A War of Images: Russian Popular Prints, Wartime Culture, and National Identity, 1812–1945.* De Kalb: Northern Illinois University Press, 2006.

Petrone, Karen. "Family, Masculinity, and Heroism in Russian War Posters of the First World War." In *Borderlines: Genders and Identities in War and Peace, 1870–1930,* ed. Billie Melman, 172–93. London: Routledge, 1998.

Pskovitinov, E. *Iskusstvo i voina.* Petrograd: Manasevich, 1914.

Railian, Foma. "Khud-naia zhizn': O vliianii voiny na tvorchestvo." *Petrogradskaia gazeta,* January 5, 1917, 2.

———. "Khud-naia zhizn': Voina i radosti zhizni." *Petrogradskaia gazeta,* February 6, 1917, 4.

Reisner, M. A. "Kh-k i obshchestvo." *Den'*, October 19, 1915, 3.

Rother, Rainer, ed. *Die letzten Tage der Menschheit: Bilder des Ersten Welt-krieges*. Berlin: Deutsches Historisches Museum, 1994.

Roult, Neil. *A Catalogue of the Russian War Loan Posters of 1916 and 1917*. Library of Congress, 1993.

Sharp, Jane A. "The Critical Reception of the *0.10* Exhibition: Malevich and Benua." In *The Great Utopia: The Russian and Soviet Avant-Garde, 1915–1932*, 39–52. New York: Guggenheim Museum, 1992.

Slavenson, Vera. "Voina i lubok." *Vestnik Evropy* 50 (July 1915): 91–112.

Solomonov, M. "Voina i khudozhniki." *Zhurnal zhurnalov*, no. 8 (1915): 12–13.

"Spectator." "Kak otrazilas' voina na iskusstve?" *Petrogradskaia gazeta*, April 10, 1915, 2.

Stites, Richard. "Days and Nights in Wartime Russia: Cultural Life, 1914–1917." In *European Culture in the Great War: The Arts, Entertainment, and Propaganda, 1914–1918*, ed. Aviel Roshwald and Richard Stites, 8–31. Cambridge: Cambridge University Press, 1999.

Stromberg, Roland N. *Redemption by War: The Intellectuals and 1914*. Lawrence: Regents Press of Kansas, 1982.

Tugendkhol'd, Iakov, "Bor'ba s voinoi i izobrazitel'nye iskusstva." In *Voina voine*, ed. L. A. Sosnovskii, 61–74. Moscow: AKhRR, 1926.

———. *Problemy voiny v mirovom iskusstve*. Moscow: Sytin, 1916.

———. "V zheleznom tupike." *Severnye zapiski*, nos. 7–8 (July–August 1915): 102–11.

Vinogradov, V. A. *Pervaia mirovaia voina: Ukazatel' literatury, 1914–1996 gg.* Moscow: RAN, 1994.

Vlagin, M. "Krizis v iskusstve." *Lukomor'e*, April 30, 1916, 24–25.

"Voina i tvorchestvo." *Utro Rossii*, December 17, 1916, 5.

Vrangel', N. "Kliuch k serdtsu." *Rech'*, September 20, 1914, 2–3.

Zhulev, P. "Ulichnoe iskusstvo." *Iskusstvo i zhizn'*, no. 4 (1915): 89–96.

Index

Studies in War, Society, and the Military

*Military Migration and State Formation: The British Military
Community in Seventeenth-Century Sweden*
Mary Elizabeth Ailes

The State at War in South Asia
Pradeep P. Barua

An American Soldier in World War I
George Browne
Edited by David L. Snead

Beneficial Bombing: The Progressive Foundations of American Air Power, 1917–1945
Mark Clodfelter

Fu-go: The Curious History of the Japanese Balloon Bombs
Ross Coen

*Imagining the Unimaginable: World War, Modern Art,
and the Politics of Public Culture in Russia, 1914–1917*
Aaron J. Cohen

The Rise of the National Guard: The Evolution of the American Militia, 1865–1920
Jerry Cooper

The Thirty Years' War and German Memory in the Nineteenth Century
Kevin Cramer

Political Indoctrination in the U.S. Army from World War II to the Vietnam War
Christopher S. DeRosa

In the Service of the Emperor: Essays on the Imperial Japanese Army
Edward J. Drea

American Journalists in the Great War: Rewriting the Rules of Reporting
Chris Dubbs

America's U-Boats: Terror Trophies of World War I
Chris Dubbs

The Age of the Ship of the Line: The British and French Navies, 1650–1815
Jonathan R. Dull

American Naval History, 1607–1865: Overcoming the Colonial Legacy
Jonathan R. Dull

*You Can't Fight Tanks with Bayonets: Psychological Warfare against the Japanese
Army in the Southwest Pacific*
Allison B. Gilmore

A Strange and Formidable Weapon: British Responses to World War I Poison Gas
Marion Girard

Civilians in the Path of War
Edited by Mark Grimsley and Clifford J. Rogers

CPSIA information can be obtained
at www.ICGtesting.com
Printed in the USA
BVOW06*1130291117
501546BV00007B/71/P

9 780803 215474